GLOBAL VILLAGE: THE 1960s

Edited by Stéphane Aquin

Interviews with
Capt. Alan L. Bean, Michael J. Watts,
Ettore Sottsass, Derrick de Kerckhove,
Arthur Danto, Bert Stern,
Agnès Varda, Daniel Cohn-Bendit,
Okwui Enwezor, Tobias Wolff,
Michel Tremblay, Carolee Schneemann,
Theodore Roszak, and Yoko Ono

Essays by
Stéphane Aquin, Anna Detheridge

The Montreal Museum of Fine Arts

in association with Snoeck Publishers

GLOBAL VILLAGE: THE 1960s

This catalogue was published on the occasion of
the exhibition *Global Village: The 1960s* organized by
The Montreal Museum of Fine Arts.

General Curator of the Exhibition
Stéphane Aquin, Curator, Contemporary Art,
The Montreal Museum of Fine Arts

Deputy Curator
Diane Charbonneau, Curator of Non-Canadian
Decorative Arts after 1960,
The Montreal Museum of Fine Arts

Guest Curator
Anna Detheridge, Artistic Director of Italian Foundation
of Photography, contributor to the newspaper
Il Sole 24 Ore, and independent curator, Milan

Research Assistant
Maryse Ménard

Exhibition Designer (Montreal venue)
Robert Hayward Anderson

Exhibition Venues
The Montreal Museum of Fine Arts
Jean-Noël Desmarais Pavilion
October 2, 2003, to January 18, 2004

Dallas Museum of Art
February 19 to May 23, 2004

The exhibition *Global Village: The 1960s* is presented in
Montreal by Hydro-Québec in cooperation with METRO
and the Volunteer Association of the Montreal Museum
of Fine Arts.

The Montreal Museum of Fine Arts wishes to thank
Quebec's Ministère de la Culture et des Communications
for its ongoing support, as well as its media partners
La Presse, The Gazette, Société Radio-Canada, and
105.7 RYTHME FM.

The Montreal Museum of Fine Arts international
exhibition program receives financial support from the
Exhibition Fund of The Montreal Museum of Fine Arts
Foundation and the Paul G. Desmarais Fund.

**THE MONTREAL MUSEUM
OF FINE ARTS**
Jean-Noël Desmarais Pavilion

SNOECK

The Montreal Museum of Fine Arts
P.O. Box 3000, Station H
Montreal, Quebec
Canada
H3G 2T9
www.mmfa.qc.ca

Management
Guy Cogeval, Director
Nathalie Bondil, Chief Curator
Paul Lavallée, Director of Administration
Danielle Champagne, Director of Communications

© 2003 The Montreal Museum of Fine Arts

ISBN (English soft cover): 2-89192-267-0
Également publié en français sous le titre
Village global : les années 60
ISBN (version brochée en français) : 2-89192-266-2

Legal deposit — 3rd quarter
Bibliothèque nationale du Québec
National Library of Canada

© 2003 Snoeck Publishers
ISBN: 90-5349-448-0 (English hard cover)
Legal deposit: D/2003/0012/11
ISBN: 90-5349-455-3 (French hard cover)
Legal deposit: D/2003/0012/10

© Agnès Varda (Interview with Agnès Varda)

CONTENTS

I am always moved when I recall the final scene of Federico Fellini's *La dolce vita,* where Marcello Mastroianni, in the role of a jaded paparazzo, ends up on the beach after a hard night of partying and fails to recognize the sweet young girl with whom he had talked earlier. His attempts to place her are thwarted by his drunken stupor, and with a careless wave, he drifts away. All connections with the past have been severed. He is a man with no ties, cut off from tradition and unsure of the future. Not everyone lived a life of chaos in the '60s. No other period of the twentieth century conjures up so many different memories, pictures, and feelings. Yet for me, this quintessential 1960 image depicts the full depth and immensity of the schism engendered by those years. History has already chalked up one thing to that tumultuous decade: the birth of a new world that is still ours today. And indeed, it fell to a Canadian academic, Marshall McLuhan, to coin the supremely apt term "global village." Conceived as a follow-up to the other major historical exhibitions produced by the Montreal Museum of Fine Arts — *The 1920s: Age of the Metropolis* in 1991 and *Lost Paradise: Symbolist Europe* in 1995 — this exhibit takes a boldly innovative approach to exploring the different facets of the planetary imagination that found new expression in the '60s.

Any exhibition of this magnitude is the result of team-work. Well-deserved gratitude goes to team leader Stéphane Aquin, Curator of Contemporary Art, for having brought this ambitious project to fruition. And to independent curator Anna Detheridge, who I met through my friend Gabriele Mazzotta and who developed the exhibition concept with him, and to Diane Charbonneau, Curator of Decorative Arts, who produced it. Together, seconded by Maryse Ménard, they have delivered a show that makes us proud, that furthers our efforts to revisit the history of art in ways that challenge conformity. While the association of such widely diverse works may violate the categories known to art historians, they result in enlightening connections. I trust that the catalogue, through its simple consistency, page after page, with texts supported by exceptional graphics, clearly enunciates the global village reality. For this, I am grateful to all the outstanding thinkers who so graciously shared their musings and memories: Capt. Alan L. Bean, Daniel Cohn-Bendit, Arthur Danto, Derrick de Kerckhove, Okwui Enwezor, Yoko Ono, Theodore Roszak, Carolee Schneemann, Ettore Sottsass, Bert Stern, Michel Tremblay, Agnès Varda, Michael J. Watts, and Tobias Wolff. To the entire Museum staff, I once again extend my sincere thanks.

Thanks go as well to our friends at the Dallas Museum of Art who believed in this project from the outset: Charles L. Venable, now Deputy Director of Collections and Programs at the Cleveland Museum of Art, John R. Lane, Director, Dorothy Kosinski, Senior Curator of Painting and Sculpture and the Barbara Thomas Lemmon Curator of European Art, and Charles Wylie, Curator of Contemporary Art. We are also indebted to the many lenders, collectors, museums, art dealers, and artists who agreed to temporarily part with their works to make this exhibition possible.

The Museum wishes to thank all of the institutions that have helped to underwrite this project. We are grateful to Hydro-Québec, which is sponsoring the exhibition in collaboration with Metro and the Volunteer Association of the Montreal Museum of Fine Arts, and to our media partners, *La Presse, The Gazette,* Radio-Canada, and 105.7 Rythme FM. We also thank the British Council, the Ministère de la Culture et des Communications du Québec for its ongoing funding, and the Canada Council for the Arts for funding our contemporary art program-ing. The international exhibition program of the Montreal Museum of Fine Arts enjoys the financial support of the Exhibition Fund of the Montreal Museum of Fine Arts Foundation and the Paul G. Desmarais Fund.

Guy Cogeval
Director, Montreal Museum of Fine Arts

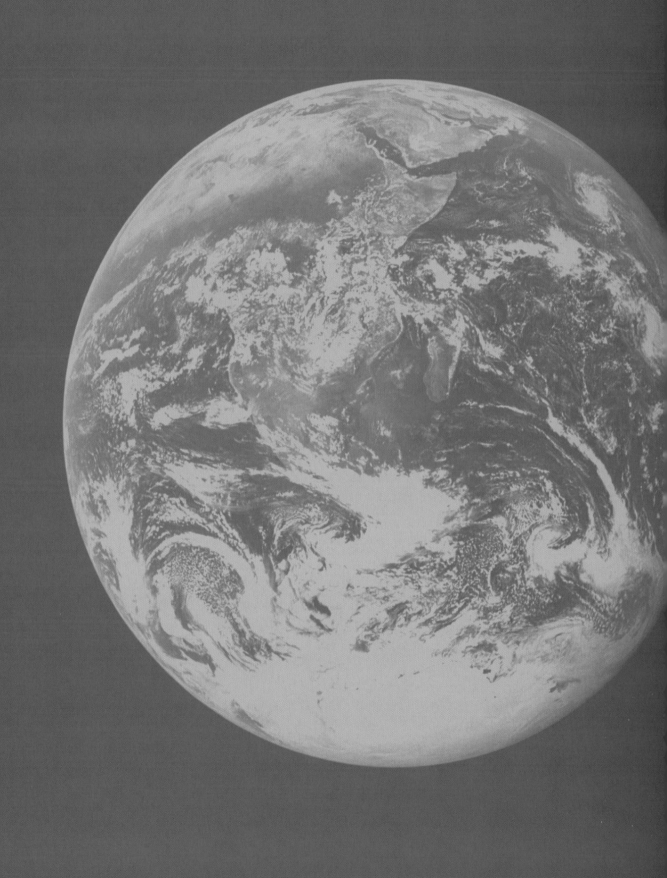

Forty years ago, a dream was born.

On May 1, 1963, Hydro-Québec finalized the acquisition of Québec's private-sector electricity generators and distributors, making Quebecers the owners of one of our greatest natural resources — hydroelectricity. This marked the beginning of a great human, technical, and economic adventure throughout all regions of Québec.

In only three years, Hydro-Québec completed the integration of more than eighty companies. This provided it with the means to carry out the mandate it had been given — to fully exploit Québec's energy potential. Hydro-Québec's technological feats, notably the Daniel-Johnson Dam and the development of 735-kV power transmission, soon made it a symbol of the Quiet Revolution and launched its international reputation.

It is therefore only natural for Hydro-Québec to be the presenting sponsor of the Montreal Museum of Fine Arts *Global Village: The 1960s* exhibition, particularly since even in those days, Hydro-Québec believed that art should be accessible to everyone.

At the beginning of the '60s, Hydro-Québec launched a contest open to all Québec artists to propose and create a mural for the lobby of its new head office building. Jean-Paul Mousseau carried off first prize with a proposal entitled *Lumière et mouvement dans la couleur,* in which electrical energy is continually transformed and renewed in a play of light and colors.

In 2002, Hydro-Québec proceeded with the re-lighting of Mousseau's mural. To do this, state-of-the-art technologies were used, while respecting the integrity and spirit of the 1963 chef d'oeuvre. The public is invited to come and admire this great work of art, one of the landmarks in the birth of public art in Québec.

Hydro-Québec is very pleased to be associated with the Montreal Museum of Fine Arts to present *Global Village: The 1960s* exhibition. We wish to congratulate the Museum's staff for their extraordinary creativity in making this one of the outstanding cultural events of 2003.

By preserving our collective heritage, we perpetuate the dream for generations to come.

Jacques Laurent
Chairman of the Board of Hydro-Québec

Q Hydro
Québec

LENDERS TO THE EXHIBITION

We gratefully acknow-
ledge the generosity of
the institutions and
individuals whose loans
have made the exhibition
possible and those
lenders who prefer to
remain anonymous.

Mr. Denis Allison, Quebec
Christo and Jeanne-
 Claude
Mr. François Dallegret
Dubaere Collection,
 Belgium
Estate of Dan Flavin,
 New York
Mr. Robert Freeman
Mr. Hans Haacke
Anthony Haden-Guest
 Collection
Mr. Dennis Hopper
Carroll Janis Collection
Joplin Family Collection
Mr. On Kawara
David Knaus Collection
Ms. Kathleen Kriegman
Giulio Paolini Collection,
 Torino
Ms. Barbara Plumb,
 New York
Mr. Rupert E. G. Power
Ms. Faith Ringgold
Roddy Maude Roxby
 Collection
Daniel Savage Collection
Ms. Carolee Schneemann
Judith and Martin
 Schwartz Collection
Sue and Bruce Skilbeck
 Collection
Christian Stein
 Collection, Turin
Mr. Bert Stern
Jill Sussmann and
 Samson Walla
 Collection
Yvon Tardif Collection,
 Quebec
Mr. Jacques Van Daele
Ms. Agnès Varda
Mathew and Ann Wolf
 Collection

Canada
L'Affiche vivante,
 Montreal
Art Gallery of Ontario,
 Toronto
Canadian Centre for
 Architecture, Montreal
Electrohome Limited,
 Kitchener
Montreal Museum of
 Fine Arts
Musée d'art
 contemporain de
 Montréal, Lavalin
 Collection
National Film Board
 of Canada, Montreal
National Gallery
 of Canada, Ottawa
Société de la Place des
 arts, Montreal
University Laurentienne,
 J. N. Desmarais
 Library, Sudbury
Vancouver Art Gallery

Denmark
Herning Kunstmuseum

France
Archives Klein, Paris
Centre Georges
 Pompidou,
 Musée national d'art
 moderne / Centre de
 création industrielle,
 Paris
Musée d'Art moderne et
 d'Art contemporain,
 Nice
Musée d'Art moderne de
 la Ville de Paris
Musée départemental
 d'art ancien et
 contemporain, Epinal

Germany
Block Collection, Berlin
Deutsches Architektur-
 Museum, Frankfurt-
 am-Main
Ludwig Forum, Ludwig
 Collection, Aachen
Sprengel Museum,
 Hanover

Ireland
Donovan Archives,
 County Cork

Italy
Archivio Opera Piero
 Manzoni, Milan
Archivio Superstudio,
 Florence
Fondazione Pistoletto,
 Biella
Prada

The Netherlands
Museum for
 Contemporary Art,
 's-Hertogenbosch

Switzerland
Barr & Ochsner GmbH,
 Zurich

United Kingdom
Hayward Gallery, Arts
 Council Collection,
 London
20th Century Marks,
 Westerham, Kent

United States
ACA Galleries, New York
Albright-Knox Art Gallery,
 Buffalo
Alexander and Bonin,
 New York
Alta Light Inc., Venice
Andy Warhol Museum,
 Pittsburgh
The Art Collection of
 Bank One, Chicago
Eli and Edythe L. Broad
 Collection, Santa
 Monica
Butler Institute of
 American Art,
 Youngstown
Couturier Gallery,
 Los Angeles
The Dallas Museum of Art
David Zwirner, New York
Fine Arts Museums of
 San Francisco
Fraenkel Gallery, San
 Francisco
Franklin Parrasch Gallery,
 New York
Galerie Lelong, New York
Gorney Bravin & Lee,
 New York
Hirshhorn Museum and
 Sculpture Garden,
 Smithsonian Institution,
 Washington
International Center
 of Photography,
 New York
Jack Shainman Gallery,
 New York
Jane Voorhees Zimmerli
 Art Museum, Rutgers,
 The State University of
 New Jersey
Kobal Collection,
 New York
Matthew Marks Gallery,
 New York
Menil Collection, Houston
Milwaukee Art Museum
Minneapolis Institute
 of Arts
Museum of Contemporary
 Art, Los Angeles
Museum at the Fashion
 Institute of
 Technology, New York
Museum of Fine Arts,
 Houston
National Museum of
 American History,
 Smithsonian Institution,
 Washington
New Museum of
 Contemporary Art,
 New York
Norman Rockwell
 Museum, Stockbridge
Norton Simon Museum,
 Pasadena
Pace/MacGill Gallery,
 New York
Pace Wildenstein,
 New York
Paula Cooper, New York
Philadelphia Museum
 of Art
Revolution Gallery,
 Ferndale
Rock & Roll Hall of Fame
 and Museum,
 Cleveland
Simon Salama-Caro,
 New York
Smithsonian American
 Art Museum,
 Washington
Studio One, New York

ACKNOWLEDGEMENTS

The curators of the exhibition would like to thank the following people for their kind cooperation.

Anne Adams
Georges Adams
Darrin Alfred
Lucy Andersen
Perazzo Antonio
Alessia Armeni
Grant Arnold
Beth Ashley
Sharon Avery-Fahlstrom
Stéphane Baillargeon
Carolyn Bane
Alan L. Bean
Josée Bélisle
Tiffany Bell
Gianfranco Benedetti
Marie-Agnès Benoit
Anita Benoliel
Chantal Béret
Carole Berk
Tosh Berman
Patrizio Bertelli
Claire Blanchon
Michel Blouin
Shawn Boisvert
Ted Bonin
Luc Boulanger
Paul Bourassa
Philippe Boutté
Sebastian Boyle
Christine Brachot
Isy Brachot
Jessica Bradley
Sophie Brégiroux
Randall Brooks
Nora Brown
Sabrina Buell
Jeff Burch
Jacques Busolini
Michael Castellana
Richard Castellane
Enrico Castellani
Dennis Phillip Cate
Dorothée Charles
Olga Charyshyn
Julie A. Chill

Wendy E. Chmielewski
Angela Choon
Andrea Clark
Françoise Cohen
Daniel Cohn-Bendit
Lucy Commoner
Cathy Connor
Darrel Couturier
Cozic
Cherese Crockett
Dennis Crompton
DeAnn M. Dankowski
Arthur Danto
Mela Dávila
Rebecca Davis
Sarah Dawbarn
Philippe Decelle
Nathalie Decrand
Kevin De Forest
Gerry Deiter
Derrick De Kerckhove
Fred Dennis
Cécile Deprey
Pierre Dessureault
Anita Dimas
Gwendoline Di Sario
Donovan
Helen Drutt
Lon Dubinsky
Guy Dubois
Susan Dunne
Anita Duquette
Kathy Earnhart
Teri Edelstein
Patrick Elliott
Maury Englander
Okwui Enwezor
Éliane Excoffier
Patricia Failing
Donatella Farina
Philippe Faure
Alison H. Fenn
Lauri Firstenberg
Mr. and Mrs. Donald
 G. Fisher
Caroline Flahaut
Rick Floyd
Katia Fornara
Louis Fortin
Jun Francisco
Karen Freedman

Jim Fricke
Anna Maria Fumagalli
Manuela Gandini
Stephen J. Garber
Gianni Berengo Gardin
Mike Gentry
Josh L. Glick
Katie Glicksberg
Arne Glimcher
Pamela Golbin
Leon Golub
Allan B. Goodrich
Nathalie Goodwin
Anne Grace
Margaret Grandine
Catherine Grenier
Lisa Griffin
Marty Gross
Jeffrey D. Grove
Jordan Gutcher
Rosemary Haddad
Bruce Hainer
David Hanks
Beth Hannant
Juliana Hanner
Karen Hanus
Tim Hardacre
Stephen Harrison
Becky Hart
Barbara Hartman
Eileen Hawley
Jon Hendricks
Steve P. Henry
Joanne Heyler
Ellen J. Holdorf
Antonio Homen
Abigail Hoover
Joanne Hourie
Julius Hummel
Fulvio Irace
Sandra Isgro
Richard Jeffrey
Michael Johnson
Stephen Johnson
Laura Lee Joplin
Alain Jouffroy
Robert Keil
Emily-Jane Kirwan
David Knaus
Stephan Kohler
Mstislav Kondrachov

Dorothy Kosinski
Charlotta Kotik
Paul Kotula
Samm Kunce
Ronald Labelle
Laura Lacchio
Phyllis Lambert
Pierre Landry
John R. Lane
Emma Lavigne
Marie Lavigne
Jean-Jacques Lebel
Denise Leclerc
Carole Lee
Shelley Lee
Jamie Legon
Nathalie Leleu
Julio Le Parc
Doris Leutgeb
Marco Livingstone
Peter Loughrey
Anne M. Lyden
Hazel MacKenzie
Tammy MacMillan
André Magnin
Elena Manzoni
Maroussia
Rosanita Martens
Massimo Martino
Maria Grazia Mattei
Dirk Matten
Grace Matthews
Marc Mayer
Gabriele Mazzotta
John Paul McAree
Fred McDarrah
Cuauhtemoc Medina
Betsi Meissner
David Mellor
Jörn Merkert
Karla Merrifield
Beatrice Merz
Craig Miller
Giulio Molfese
Renata Molho
D. Levi Morgan
Steve Morse
Mr. and Mrs. Olivier
 Mourgue

Irena Murray
Juliet Myers
Diana Nemiroff
Patrick Noon
Deborah Nordon
François Odermatt
Nicholas Olsberg
Yoko Ono
Hiroko Onoda
Mr. and Mrs. Roman
 Opalka
Sarah O'Reilly
Ken O'Sullivan
Didier Ottinger
Reiner Packeiser
Dominique Païni
Alexandra Palmer
Giulio Paolini
Daniela Parasassi
Louis Parker
Rosalia Pasqualino
 di Marineo
Sheri L. Pasquarella
Varshali Patel
Susanna Patrick
Lori Pauli
Jeffrey Peabody
Gilbert Perlein
Pierluigi Pero
Ana Petrovich
Lisa Phillips
Jean Pigozzi
Maria Pistoletto
Michelangelo Pistoletto
Françoise Portelance
Ben Portis
Rolande Pozo
Mariuccia Prada
Monique Quesnel
Suzanne Quigley
Neil K. Rector
Harry Redl
Dennis Reid
Clément Richard
Tanya Richard
Bridget Riley
Nancy Ring
Mervin Robin

Alla Rosenfeld
Theodore Roszak
Robert Rothery
Danièle Roussel
Catherine Rouvière
Francine Roy
Karen Ruthberg
Veronica Sachs
Judy Sagal
Paul Saltzman
Elisabetta Salzotti
Giulio Sangiuliano
Alex Sax
Sandra Schemske
Carolee Schneemann
Barbara Schroeder
Suzanne Schwinghammer-
 Kogler
Claudine Scoville
Ellen Shanley
Jane A. Sharp
Innis Howe Shoemaker
Philippe Siauve
Claude Simard
Bruce Skilbeck
Jeffrey D. Smith
Kristin Smith
Thomas Sokolowski
Richard Sorenson
Ettore Sottsass
Jeffrey Spalding
Hilda Stafleu
Jen Stamps
Sonnet Stanfill
Bert Stern
Liliane M. Stewart
Sidra Stich
Betty Stocker
Peter Sullivan
Nancy Swallow
Hilary Tanner
Matthew Teitelbaum
Sophie Tellier
Ann Temkin
Abigail Terrones
Pierre Théberge
Anne Thomas
Iris Thuwis
Barbara Toopeekoff

Gesine Tosine
Michel Tremblay
Cynthia Trope
Gabriela Truly
Rona Tuccillo
Diana Turco
Frederic Tuten
Frank Ubik
Sabrina van der Ley
Agnès Varda
Michèle-Catherine
 Vasarely
Shirley Veer
Charles Venable
Angela Vettese
Pâquerette Villeneuve
Stephen Vitiello
Myra Walker
Andrew Wallace
Michael J. Watts
Angela Westwater
Justin White
Thérèse Willer
Inge Wolf
Tobis Wolff
Gabriele Woolever
Tamara Wootton-Bonner
Barbara A. L. Woytowicz
Charles Wylie
Cynthia Young
James Zemaitis
Anne-Marie Zeppetelli
George Zombakis

11

Stéphane Aquin

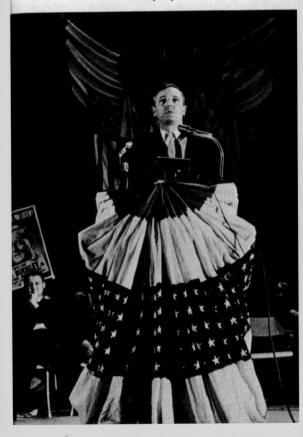

Figs. 1 and 2. *The Medium Is the Massage: An Inventory of Effects,* written by Marshall McLuhan and Quentin Fiore, 1967.

"Since Sputnik, the earth has been wrapped in a dome-like blanket or bubble. Nature ended. Art took over the ambidextrous universe. We continue to talk of a machine-world." [1]

In 1962, Marshall McLuhan coined the phrase that would become famous. In *The Gutenberg Galaxy* he wrote, "The new electronic interdependence recreates the world in the image of a global village." [2] According to this Canadian academic — who was not yet the controversial celebrity he would become with the publication of his next book, *Understanding Media*, in 1964 — satellite telecommunication brought the world together under a vast "cosmic membrane," an immense web of waves that echoed information across the big village that the Earth had become, abolishing distance and time. Henceforth, dreams, plans, and conflicts would no longer be limited to hermetic borders, but would be experienced on a global scale, relayed by a sophisticated telecommunication system, a dividend of the competitive exploration of space by the Americans and Soviets. Ironically, this space race that pitted one superpower against the other, splitting the world into two great rival blocs, helped to unite international consciousness. Even the Berlin Wall could not divide the Global Village, in which nothing that was human would seem strange to people anymore. "We can now live, not just amphibiously in divided and distinguished worlds, but pluralistically in many worlds and cultures simultaneously. . . . We live in a single restricted space resonant with tribal drums," McLuhan said. [3]

Electromagnetic Feelings

Under the auspices of this technological revolution, people in all societies began to see themselves united in the same global destiny (Fig. 1). Contemporary history seemed to confirm McLuhan's vision. The "tribal drums" he envisioned resonated in unison in all corners of the global village (Fig. 2). The wind of change blowing in America with the election of President John F. Kennedy was blowing in

France, where the Algerian War was finally ending, in Israel, where the Nazi Adolf Eichmann was on trial, in the Congo, Brazil, Japan, Canada — the signs of renewal were multiplying, announcing a vast simultaneous springtime. Mankind suddenly found itself on the threshold of a new, young, and prosperous world, one that would be radically different from the old, rigid, unjust world, now on its last legs, that had to be ended once and for all. Utopia was possible. "The times, they are a-changin'," sang the young Bob Dylan. In this new epoch, blacks would be recognized as equal to whites, women as equal to men, the free world would get some free time, communism would have a bright future, and we would walk on the moon.

This electromagnetic wedding party was to unite mankind for better or for worse. If the new communication system allowed individuals to extend their antennae beyond their natural physical sphere, it also allowed "Big Brother" to intrude into everybody's living room, lending ominous credibility to the Orwellian nightmare. "So, unless aware of this dynamic, we shall at once move into a phase of panic terrors," predicted McLuhan.[4]

Economic globalization, the fateful consequence of the emergence of a global sphere of exchange, was to take off as corporations began to extend their advertising hold on the planet's imagination. The Global Village became aware of its real frontiers: power and money, unequally distributed.

The global accounting of current events abolished time to a continuous present. Local and national reports were repeated on a large scale, as though a vast dome were amplifying their sound, re-echoing it within a symbolic sphere inhabited by incessant, indiscernible news, declarations, turmoil, and emotion. Once again, McLuhan saw things correctly; he suggested (elliptically, as was his habit) that this new environment was leading mankind to its unconscious. "We now live in a world environment that has the structure of our own subconscious lives."[5] The history of the Global Village became a history of the stirring of the collective psyche, wedded to the movement that the author elsewhere called the "psychosocial complex." To record the history of the '60s is to follow the Global Village's waves of imagination, the new global consciousness in its complex response to the course of events. Remembering the '60s —

how many people still do! — is to recall those collective frames of mind, those mass movements, that "group synergy," to use an expression from that time, experienced watching television or listening to music, the collective art *par excellence*, above all other art most closely tied to the impulses of history.

The '60s started with optimism; they ended in disorder. As the decade progressed, the "cosmic membrane" covering the Earth clouded over with oppressive presentiments. The knell first sounded in 1968 (Fig. 3), less than a year after the "summer of love." In Prague, Paris, and Mexico City, student revolts brutally miscarried. In the United States, two symbols of hope, Martin Luther King, Jr., and Robert Kennedy, were assassinated. In the Soviet Union, Yuri Gagarin died in a plane accident. The feeling of catastrophe worsened in 1969. American bombing in Vietnam intensified. The counter culture witnessed a macabre turning point when Charles Manson and his "family" indulged in hallucinogenic slaughter. Although prodigious, the first steps on the moon were to take away Man's last dreamland. An end-of-the-world feeling haunted such films as Dennis Hopper's *Easy Rider* and Michelangelo Antonioni's *Zabriskie Point*. As the decade came to an end, the terminal signs started piling up, the global mindset was in a critical state. The American National Guard killed peaceful demonstrators at Kent State University. Nigeria was starving Biafra. In the shadows of the Iron Curtain Dmitri Shostakovitch composed his funereal *Symphony No. 14*. Janis Joplin and Jimi Hendrix died. The Beatles broke up.

Histories of Art

At first controversial, Marshall McLuhan's arguments have since been endorsed in a number of different academic fields. The key idea of "Global Village," with its various corollary concepts, has proved fruitful in sociology, history, the theory of communication, and economics where the phenomenon of globalization is placed at the heart of contemporary thought. But are his arguments valid from the perspective of art history, and more particularly the history of art in the '60s? Did the Global Village's global consciousness resonate in the artistic creation of that time? This question must be understood in two ways. The first concerns the globalization of artistic experiences: Were the '60s the stage for global esthetic exchange? Although we already know that Pop Art crossed continents,[6] the exhibition *Les années pop*, organized by the Georges Pompidou Centre, shed light on both the geographic extent of the Pop phenomenon, which went far beyond the London/New York axis, and its all-encompassing nature.[7] Far from being limited to the traditional plastic arts, the "Pop spirit" penetrated fields of creativity that until then had remained relatively impervious to the mood of the times, starting with

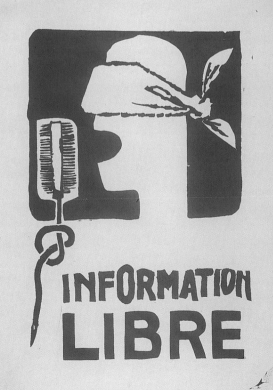

Fig. 3. "*Information libre,*" anonymous poster, Paris, May 1968.

architecture. The exhibition *Global Conceptualism*[8] also highlighted the global range and simultaneity of conceptual practice, in exchanges between artists in different countries. Artists in the Soviet Union, Eastern Europe, and South America, for example, adopted experimental techniques used in America and Europe to express their own identity. Similar exchanges took place in other artistic fields, notably performance and kinetic art.[9]

If the art scene in the previous decade was a place where exchanges became more and more frequent, but still between a small number of cities, in the '60s it would take on the appearance of a vast open-air symposium. Today's overviews of 1960s movements and styles include many more specific works, from both sides of the Atlantic, but also from Asia and South America. These in turn have helped refine our understanding of individual works of Piero Manzoni, Paul Thek, Lygia Clark, Yves Klein, Michelangelo Pistoletto, Wolf Vostell, Yoko Ono, Oyvind Fahlström, and so many others, enabling us to expand our overall view of the period from the familiar genealogy of the major currents such as Pop Art, Op Art, Minimalism, and Conceptual Art.

The second aspect of our question concerns more specifically the active relationship of art to its historical environment. Did '60s art react to historic events and the global debates that surrounded it? Did it join in the vast electronic tribal drum session to which the Global Village had become addicted? Did it enter into a dialogue with history? Or did it develop parallel to history, following its own genealogy and agenda? The answer to this question was decided a long time ago because the historiography of '60s art was itself divided, from the outset, between two contradictory interpretations, reflecting the ideological polarization in avant-garde art between high abstraction and realist Pop Art.[10] On one hand, the model established by the American critic Clement Greenberg centered on the argument that art is or should be independent of history.[11] On the other, the ambivalent relationship of art to mass culture in capitalist society had become suspect in the eyes of critics.[12] Two models: one purity, the other corruption. But like the art that inspired them, these models did not enjoy the same prestige in academic circles. The first, with its various premises — art's "negative" resistance to the forces of history, the critical position of the artist, the reflexiveness of artistic works — mapped out aesthetic debate about the period and the history of art that was to follow. Although disputing several points in Clement Greenberg's theses,[13] the dominant views relating to the emergence of Minimalism, then to Conceptual Art and the different forms of dematerialization of artistic subjects, only confirmed that interpretation of '60s

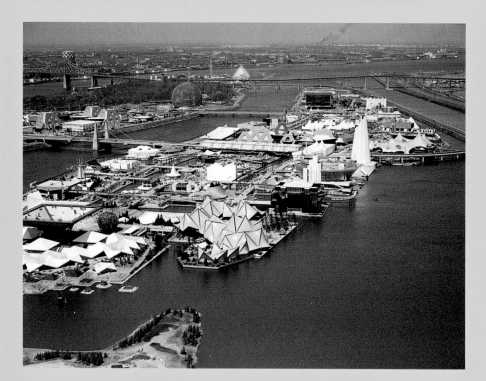

Fig. 4. Aerial view of the International Exhibition of 1967, Montreal.

art regarded the link with the contemporary environment as a form of negative criticism or more or less servile reproduction.[14]

Some recent research has made a breach in the historiography of '60s art and allowed us to overcome this problem. In Paris, the Georges Pompidou Centre has launched, with its exhibition *Face à l'histoire*, 1933–1996,[15] a stimulating rereading of the relationship of art to historic events. In America, Thomas Crow in his work *The Rise of the Sixties*,[16] for his part, has managed to combine respect for the specific genealogy of practices and subjects with the risk of a global explanation of the relationship of art to its historic environment. On a more modest scale, although equally relevant, an exhibition at the Austin Museum of Art[17] has made it possible to take stock of the repercussions of the development of television and the particular formal, plastic properties of the television image on the arts. In these and other instances can be found the wish to reconcile, through study, the role of resistance specific to the work of art to historic text and the work's objective relationship with history. Art, an autonomous plastic object, is also the witness and conveyor of a wider cultural life.

Man and His World

More than three decades now separate us from the end of the '60s; nearly fifteen years have gone by since the fall of the Berlin Wall, its most powerful relic. With this look at history and recent developments in the history of art, we have risked a different reading of art in this decade. The interpretation we put forward goes beyond local genealogies of style, movements, and aesthetic allegiances. It is founded on a concept of the period itself, the Global Village, a concept endorsed in other fields of study. This lens has led us to reformulate the interplay of association between art and its time. We have redealt the now-familiar art-history cards and rearranged them according to what seems the main areas of experience in the Global Village; the major crossroads of this vast symbolic exchange current during the '60s under the "cosmic membrane" that McLuhan talked about. In this exhibit we have identified four themes, four principal obsessions of the imagination, knowing that other people may come to a different count — space, media, disorder, and change. The arts, from the most formalist of practices to the inventions of fashion, reacted to these themes and shed a special light on them. Works of art help define our perception of reality, at the same time setting the limits of their own scope. It is totally appropriate that our exhibition has its beginnings in Dallas and Montreal, since the Global Village experienced some of its most memorable moments in these places: in November 1963 the assassination of President Kennedy in Dallas brought mankind together for a televised funeral; in 1967 the International Exhibition of 1967, Montreal (Fig. 4) brought together countries from all over the world for a vast celebration, one of the decade's last, whose theme was "Man and His World."

Notes

1. Marshall McLuhan, *Culture Is Our Business*, 1970, repr. in *Essential McLuhan*, ed. Eric McLuhan and Frank Zingrone (Concord, Ont., House of Anansi Press), 1995, p. 40. Born in 1911 in Edmonton (Canada), died in 1980, Marshall McLuhan was a professor at the University of Toronto, where he founded the Center for Technology and Culture (an organization that now bears his name). He became world famous during the '60s and '70s for his visionary studies on the effects of mass media on thought and social behavior.

2. Marshall McLuhan, *The Gutenberg Galaxy*, 1962, repr. in *Essential McLuhan*, p. 127.

3. *Ibid.*, p. 126.

4. *Ibid.*, p. 127.

5. *Ibid.*, p. 275.

6. See David E. Brauer, *Pop Art: U.S. / U.K. Connections, 1956–1966* (Houston, Tex., The Menil Collection in association with Hatje Cantz Publishers), 2001.

7. *Les années pop, 1956–1968*, under the direction of Mark Francis (exhibition catalogue, Centre Georges Pompidou, Paris), 2001.

8. *Global Conceptualism: Points of Origin, 1950s–1980s*, texts by Luis Camnitzer, Jane Farver, and Rachel Weiss (exhibition catalogue, Queens Museum of Art, Flushing, N.Y.), 1999.

9. See Guy Brett's synthesis in *Force Fields: Phases of the Kinetic* (London, Hayward Gallery/Barcelona, Museu d'Art Contemporani de Barcelona), 2000. See *Out of Actions: Between Performance and the Object, 1949–1979*, under the direction of Paul Schimmel (exhibition catalogue, Los Angeles Museum of Contemporary Art, Los Angeles, MOCA–London, Thames and Hudson), 1998.

10. As the art historian Hal Foster recently summarized: "Advanced art in the 1960s was caught between two opposed imperatives: on the one hand to achieve an autonomy of art as demanded by the dominant logic of late modernism; on the other hand to break up this autonomous art across an expanded field of culture that was largely textual in nature." (Hal Foster, *The Return of the Real. The Avant-Garde at the End of the Century*, Cambridge, Mass./London, MIT Press, 1996, p. 71.)

11. Its relationship with history is reduced to a dialectic of negativity (which perhaps only mimics innovation, one should add).

12. In this interpretative context, the reading put forward by Arthur Danto in his article "The Art World," which appeared in 1964, stands out due to its philosophical considerations on the ontology of art.

13. Developed during the 1950s, Clement Greenberg's theses were definitively formulated and achieved maximum influence at the beginning of the '60s, with the publication of his collection of essays, *Art and Culture. Critical Essays* (New York, Beacon Press, 1961) and the article "Modernist Painting," which he republished in 1965 in *Art and Literature*.

14. Anne Rorimer's study of art in the '60s and '70s (masterful in its presentation of the aesthetic issues of the period) continues this opposition. "Aesthetic activity from the late 1960s to the end of the 1970s has served self-analytically to ensure that visual art preserve its role as a cognitive conduit between graspable representation and amorphous reality" (Anne Rorimer, *New Art in the 60s and 70s. Redefining Reality*, London, Thames and Hudson, 2001).

15. *Face à l'histoire, 1933–1996. L'artiste moderne devant l'événement historique*, under the direction of Jean-Pierre Ameline (exhibition catalogue, Centre national d'art et de culture Georges Pompidou, Paris, Flammarion-Centre Georges Pompidou), 1996.

16. Thomas Crow, *The Rise of the Sixties* (New York, Harry N. Abrams Inc.), 1996.

17. *The New Frontier: Art and Television, 1960–1965*, edited by John Alan Farmer (Austin, Tex., Austin Museum of Art), 2000.

Anna Detheridge

A New Age: The Visionaries

Utopias on the verge of despair, in a nutshell, could be considered the defining mood of the '60s. Generally identified with carefree optimism, this decade revealed an underside of nascent anxieties, a more ambiguous terrain explored by the exhibition *Global Village.*

In his book with the very same title,[1] the Canadian scholar Marshall McLuhan observes that in July 1969, when the Apollo astronauts landed on the moon, their initial act was to install a camera pointed at the Earth. We were for the first time inside and outside ourselves, at the same moment on the Earth and on the moon. From then on, as McLuhan observes elsewhere, the world itself became a sculpture, a work of art.

Several years earlier, in 1961, the Italian artist Piero Manzoni, a small plump aristocrat with a classical education, created a series of "world pedestals," or Socle du monde, the third of which, a sort of magic base made out

Fig. 1. Geodesic dome designed by Buckminster Fuller and Shoji Sadao (United States Pavilion, International Exhibition of 1967, Montreal).

of iron, he solemnly placed in a park in the suburbs of Herning in Denmark. Ostensibly an homage to Galileo, he writes that "written upside down it metaphorically supports the entire world on its weight-bearing surface, thus transforming all the inhabitants of the earth into works of art."[2]

The brief parabola of Manzoni's activity from 1956 to his death in 1963 represents a synthesis of many aspects of art in the '60s. Burning out his energy in just seven years, he broke down the boundaries between painting, sculpture, photography, and performance. From his *Achromes* (1957), small canvases soaked in plaster to resemble blank walls, to his ritual performances in which boiled eggs were signed with his thumb and given to the audience to eat (1960), to his *Merde d'artiste* (thirty grams per can) and his "signed" living sculptures (1961), his self-defeating pessimism defined the passage from modernism — which still laid claim to universal truths — to postmodernism.

In the '60s, radically changing perceptions opened the road to those who would venture beyond the boundaries of their disciplines. The decade spawned many radical thinkers, among the most influential, Marshall McLuhan, Richard Buckminster Fuller, Herbert Marcuse, Reyner Banham, Claude Lévi-Strauss, Umberto Eco, and Roland Barthes.

In his seminal work, *The Gutenberg Galaxy,*[3] McLuhan explains how the media would significantly alter world perceptions and the ways in which the individual relates to time, space, and, ultimately, him- or herself. Film, television, and the visual realm would stimulate new sensorial sinaesthetic awareness that would privilege the spectacular and touch the emotions, thereby relegating grammar, speech, and sequential logic to a secondary level. McLuhan's witty aphorisms; his emphasis on lateral thinking, the importance of context, the environment, and interconnectedness; his guerrilla attacks on all platitudes; and his attack on specialism were all prophetic.

Nicknamed "the planet's friendly genius," the architect and mathematician R. Buckminster Fuller was another original thinker who understood better and earlier than most the incipient complexity of the age. In his autobiographical "last call for humanity," entitled *Critical Path,*[4] Fuller, like McLuhan, takes his cue from the Apollo project. As he states, when funds were first allocated by President Kennedy, the project of ferrying people to the moon and back appeared practically impossible. Apollo's millions of technical requirements could only be achieved through a

"non-obvious, vast time-scale inventory of evolutionary, historical, technological accomplishments," a plan so complex that it was named "the critical path."

Fuller was among the first to advocate applying scientific knowledge and technology to solving humanity's universal needs; he was also among the first to talk of sustainable development. In 1954, to worldwide acclaim, he patented his translucent geodesic domes for cities (Fig. 1). His Geo-scopes were conceived as a precise theatrical replica of the world's position within the universe. The dome was to be used as the visual reference for hourly newscasts, a cosmic screen on which to project global information of relevance to everyone, from the world history of earthquakes and volcanic eruptions to strategic matters.

New Perceptions: The Return to Zero

Perhaps it is no coincidence that the 1960s opened with the important exhibition *Monochrome Malerei*.[5] The post-war years had brought with them the desire to start from scratch, the "return to zero" and the reemergence of the monochrome as a new beginning, a mark of disenchant-ment with humanistic ideals. It was a sort of postwar nemesis after the excessive emotion of abstract expres-sionism in a world where serial production, programming, and digitalization were a nascent reality. Implicit was the idea that all knowledge had become useless baggage.

The depiction of space as a void, the absence of a focal point, was pioneered by Lucio Fontana. French artist Yves Klein embodied ideas of space, immateriality, and spirit-ualism in the monochrome. Klein was fascinated by a particularly intense blue, which the critic Pierre Restany compared to Giotto's blue, thereafter rebaptized Interna-tional Klein Blue. At the same time all over Europe, groups of artists referred to themselves and defined their work as the Zero Group, the Nul group, the Anonima Group, Azimuth, Arte Programmata, T Group, N Group, and others, implying nothingness, blank, void, anonymity.

In 1965 the Stedelijk Museum in Amsterdam brought together many artists working in this experimental vein[6] (including Pol Bury, Enrico Castellani, Piero Manzoni, Gianni Colombo, Yves Klein, Hans Haacke, Yayoi Kusama, Henk Peters, Otto Piene, Jésus Raphael Soto, Atsuko Tanaka, Guenther Uecker, Jiro Yoshihara) all of whom accepted the definition offered at the time by Hans Sleute-laar of art as "visual information," signifying, in practice, the elimination of all individual, cultural, and emotional content.

A similar terrain was being explored by artists grouped together by William C. Seitz in the exhibition *The Respon-sive Eye*.[7] In different countries, artists such as Bridget Riley, Cunningham, Agam, Morellet, Vasarely, and Guido Molinari, all working in the field of perception and visual communication, presented carefully controlled static images. For perceptual artists, meaning did not reside in the objective reality of things (for there was none) but more ambiguously in that unexplored intermediate territory where it is reconstructed between the cornea and the brain. The exhibition *Cybernetic Serendipity*[8] explored the nature of computer-generated pictures, as the result of mathematical expression.

From Zero to Minimalism

The "return to zero" was necessary for the engagement of artists with science, language, hermeneutics, and semi-otics. Throughout the decade, the newfound science of linguistics and its leading lights, Roman Jakobsen, Noam Chomsky, and others, provided a bridge between many disciplines through the structural analysis of all systems of communication. A direct consequence in the creative field was a new emphasis on the text rather than the author, the idea of the open work or *Opera Aperta*.[9] The "death of the author" declared by Roland Barthes in 1968 was already a reality for many artists fascinated by the idea of reinventing the basic grammar of creativity.

The Italian Giulio Paolini worked strictly and obstinately within the discipline of art and art history, and defined art as a system of signs that cannot change and whose very materials (paper, canvas, paint, color, artist, history of art, title) are all that counts. Remaining within the boundaries of a structural discourse on art he was the first to coherently and consistently explore the aporias, tautologies of any discourse on representation. His insistence on form and the impossibility of all content amount to an aporia in itself.

Diametrically opposed to Paolini, Michelangelo Pistoletto, an artist in constant metamorphosis, epitomized openness to change. His *Oggetti in meno* spring from a sense of the world overloaded with images and items in constant flux. From his first mirror painting, entitled *The Present* (1961), the canvas became a surface that reflects but does not retain whoever and whatever passes in front of it — a mere spatial and temporal fragment of fleeting phenomena. Much of Pistoletto's work is influenced by the theater, using baroque strategies that oblige the onlooker to step right into the composition.

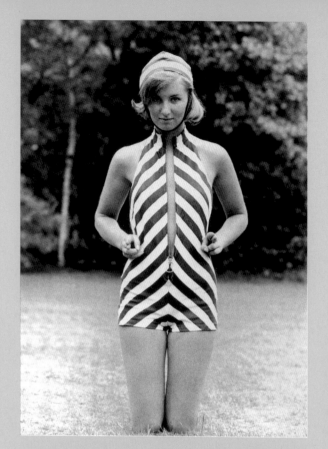

Fig. 2. Zipper-front swimsuit by Barbara Hulanicki (Biba Boutique), 1965.

The exhibition *Primary Structures, Younger American and British Sculpture,*[10] which canonized Minimalist art, confirmed on a much larger scale the new grammar of art. Painting and sculpture merge, colors separate from shapes. Sculpture becomes immaterial, no longer an object in space but the definition and animation of space itself. Dan Flavin called his light works "proposals," Sol Le Witt described his work as "structures." Donald Judd's famous remark in his essay "Specific Objects," [11] generally considered a manifesto of Minimalism, that "half or more of the best new work in the last few years has been neither painting nor sculpture" does not sound quite so prophetic alongside the work of many European artists. Indeed many of the tenets and practices of Minimalist artists appear to be a late confirmation of the neopositivist industrial and serial language of modernism that took its cue from the Bauhaus and figures such as Mies van der Rohe.

From Minimalism to the Miniskirt

The cool appeal of Donald Judd portrayed in a fashion feature of *Harpers Bazaar* in July 1966, with his wife, Julie, in a pink dinner tent-dress alongside his "sleek dry assertive boxes," represents the canonization of the sex appeal of the '60s artists and of art marketed as the leisure activity of the affluent. That same year, Paco Rabanne,

the most minimalist of designers, presented a series of "metonymic" mesh designs in modern materials from stainless steel to transparent plastic, worn by barefoot black models in a sort of neo-Dada happening.[12] Fashion in the '60s was a tightrope walk between the traditional Parisian sophistication of *haute couture* and the new dynamic street culture of Swinging London (Fig. 2). In the new color supplements, the "future woman" floated freely in space against white backgrounds in her scanty Courrèges-style outfits.

The miniskirt, invented by Mary Quant in London, was conceived for a fast-moving Twiggy-like city girl, all legs and no bust. Brought up in the nuclear family cuddling a Barbie doll, a replica of the self-image she coveted, Twiggy was the eternal adolescent, a model initiated with Brigitte Bardot and the cinema. The film industry, from Godard's *À bout de souffle* (Breathless) (Fig. 3) to Antonioni's *Blow-Up* (Fig. 4), was much more influential in forming role models and trends than was the fashion trade itself.

**The Aesthetics of Abundance:
The Mingling of High and Low**

The first uncertain steps of Pop Art, which more closely reflected society and its rapid transformations, were heralded by the British critic Lawrence Alloway with the exhibition *This Is Tomorrow,* organized by the Institute of Contemporary Art in London in 1956. Disbelieving of the educational merits of abstract and minimalist art, Alloway harshly criticized the inherent elitism and aestheticism of abstraction, and the philosophy of Clement Greenberg. The most important aspects of change for Alloway were post-war abundance and availability of a multitude of styles and critical attitudes.

The semantic boundaries of the terms "Art" and "Culture" have expanded radically since Greenberg's attempt to pinpoint them in his essays. As Alloway writes in *Topics in American Art since 1945*, "Pop Art and Happenings forced an expansion of the spectator's attention into a variety of environmental spaces and objects." In the essay "Hi-Way Culture," he defines American Pop Culture as "urban folklore." The new *en route* time/space perspective carries with it a scattering of brief glimpses: hotels, motels, road signs,

critique

billboards, signals, airports, planes, international symbols. All these visions dominate Pop artists' work, from Oldenburg's fast food to Indiana's iconic codes, from Wesselman's universal nude with her sexual signals — contours, lips, nipples, hair — to Ruscha's gas stations and parking lots. Commercial culture influenced structural aspects such as the scale of works, eventually bringing with it an idea of expendability and the sense of a mass landscape made to not last. Not surprisingly, Pop artists like Roy Lichtenstein and Andy Warhol borrowed photomechanical effects from printing, solarization, silkscreen techniques, etc. "The effect of looking at a Rosenquist is like looking through a magazine," wrote Richard Hamilton in 1968.[13]

Reyner Banham, author of *Theory and Design in the First Machine Age* (1960), poet and impresario, and radical critic of modernism, coined terms such as "visual currency" and was the first to talk of "built-in obsolescence." He registered the fascination of the consumer whose imagination had been sparked by the sexual symbolism of the automobile. Acceleration, impermanence, symbolic metamorphosis became primary concerns for artists and critics throughout the decade.

Fig. 4. David Hemmings and the model Veruschka in Michelangelo Antonioni's *Blow-Up,* 1966.

From Assemblage to Performance

The Art of Assemblage, a major exhibition at the Museum of Modern Art in New York in 1961, curated by William C. Seitz, had a great influence on the decade. Although it did not show strictly contemporary art but instead spanned half a century, the show was influential in highlighting the underlying themes of time, duration, and decadence. In a 1960 manuscript, "Paintings, Environments, and Happenings,"

Alan Kaprow advocates "a quite clear-headed decision to abandon craftsmanship and permanence" in favor of "the use of obviously perishable media such as newspaper, string, adhesive tape, growing grass or real food," so that "no one can mistake the fact that the work will pass into dust or garbage quickly." Performance and happenings as presented by Kaprow and other New York artists at the Reuben Gallery and elsewhere owe much to the concept of perishable assemblage and collage.[14]

Whether to assert new sexual freedom, search for new identities, or indulge in self-flagellation, artists from all countries found new terrain in the form of the body, self-portraits, and performance. Among the most extreme artists were the Viennese Actionists Günter Brus, Otto Muehl, Herman Nitsch, and Rudolf Schwarzkogler. Their aesthetic had, in Nitsch's words, a sacrificial scapegoat quality: "Through my artistic production I take upon myself all that appears negative, unsavory, perverse, and obscene, the lust and the resulting sacrifical hysteria, in order to spare YOU the defilement and shame entailed by the descent into the extreme."

Fluxus was a loose group of artists with unexpectedly long-lasting influence. Fluxusfestivals and Fluxusconcerts centered on social creativity, and Situationism was in some ways akin to Fluxus as a radical practice despite the

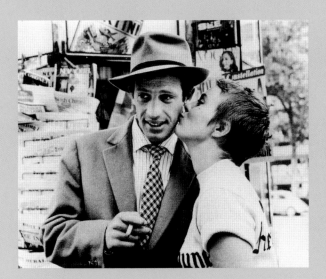

Fig. 3. Jean-Paul Belmondo and Jean Seberg during the filming of Jean-Luc Godard's *À bout de souffle* (Breathless), 1959.

prophetic pessimism of the legendary Guy Debord in his *Societé du spectacle*.[15] The group's radical humanism, in abhorrence of the tabula rasa of modernism, and their attention-grabbing tactics, are still a role model for many young artists and architects engaged in urban art today.

Another figure with a long-standing reputation as master and initiator of a radical social aesthetic is Joseph Beuys. The difference between Beuys and the Actionists is that he did not merely expiate the horrors of existence, but he emphasized the healing qualities of nature and natural substances, pointing to his personal survival story as catharsis.

From Political Dissent to Counter Culture

As the decade progressed, political radicalism and minority issues became ever more relevant in a world characterized by the polarization from the Cold War; destabilization after the assassination of President John F. Kennedy and, later, his brother Robert; decolonization from the war in Algeria to the atrocities of the Nigerian civil war; the war in Vietnam; the civil rights movement, the murder of Dr. Martin Luther King, Jr., and the emergence of the Black Panthers; and the student protests of May 1968. The globalization of information and television's as yet imperfect techniques for manipulating consent paradoxically became a megaphone for the outposts of a world arena spanning Vietnam to Indonesia, Africa to the Bronx. The world was perceived to be ever more conflictual.

Photoreportage in particular brought images to the West of an exotic, threatening East in the work of Larry Burrows, the *Life* photographer who died in Vietnam. The painter Malcolm Morley's mimetic remakes of Larry Burrows's most famous 1966 photographs with American soldiers as Christ figures triggered the connections between the purposely ambiguous paint/print originals and the images of "the compassionate photographer." Youth culture and radical dissent in America grew out of an open challenge to social dictates on sexual behavior, personal freedom, and civil rights. From the Beat generation of Ferlinghetti, Kerouac, and Ginsberg, to the Black Mountain College of John Cage and Rauschenberg, to radical campus dissent, the impetus for protest snowballed. In Europe, the dissent fell into the mold of an extreme political utopia, born inside the universities. Counter culture in America has its roots in the civil rights movement and developed alongside the re-elaborations, by white rock stars, of black music and the blues, engendering an energy and emotion that found a new and receptive mass audience all over the world.

The beating rhythms and the radical critique of middle-class complacency in the lyrics of the Rolling Stones, the sexual ambiguity of Mick Jagger, the Beatles's dreamy Sergeant Pepper universe accompanied by acid Botticelli colors, the new ritual of smoking pot, psychedelia, and Woodstock were an antidote to stifling convention. Some creative moments were truly epical — Jimi Hendrix's rendering of the U.S. national anthem, intended by its author as a work of art and homage to America, and Jasper Johns's *Flag,* a comment on the meanings of the symbol itself.

When Attitudes Become Form:
Back to Planet Earth

By the end of the decade, the increasing visibility of nations far from center stage was beginning to look more like a global network than a village. The writings of Franz Fanon, black political thinker and psychiatrist in France, inspired black identity and liberation from cultural oppression. Writers and artists from the Nigerian Chinua Achebe to Wole Soyinka and the Martinican Aimé Cesaire, all part of a modernist culture, were coming to terms with their hybrid natures, conjugating local origins and a Western education. It was no longer the prerogative of the West to "discover" the rest of the world; it was the rest of the world that began to find its footing in the new global arena.

The decade closes with the 1969 Bern exhibition *When Attitudes Become Form* curated by Harald Szeemann. The show's subtitle, *Live in Your Head,* is an implicit definition of Conceptual Art: the specified categories are *works, concepts, processes, situations, information*. In the catalogue to the exhibition, Scott Burton declares that "form proves capable of apparently infinite extension." Art had been invaded by life. Art and ideas became indistinguishable; as Marcel Duchamp once asked, "Can one make works which are not works of 'art'?" Among the artists in the exhibition were American minimalists Carl André and Sol Lewitt; German conceptual artists Hanne Darboven, Eva Hesse, and Hans Haacke; and artists known under the umbrella of *Arte Povera* in Italy. For many of the latter, the primacy of the idea did not always go hand-in-hand with dematerialization. Some artists including Mario Merz,

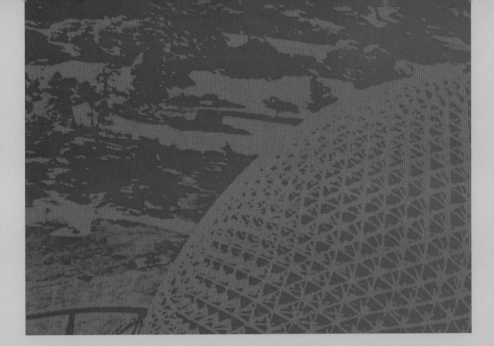

Giuseppe Penone, Jannis Kounellis, and Alighiero Boetti had a very strong attachment to the physical world, to nature, and to the environment. Penone's work involved a magical identification with the Earth, a reciprocally creative relationship between humans and the environment they inhabit.

Alighiero Boetti's creations are the stuff that dreams are made of: his world maps bearing national flags embroidered by Afghan women and signed with the humorous pseudonym "Ali Ghiero" are today a poignant reminder of what Afghanistan is no longer and what the world has become. In turning to nature, the *poveristi* were not very far from the American and English Land Artists. The difference lies mainly in the dimensions and the foregrounding of nature itself. From the beginning, Land Art, Earth Art, Environmental Art, the work of artists such as Michael Heizer, Robert Morris, the monumental *Wrapped Coast* of Christo and Jeanne-Claude in Australia, and *Spiral Jetty* (1970) by Robert Smithson, placed the physical landscape at the center of attention. Smithson believed that by reclaiming land in terms of Earth Art, his operations would gain visibility for a different concept of the environment. Smithson, who died tragically in 1973 in a flying accident, placed the human adventure firmly back where it belongs, inside the geological and astronomical time/place dimension, embracing Karl Popper's idea of an open-ended future and universe.

Notes

1. McLuhan's last work, *The Global Village,* edited by Bruce Powers, was published posthumously (New York and Oxford: Oxford University Press), 1977.
2. *Piero Manzoni,* catalogue to the exhibition at the Serpentine Gallery, London, February 28–April 26, 1998 (Milan: Charta).
3. *The Gutenberg Galaxy: The Making of Typographic Man* (Toronto: University of Toronto Press), 1962 and reprinted.
4. R. Buckminster Fuller, *Critical Path* (New York: St. Martin's Press), 1981
5. The exhibition was curated by Udo Kultermann at the Museum of Leverkusen in Germany.
6. Entitled nul negedtienhonderd vijf en zestig.
7. *The Responsive Eye* at the Museum of Modern Art, New York, also in 1965.
8. *Cybernetic Serendipity:The Computer and the Arts,* curated by Jasia Reichhardt at the Institute of Contemporary Art in London, 1968.
9. Umberto Eco, *Opera Aperta* (Np: Bompiani), 1962.
10. *Primary Structures, Younger American and British Sculpture* at the Jewish Museum in New York, opening April 26, 1966.
11. "Specific Objects," *Arts Yearbook* 8, 1965.
12. Renata Molho, *Gli anni 60 le immagini al potere* (Milan: Mazzotta Editore), 1996.
13. Richard Hamilton, "Studio International" (London: np), 1968.
14. Recounted by William C. Seitz in the catalogue *The Art of Assemblage,* The Museum of Modern Art, New York, October 2–November 12, 1961.
15. Guy Debord, *La societé du spectacle,* 1967–70. (Np).

In October 1957 the Soviet satellite <u>Sputnik</u> orbited the Earth. The news of this feat staggered the imagination and announced the start of an epic race between the United States and the Soviet Union for the conquest of space. On July 21, 1969, this race had an outcome that would have seemed incredible barely a few years earlier — Neil Armstrong and Buzz Aldrin planted an American flag on the moon.

In a decade, our notion of the Earth and space was profoundly transformed. The Milan artist Piero Manzoni expressed this disruption in our relationship with the world by presenting the planet as a total work of art and made an iron base for it, <u>The Base of the World</u>. From their vantage point as observers, European artists, moreover, were the first to respond to the new challenge that science made to the imagination. The year <u>Sputnik</u> was launched Yves Klein began his series of "planetary

reliefs" covering topographical fragments and even a globe of the world with the famous IKB, "International Klein Blue." On October 19, 1960, he made a leap into the void — in reality, a photomontage — declaring himself "the painter of space." Infinity, emptiness, weightlessness, strange surfaces: all these properties attributed to outer space made their way into the decorative arts. The Italian designers De Pas and D'Urbino invented a floating pneumatic armchair, Paco Rabanne created a Rhodoid dress made of transparent plastic strips.

Artists' fascination with the idea of space also found expression in research on visual perception by the proponents of Op Art. Bridget Riley in London, Guido Molinari in Montreal, and many others throughout the world created the illusion of mobile, virtual spaces. In the United States, Minimalist artists emphasized the rationality of "primary structures." Sol LeWitt's modular constructions were geometrically transparent; Donald Judd argued for "real space" as a definitive antidote to illusionism.

To speak of space is to speak of futurism. Carried by the optimism created by the conquest of space, artists, designers, and architects designed the town and life of the future. Dishes are stacked in spheres, televisions look like astronauts' helmets, furniture is made in modules. Mankind is living on the threshold of utopia. The British group of architects Archigram invented both the nomadic town and the instant town, versatile and multifunctional. Buckminster Fuller, the architect and mathematician, planned to cover New York with a "geodesic dome." (Moreover, he made one for the United States pavilion at the International Exhibition of 1967, Montreal.) The Italian group Superstudio conceived an orthogonal multipurpose superstructure. More of a realist, Ed Ruscha conjured up the dark side of the future, borrowing the novelist George Orwell's fateful date, 1984.

S. A.

space

Astronaut and painter

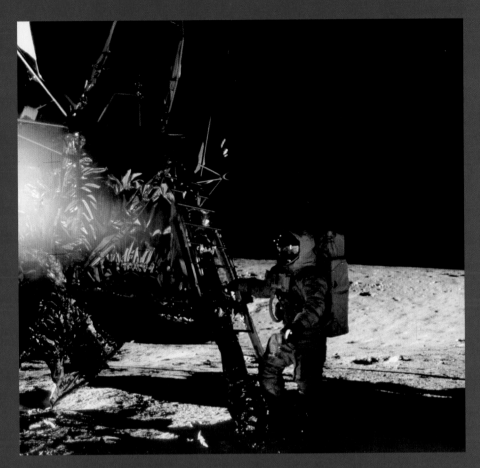

Fig. 1. Alan Bean stepping off the lunar module's footpad for the first time, Apollo 12 Mission (November 14–24, 1969).

Q: On November 19, 1969, you walked on the moon for the first time. Can you describe the physical nature of this experience?

A: Well it is a physical experience. A lot of people were counting on us to deploy their experiments or make observations, pick up rocks, check out the lunar module, put up the flag — all that stuff. And we had only a limited amount of time. Every minute was scheduled. But at the same time, I was in an environment of one-sixth gravity. So, for example, if I had closed my eyes and just stood there, I would have soon fallen over because the sensors on the bottom of our feet that let us close our eyes on Earth and still stand erect have been trained at a body weight that we know (Fig. 1). At first, if I didn't pay attention I would be leaning way over forward, sideways, or back before I noticed that I wasn't standing up straight. I felt like I could keep my center of gravity in the right place if I kept moving, but if I stood still, pretty soon my center of gravity would move into the wrong place and I would not notice it real quickly. Our balance mechanisms just aren't trained to these conditions and I don't feel that my body ever learned,

while I was there, to really stand up well with my eyes closed. With my eyes opened, I learned pretty quick.

Q: How about the moon itself? What struck you the most about the lunar landscape?

A: It is so dusty up there, and the dust, because there has never been water or wind on the moon (Fig. 2), has many more and much finer particles than any dusty area or desert anywhere else where the wind and water have washed away the real fine particles. The particles themselves are not rounded like beach sand or most dirt particles, like stones in a creek are rounded by the weather. They're kind of microscopic fairy-castle structures so that they don't roll over one another. **When you pick up dust, it doesn't boil up around you like it does on Earth, it goes out like little bullets.** Also you get much dirtier, and your suit gets dirty and your zippers get dirty because of all this extra-fine dust.

Q: How about what you saw?

A: Buzz Aldrin (Fig. 3) spoke of the "magnificant desolation" of the lunar surface. No one coined a better phrase. It is a void, but it's beautiful. If you think of beauty related to flowers and animals and clouds and colors, then it's not beautiful at all. It's a different kind of

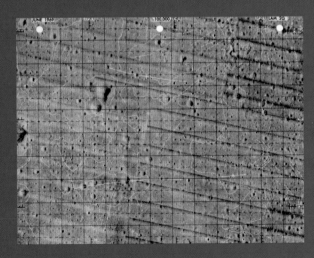

Fig. 2. Photographic map of the landing site for the Apollo 11 Mission (July 16–24, 1969).

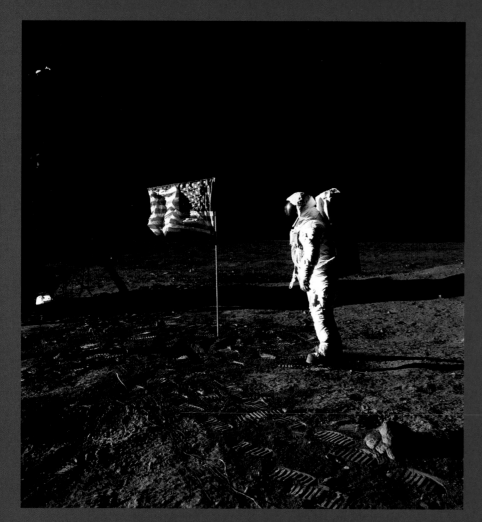

Fig. 3. Edwin (Buzz) Aldrin, Apollo 11 Mission (July 16–24, 1969).

moving along and we can't stop it but we can't push it too fast neither. You can say we were the scouts, the explorers. The pioneers have not gone yet. Now we are going into space to live and see how we can exploit the space station and stay for longer periods.

Q: From the moon, you looked back at the Earth, "the most beautiful object," as you have written, that you could see from there.

A: Well, it was an object in the black sky. In this gray world that you are in on the moon, you look up, and then there's this beautiful blue-and-white object with some kind of orangey shades (Fig. 4) just sitting up there against the vastness from horizon to horizon. And even though the Earth is four times the diameter of the moon, **it looks small like a marble.** It's a curious thing, too. Since the moon rotates with the same side facing the earth all the time, it seems to be just static there. The stars move across the sky in fourteen Earth days and then it's dark for another fourteen Earth days and yet the Earth stays in the same spot day and night. However, if you go back and look four to five hours later, you see that some of the cloud patterns that were to your left are now to your right. So you know that something is turning around up there. I felt that if humans had evolved on the moon, instead of on the Earth, Copernicus wouldn't have been able to figure it out yet. From the moon, the Earth would easily be seen as the eye of God, opening and closing, going in a twenty-eight-day period from full light blue and white down to night where all is dark.

beauty; it's so pristine and so different from what you have ever seen before. The sky is a shiny black even under sunlight. It is not dull like night on Earth. It's an interesting world, but it is equally a harsh and unforgiving world and we will have those sorts of things to contend with when pioneers do go up there.

Q: There was much optimism in the '60s about conquering the moon. Many thought that it was a question of years before we'd establish ourselves there.

A: We have not been back in some thirty years. However, between the time Columbus discovered America and a pilgrim showed up over here, many years passed. Cultures do not move in the most effective or efficient ways. There are delays as they lose the attention span. We're not in bad shape. I'm not the least bit discouraged for the long-term effect. In two hundred, three hundred, four hundred years from now, we will be back there and people will be going there for vacation and people will live their whole lives there. Humanity is

Q: The '60s were a troubled time in the United States, not to mention the rest of the world. Looking at the Earth from a distance, did you ever think about these troubles?

most bea

A: No, I didn't. I would have to say that all during that troubled time, we in NASA never did. I don't remember a discussion about Vietnam. I don't remember a discussion about race relations. I don't remember a discussion about much else other than space and what we were trying to do, how to do the *rendez-vous*, whether we needed a radar or a star-tracker, or how to get ready for the next Gemini flight. We had so many things we were trying to accomplish by the end of the decade that we had complete tunnel vision. At parties we might say something like "I heard Bill Smith got killed in Vietnam," because all our contemporaries were over in Vietnam fighting, but we didn't worry about it. We didn't talk about the politics of it or any of the other things that many Americans were discussing. What I know of the '60s, I found out afterwards by watching Discovery channel and reading books. **In a sense it was like a lost decade,** but it was a dedicated time to do a certain job that required 100 percent of your mental attitude.

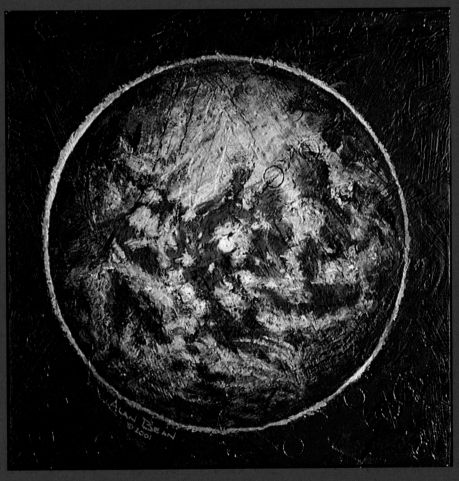

Fig. 4. Alan Bean, *A Most Extraordinary Eclipse,* acrylic on aircraft board, 2001.

Q: Yet you were an actor of history. The conquest of space was a competition between the United States and the Soviet Union. You were at the forefront of this race. Did you live it as such ?

A: We all felt we were in the race. We all felt that we were responsible. Not just astronauts, the people building the spaceship and testing it and everyone involved in it felt like we were in competition. Don't forget, all of us were ex-military, and so we all had this background and NASA is similar to a military organization, it thinks a lot like the military and it is organized like the military. And it was founded immediately following the launch of the *Sputnik* (Fig. 5) satellite by the Soviets. People were concerned to see that communists could do that and that democracies could not do it. Our way of life, our democracy being the best way, superior to communism (I am not saying it is, I am just saying how we felt), was being tested. We felt that we had responsibility to the President and to the American people and to future generations to show that the democracy that we believe in was the right thing to do in the best way. It was important that it be the American flag, or any democratic country's flag for that matter, that was planted on the moon. But not the Russian flag. My feeling is that's what fueled the space race: the fear of the average person in the U.S. and probably in other places in the world that maybe our way of life really wasn't as good as communism. **The greatest motivator in life is fear.**

Q: You say this yet you were exposing yourself at the highest risk imaginable, weren't you?

A: We were, that's true. But most of us had been test pilots in the military, trained and skilled at doing difficult things in a dangerous environment with the highest performance machines you could get. As a pilot and an astronaut, you learn to have confidence that you can survive that environment; you're able to push back fearful thoughts. We got hit by lightning about fifty seconds after launch, and our electrical system went down. It gave us a scare for a second but then we

pushed fear out and began to think about what we had to do, and then fear would creep in and we'd push it back. So it's not like you're not fearful, it's that you are able to compartmentalize it and push it back, so that you can perform.

Q: You walked on the moon and accomplished a dream as old as mankind. How does it feel to have been of the happy few who have lived this adventure?

A: I feel lucky. But a lot of people could have done it. Certainly all the astronauts could have done it and a lot of people who weren't picked as astronauts could have done it. But I was the right age and the right health. My eyes were good, and I just got the chance. And then once I got the chance, I didn't screw it up too bad.

Jet pilot and test pilot for the United States Navy, **Alan Bean** (Wheeler, Texas, U.S., b. 1932) was one of the third group of astronauts named by NASA in October 1963. Captain Bean was the lunar module pilot on Apollo 12, man's second lunar landing mission. In 1973, he served as spacecraft commander of Skylab Mission II, accomplishing a fifty-nine-day, 24,000,000-mile world-record flight. Alan Bean resigned from NASA in 1981 to devote his time to painting.

Interviewed by Stéphane Aquin

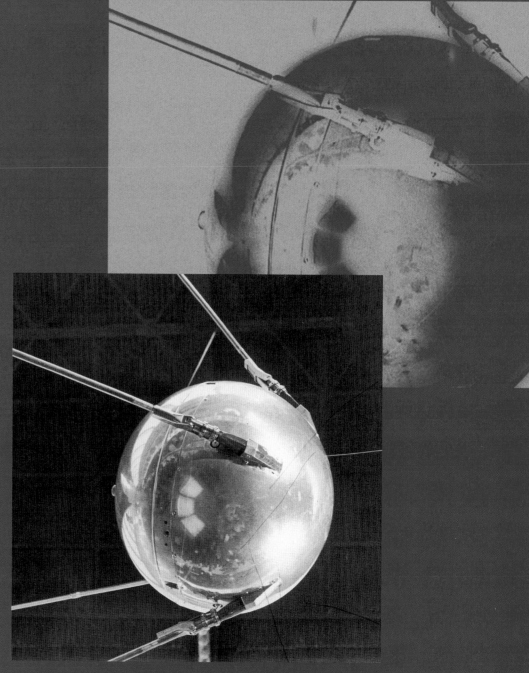

Fig. 5. *Sputnik,* the world's first satellite put into orbit by the Soviets on October 4, 1957.

INTERVIEW: MICHAEL J. WATTS

Geographer

Q: As a geographer, why are you interested in the '60s and is there something like a geography of the '60s?

A: There are two sides to your question: one personal and one substantive. Let me begin with the personal. I came of age in the 1960s in England and was formed in some fundamental way by that decade; I was living in London in the late 1960s reading geography and economics. So, for me personally, being involved in left-wing student politics and in the study of something called geography were inseparable. For the record, I had already become involved in left-wing politics prior to university. When I was sixteen, largely through the influence of a high-school classmate, I became quite active in a small and totally insignificant Trotskyist group. Coming to the university in London was a continuation of these naive political leanings, and in that cosmopolitan urban context there was a panoply of such left splinter groups. I ended up being most closely affiliated with a Marxist political group, which, as it happens, had close connection with many of the left-wing student movements in Paris.

Q: And about the second, more substantive aspect: why would a geographer be interested in the '60s and what would a geography of the '60s look like?

A: There are a number of ways of thinking about this. Let me begin by focusing specifically on the events of 1968. These events were geographical in the sense that they were global in character, and this partly explains their significance. There were street demonstrations and riots in Paris and Berkeley, but also in Tokyo, New Delhi, Mexico City, and even Moscow. One might say that from a geographical vantage point **this was a moment of global insurrection,** comparable, let's say, to the revolutions of 1848, but in a sense more extensive and encompassing. As a geographer I became interested in precisely why, under wildly different circumstances, the radical and insurrectional aspects of the 1960s seemed to have such worldwide appeal and support. I tried to make an argument that all of these global revolts represented a desire to do politics differently but that desire was rooted in three quite different sets of political circumstances. In the communist block it represented a revolt against the party, in the advanced capitalist states against a complacent consumer capitalism, and in the

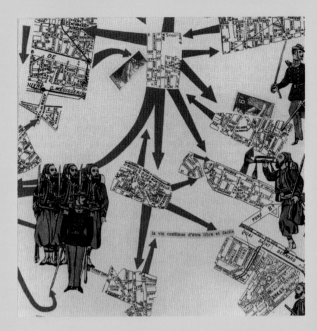

Fig. 1. Guy Debord, "*La vie continue d'être libre et facile*" (Life Continues To Be Free and Easy) (detail), about 1959.

third world against a corrupt secular nationalism. As a geographer, one then needs to look carefully at how local circumstances shaped these differing types of '68 politics. In this regard Tokyo, Mexico City, and Berlin might look quite different.

Q: In your work, you are also interested in the key role played by Situationists in those events, specifically in Paris. What is the geographical connection there?

A: Guy Debord and his comrades were deeply interested in what they called psychogeography, which for them had to do with the relationships between place (urban morphology) and consciousness (Fig. 1). So the political crisis of the late 1960s for geographers was in large part about the character of cities and the social relations and sense of community that were associated with large, dense agglomerations of people. In a way, reading the book *All That Is Solid Melts into Air,* by Marshall Burmann, sheds much light on the relationship between radicalism and the crisis of the cities, in the American context at least. In Europe and North America, the late '60s was a period in which a number of geographers were radicalized and began to use their geographical tools to explore the ideas of rethinking the city (David Harvey, for example).

Q: But at the same time, this period is often described as a superficial and faked version of resistance, when students and others started to act as rebels in the "société du spectacle," as Debord says. What is your vision of it?

A: Superficial and faked are rather different words. I am not at all sure that the people in the street in May were "faking"; there may have been a lack in some quarters of a political vision, but it was quite explicit in others — SDS in the U.S. for example. It was superficial in some cases, of course, and much of the cultural project (sex, drugs, music) while lasting in its effects was hardly the basis for a sustained political project. In many quarters there was a profound lack of alternatives and strategy, although the commune movement in northern California was utopian and had a grand and experimental vision. In that sense, yes, there was a certain superficiality. But let us not forget that the '60s gave birth to a massively organized feminism that by the mid-1970s had a UN conference! The same could be said of the environmental movement. Laws were changed, legislation passed, personal lives transformed, and so on. Much is always made by the political right of such superficiality — the idea that the politics were "adolescent" and "immature." But one should not mix up superficiality with a sense of political theater — Ginsberg, Hoffman, et al. levitating the Pentagon!

The question of the legacies of the 1960s and of 1968 in particular has to be situated on a larger landscape of rethinking the 1960s. In the last five years, for example, in the wake of the thirtieth anniversary of 1968, a minor industry has arisen decrying the negative consequences of the 1960s revolutions from the political right and the political left. There is **an overwhelming sense of failure,** and a sense that more than anything else, the 1960s were largely adolescent in their politics — self-indulgent, narcissistic, and naive. I used the metaphor "the Long March through the institutions" as a way of understanding the ways in which 1960s activists pursued their goals in the wake of the collapse of many of the political movements of which they were a part. In this regard I see the positive fingerprints of the '60s in a number of important contemporary events, not the least of which would be the bringing down of the Berlin Wall in 1989 (the Eastern European left noted that '89 was '68 upside down), the Chiapas uprisings in 1994, and the great proliferation of civic and community groups in the last quarter of the 20th century. Did not the '60s bequeath to us in some ways the contemporary clamor for civil society and civic movements?

Q: You also say that geography deals with space and that obviously space has many manifestations or types: urban, regional, local, community. Space can also take different sorts of meanings: nations, nation states, empire. From this perspective, what can you say about the geography and the relation to space during the '60s? It seems that the geographical and spatial mind was then organized around the great divide between East and West, North and South. And what about the importance of the United States in this geography or cartography of the world?

A: All of what you say is true. The geographical imagination of the '60s was overdetermined by the Cold War and the first/third-world divide. U.S. imperialism — let us call it that — framed this space of the '60s; and yet it gave birth to a spatial countercurrent or contraflow. I believe that another set of imaginaries was at work in that period. The fact that the Situationists talked of psychogeography as a way of rethinking urban space is a case in point. But there are other cases. One aspect of the 1960s was that creation of new spaces called communes, and in California, for example, this was part of a leftist project (not a dystopian rejection of everything by "hippies"). Many of these communal experiments began to fall apart in northern California in the mid-1980s, in part because of the assault on their existence by local governments, in part by the anti-drug war, and in part because of the internal contradictions of running self-sustaining communes. But they were extraordinary experiments, and the people I have interviewed, while acknowledging with sadness their failure, firmly believe that as a way of raising children, or organizing social life, the communes were foundational moments in both the legacy of the '60s and in rethinking the politics of everyday life. We have lost a sense of these accomplishments, of these fragile, delicate, complex, and contradictory spaces. And of course they are alive still as a new generation attempts to rekindle the flame of communal living and collective space — to reclaim a sense of the common in the face of the gigantic forces of neoliberal individualism.

Q: And what about globalization? For a geographer, of course, this is really not a new phenomenon. But how did it manifest itself during the '60s?

A: This is a complicated question. First, the foundations of what are now called global production networks/complexes were laid in this period. Much of what we now take to be the basics of globalization — capital flows — received its first big post-war (1945) push then. This was characterized not so much by transnational banking but by the growth of U.S. transnational direct investment (in Brazil, Europe, and so on). Second, the golden years of U.S. capitalism and of high Fordism meant that globalization also took on a strong "Americanist" cast, both in terms of American products (in an expanding world market) and culture (rock and roll, etc.). Third, the Vietnam War was also indicative of a sort of globalization and of the growth of a global media in which images, through satellites, could now give meaning to "spaceship Earth" (Fig. 2). So the '60s were global in a way that the '50s were not: economic, political, and cultural all at once.

Finally, the zeitgeist of the '60s was so powerful because the local expressions of what was at stake were radically explicable across cultures; this must have something to do with the centrality of youth, a sense of intergenerational shifts in ideas and attitudes. The mere fact, for example, that there was a movement in students between the UK, Germany, the U.S., and

France speaks to **a sort of political mobility, a globalization of student politics that was quite unusual.** As the historian Eric Hobswbawn points out, there was a circulation of materials — everyone was reading Franz Fanon and Mao. In this regard one might say that the '60s — and one of its legacies — had to do with the self-conscious awareness of local politics being part of something wider and global.

Q: How does a geographer look at cultural and artistic productions? What can your discipline tell us about art?

A: The simple answer would be that the place art is produced shapes the sort of art produced. Geography has something to say about the sense of place, the importance of locale or location. And in our epoch this must confront the relations between place and belonging, and the forces of globalization — flows, movement, overcoming the friction of distance. One could, for example, see in the new project by the Brazilian photographer Sebastião Salgado, "Migrations," precisely such an artistic and political engagement with movement, displacement, rootlessness — and what it says about the making of a world proletariat. In this regard it is interesting how space has become an object of scrutiny for the artistic community. Space matters, as we geographers regularly exclaim.

Michael J. Watts (Bristol, England, b. 1950) is director of the Institute of International Studies and professor of Geography at the University of California/Berkeley. He is author of *Silent Violence: Food, Famine and Peasantry in Northern Nigeria* (1983), co-author of *Reworking Modernity* (1992), and editor of *Geographies of Global Change: Remapping the World* (1995).

Interviewed by Stéphane Baillargeon

INVASION DMZ RUNS INTO THE MARINES

Help for a wounded Marine south of the DMZ—Demilitarized Zone

OCTOBER 28 · 1966 · 35¢

Fig. 2. Cover of *Life*, October 28, 1966 (Vietnam War: DMZ invasion).

INTERVIEW: ETTORE SOTTSASS

Designer and architect

Q: Ettore Sottsass, you are a leading name in the world of international design yet you are a totally eccentric figure. From the very first you have always conveyed a sense of calm and simplicity, a somehow totally different attitude toward life and the design profession. Has it always been so or did you have to work hard at it?

A: Both, I think. When I was sixteen or seventeen I read an anthology of the Greek pre-Socratic philosophers edited by a German scholar, of which I understood almost nothing: But what impressed me was the idea that you could be touched by a sense of magic and be interested in ideas merely by reading fragments and not through a structured ideology based on the principles of Latin grammar. Many years later I experienced the same intellectual satisfaction reading fragments of Indian texts with my friends of the Beat generation, that group of young people who thought **there was still a remote possibility of survival outside institutionalized reality.** I am a child of that generation for whom the discovery of Indian philosophy was important.

Q: Did you attempt to bring this philosophical approach to bear on your profession?

A: Perhaps I did. For example, in my work as an architect I have always chosen to work for individuals because it means having a personal relationship with people for a precise reason; the building has a purpose that I design and know. If I had to design a bank I wouldn't know where to begin.

If you go to the Venice Architecture Biennale you will find that 90 percent of contemporary architecture is triumphal, the architecture of power. I am not very interested in this type of architecture. Cities have become very aggressive. A city is no longer a place for houses, it no longer has distinctive sounds or charm.

Q: But you once contributed to building that industrial culture and ethic. In the 1950s and 1960s you worked essentially for industry.

A: That is so, but industries can take different roads. That is really where the problem lies. In the beginning, industry had its own ethic with regard to the public. Ford made motorcars because he thought people could drive them to move about. And I remember advertisements for cars that were very calm, mostly descriptive of the product. You can advertise things in many different ways. So-called "industrial culture" is a subject for thought.

Q. All through your life you have written articles for periodicals such as Il Politecnico, Comunità, Casabella, and letters and notes in which you comment on ways of life, people's habits, ways of dressing, the war in Vietnam, counterdesign, pacifism, etc. In a memorable reflection on Pop Art written in 1964, you ironize that the bad taste of this new form of art is really in extremely good taste.

A: For the first time ever art represented consumer goods. There are phenomena and events that are so typical of a society that they touch an entire people. For example, *Campbell's Soup* by Warhol, or the electric saw by Oldenburg, or Wesselman with his half-naked secretaries. They are a very precise representation of the American landscape.

Q: The '60s in Italy were more conceptual and also more political.

A: There was a big difference between the political movements in America in those years and analogous movements in Europe. In the United States criticism was intended to accompany American society, no one wished to destroy or combat society. It was not a violent protest but centered on civil rights. European movements, on the contrary, wanted to change the system, they were much more ideological.

Q: What significance did the idea of utopia have for you at the time or did you in some way bypass the issue? Utopian visions were very important for many architects in the '60s.

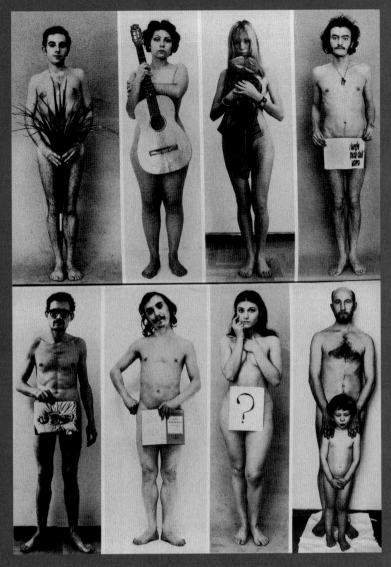

Fig. 1. Gianni Berengo Gardin, *Nudi* (Sottsass appears in the bottom row, second from the left), 1968.

A: Everything I do is utopian.

You cannot but live in a utopia if you really wish to live at all. I am very interested in recovering a childlike sense of wonder. Not in a regressive sense, but as a discovery of the world. Recently with my wife, Barbara, I translated some traditional Venetian cantos, in which you can feel a sense of the pre-religious, in which the divinity is an important part. We are inside this divine space, we are day and night in wonder over what happens because we have no explanations to offer; we open our eyes and live through phenomena like children. I believe that if we could just build attitudes of this kind, a special sort of patience, instead of always wanting to understand, always wanting to possess and control, probably we would have another form of industry.

In the '60s we imagined that technology could control nature. However we don't seem to have succeeded and I don't think we will because everything we control also has its own laws to obey, the laws of cause and effect. And even when we have discovered, as we seem to be doing, how to recreate life, we will not have solved anything because then we will have to ask ourselves what we are going to make of this life: Are we going to be all soldiers or all fugitives? More men or more women?

Q: In the '60s you posed naked as part of a series along with a group of other Milanese intellectuals photographed by Gianni Berengo Gardin (Fig. 1). It was an amusing liberating gesture. What do you think of the promiscuity that the '60s brought with it?

A: There is no longer any sense of sacredness in lovemaking. It has lost its sense of the marvellous. I feel a great pity for young people today because the over-consumption of sexuality as seen through the media is a loss of awareness. Love is a fantastic, dramatic, complicated moment of happiness, unhappiness, and emotions. It is a work of art. It is a form of survival. I'm not sure if young people live it in the same way today. They seem to have a fragility that is also fear, which leads to the pursuit of experience, proving themselves in violence.

Q: Going back to the '60s and your work as a designer, what significance did the experience with Olivetti have in professional and personal terms?

A: Adriano Olivetti invited me to work as designer for the new division that he was founding in 1957–59. I went to see what they were doing down in Pisa where they had their offices in a 19th-century villa. No one knew what this electronic stuff was all about at the time. Electronics was something that went on in American universities, factories full of huge cupboards. To get to the villa near Pisa we had to take a horse and cart because there weren't even any taxis. When I arrived and they opened the door, it was like stepping into a film. There

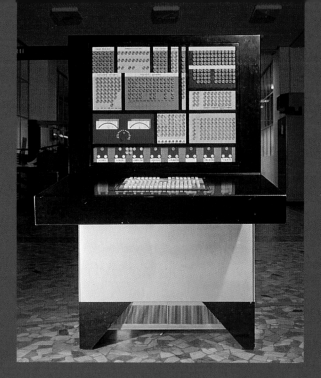

Fig. 2. Olivetti Computer
Elea 9003, 1959.

A: The first Italian electronic computer, called Elea (Fig. 2), was produced around 1959–60. At the time, Olivetti was really way out ahead. The first computers were so big that you could not see the operators behind them; they took up entire rooms, which became labyrinths. There was also the problem of wiring: we had to decide whether to put it above or below the flooring. Every three years it all had to be changed and you had to foresee the possibility of moving it, making things as compact as possible.

Q: Tell us about the Valentine typewriter.

A: When I began to design the *Valentine* for Olivetti, it seemed as if it was supposed to cost very little and I was really pleased. I imagined the market would be full of *Valentines*. It could have become the Biro of type-writers. But then there was a problem with "Pop" and "populist" design, they were not sure they wanted a popular object that cost so little. At one point they started to reason that we could not go so low in the price range that people would think the *Valentine* was worth the same as a plastic bucket. Then they thought perhaps we could take off the low key so that you could only write in capitals.

were all these people in white coats, floors covered in wiring, and valves all over the place. At that time computers still had valves; microchips didn't exist. I understood nothing, but the technical manager of the research group, a Chinese engineer named Mario Tchou, and I worked together alongside Roberto Olivetti, the son of Adriano. I felt very much at ease because we were all of a similar age and we were confronting the great monster of which we all knew very little. So it was a voyage of discovery and was one of the happiest periods of my life.

Q: What exactly did you do?

A: The engineers studied the structures and were constantly updating the technology because when we went from valves to transistors and then from transis-tors to chips, the reduction in volume was enormous: **it was a continuous race against time** not just on my side to keep up with the design but mostly for the engineers, to keep producing up-to-date products. It was an incredible adventure.

Q: What were the most significant products of that period?

Q: In the collection of the Centre Georges Pompidou there is an impor-tant piece you designed called the habitacle?

A: Yes, it consists of a series of compact storage compartments, a sort of utopia in which I imagined that everything you need could be packed away into a stan-dard wardrobe, a big cube containing cupboards, kitchen, chairs, shower, toilet (Fig. 3). It was on wheels so that according to your mood you could move around, a real utopia. At the time I thought we could do without all this enthusiasm for design; I thought that design could be practically reduced to zero. I am in favor of a civilization of boxes. I would like everything to be inside a box and for boxes to be placed on top of each other. It's not true that there is nothing to design in a box. In the Japanese universe everything goes inside a box, but there are Imperial boxes, cardboard boxes, and paper boxes, etc. But you don't have to think about them because they become part of the architecture.

Q: So you were in favor of a more elastic sense of space? Other groups of architects such as Superstudio and Archigram also designed nomadic architecture, movable and self-moving objects.

A: Yes, the same reasoning can be applied to an apartment or a house. Two people get married, have children, the kids grow up, the couple grows old, gets bored, wants to change, etc., so rooms and space should revolve around people's lives.

Q: After this experience with Olivetti, which had at the base a very concrete industrial project, in the latter half of the '60s your work changes. Especially in later years you explore a more irrational vein.

A: Absolutely. There was a desire to know and learn different things. For example, I couldn't experiment much with color on the Elea project. Today I am still experimenting with ceramics and colors and with furnishings where I am always inventing different ways to introduce color. Architecture isn't just made of hardware, but of experience — the perception of space, the observation of light, the climate, the direction of the light. All these things do not just affect the object that you design, but reciprocate with the person who will use the things you design, which means you.

Sensuality has been intellectualized, there is a whole history behind that. My Memphis range of furniture was an attempt at this vocabulary, to tell stories by putting together different parts of speech.

Q: Let's go back to where we started, your calm way of reasoning that includes the senses. If you were to summarize your approach to design, could you say that it is holistic, open to experiment with a variety of languages?

A: Yes, I think so. My attitude toward life reflects my attitude toward the unknown, toward the element of surprise. It must be **a nonpresumptuous attitude while awaiting the worst.** My wife told me a story the other day: she was on the tram, there were just three or four people on it. A young boy gets on and says, "Good day to you all." Silence. He takes out a flute and says, "now I'm going to play a little." He plays his flute and then says, "Please excuse me if I have disturbed you" and gets off. You might say it is the achievement of a lifetime: you come into the world, wish people good day, ask can I play a while, then take your leave on tiptoe. This, I think, is an attitude of nonpresumption.

Fig. 3. Container Furniture: Toilet and Shower, 1972.

Ettore Sottsass (Innsbruck, Austria, b. 1917) is a leading figure of postwar design and architecture. Known as the founder of such pioneering firms as the Studio (1947), in Milan, and the Memphis Group (1981), whose aim was to revive "Radical Design," Sottsass also worked as an industrial designer for Olivetti from 1958 through the 1960s. In this capacity, he created landmark design objects such as the *Elea 9003* computer (1959), the *Valentine* typewriter (1969), and the *Synthesis 44* integrated office environment (1968–1973). The Centre Georges Pompidou in Paris held a major retrospective of his work in 1994.

Interviewed by Anna Detheridge

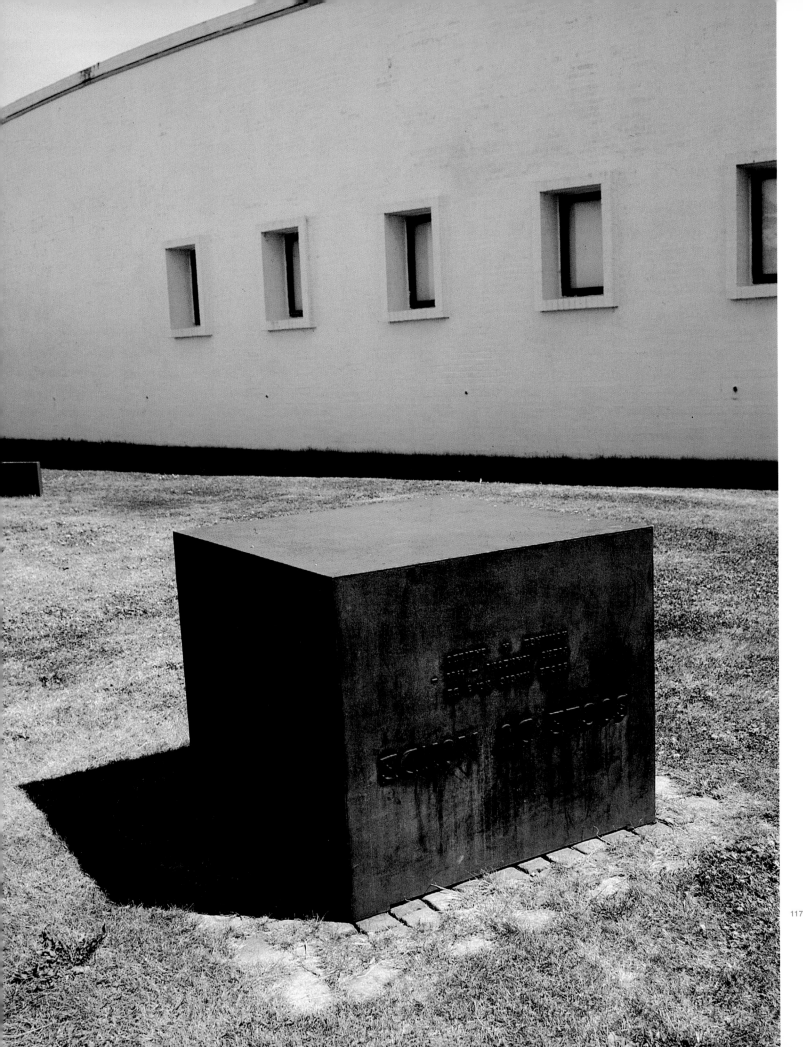

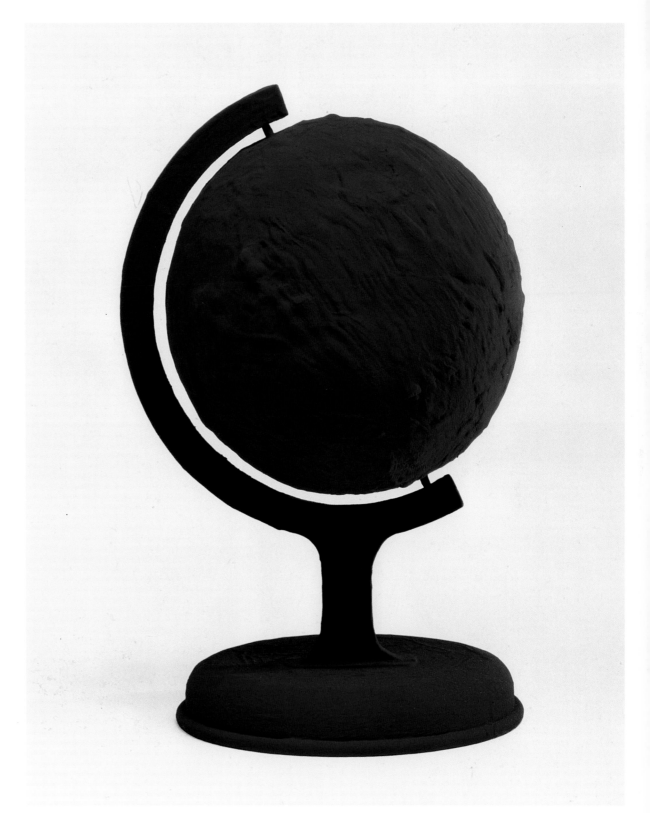

117
Piero Manzoni
Base of the World
1961

87
Yves Klein
RP7 Blue Terrestrial Globe
1957

87

100

99

97

98

100
Yayoi Kusama
No 17 A. H.
1956

99
Yayoi Kusama
Untitled
1954

97
Yayoi Kusama
Flower No. 8
1953

98
Yayoi Kusama
Flower No. 10
1953

81

79

80

81
Francisco Infante-Arana
Star Rain
(Project of the Reconstruction
of the Starry Sky)
1965

79
Francisco Infante-Arana
Nostalgia
(Project of the Reconstruction
of the Starry Sky)
1965

80
Francisco Infante-Arana
Star
(Project of the Reconstruction
of the Starry Sky)
1965

166

166
James Rosenquist
Noon
1962

209
Oleg Vassiliev
High Space
from the series "Spaces"
1968

132
Jean-Paul Mousseau
Blue Space Time Modulations
1963

209

132

153

198

43

153
Sigmar Polke
*Apparatus Whereby One Potato
Can Orbit Another*
1969

198
Vassiliakis Takis
Telesculpture 1960
1960

43
François Dallegret
Atomix – 1966
1966

32
Enrico Castellani
Black Surface
1959

116
Piero Manzoni
Achrome
1961

54
Lucio Fontana
*Spatial Concept,
Expectations 1 + 1419*
1959–1960

32

116

54

126

162

194

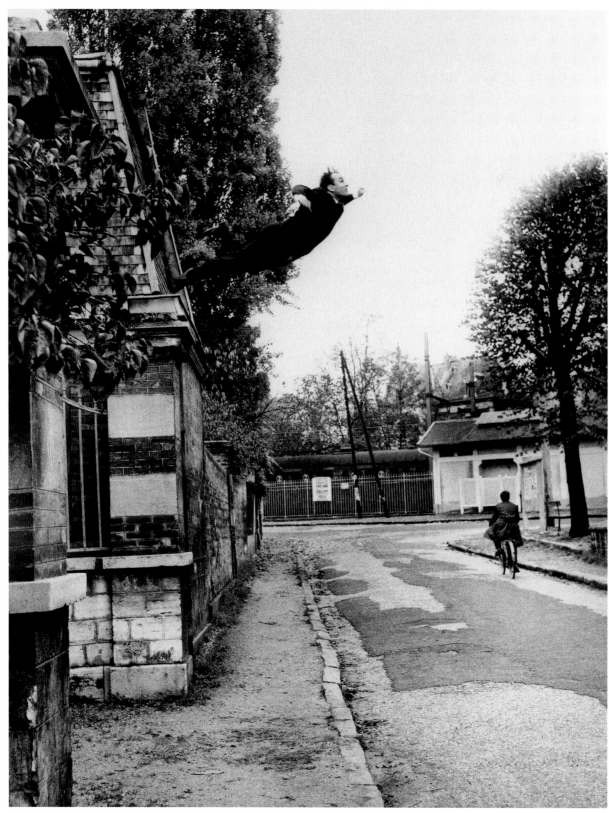

88

Yves Klein

Leap into the Void

1960

159

Robert Rauschenberg

Skyway

1964

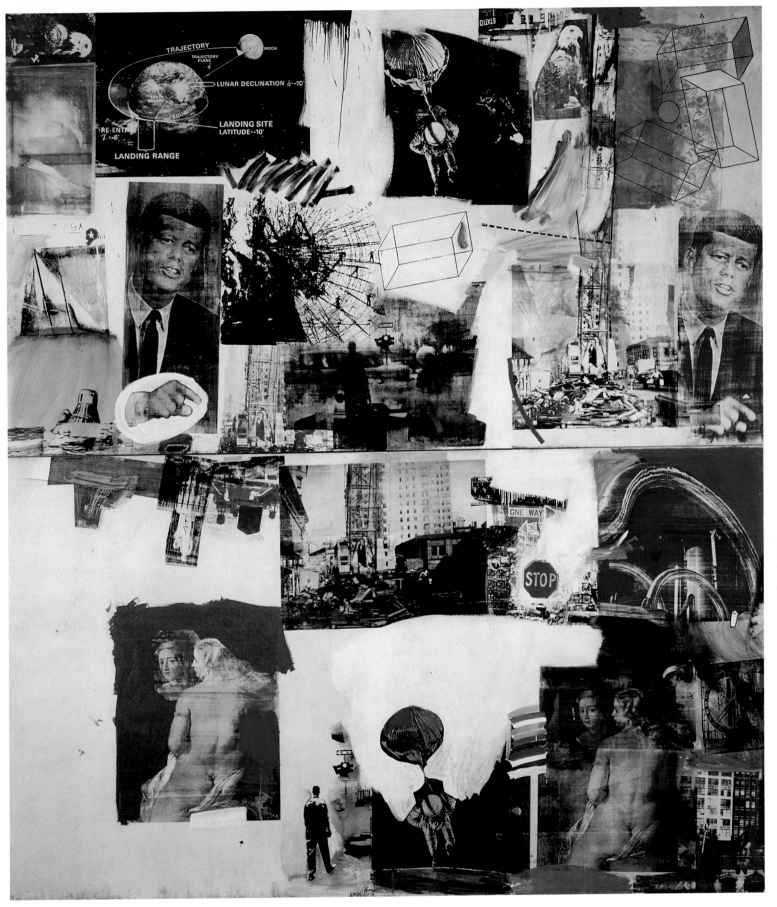

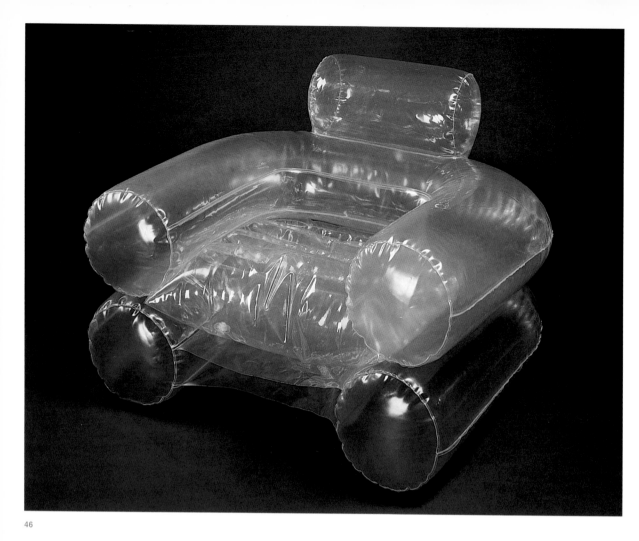

46
Jonathan De Pas
Donato D'Urbino
Paolo Lomazzi
Carla Scolari
Blow Armchair
1967

13
Gijs Bakker
Circle in Circle Bracelets
1968

115
Piero Manzoni
Line of Infinite Length
1960

158
Paco Rabanne
Dress
1967

46

13

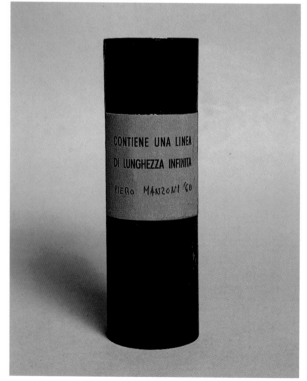

115

210

160

212

144

210

**Victor Company of Japan Ltd.
(JVC)**

Videosphere Television Set

1970

160

Martial Raysse

*Cosmonaut's Column
(Hygiene of Vision)*

1960

212

Helen Von Boch

Avant-garde Sphere Dish Set

1969–1970

144

Sue Thatcher Palmer

Space Walk Fabric

about 1969–1971

127

Nicholas Monro

Martians

1965

50

**Gordon Duern
Keith McQuarrie**

Apollo 861 Record Player

1966

127

10
Richard Artschwager
Chair, Chair, Sofa, Table,
Table, Rug
1965

108
Sol Lewitt
Open Modular Cube
1966

68
Richard Hamilton
Interior
1964–1965

77
Ideal Toy Corporation
Super City Construction Set
1967

16
Fred Forde Bassetti
Flexagons Construction Set
about 1960

114
Norman Makinson
(form)
Brian Cour
Eduardo Paolozzi
(pattern)
Coupe Savoy Plates
from the series "Variations on a
Geometric Theme"
1953 (form);
about 1968–1969 (pattern)

68

77

16

114

197

**Superstudio (Adolfo Natalini,
Cristiano Toraldo di Francia,
Alessandro Magris,
Roberto Magris, and
Gian Pietro Frassinelli)**
*Continuous Monument.
New New York*
1969

73

Hans Hollein
Rolls Royce Grill on Wall Street
1966

142

Claes Oldenburg
*Proposed Colossal Monument
for Thames River: Thames Ball*
1967

161

Gerhard Richter
City Picture Mü
1968

73

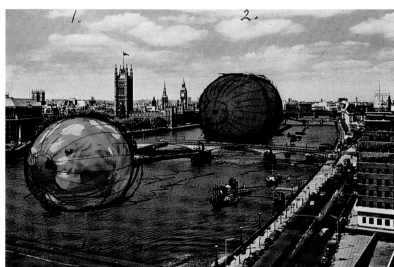

61

61

Richard Buckminster Fuller
Save Our Cities
from the series
"Save Our Planet"
1971

142

161

173

55

74

107

34

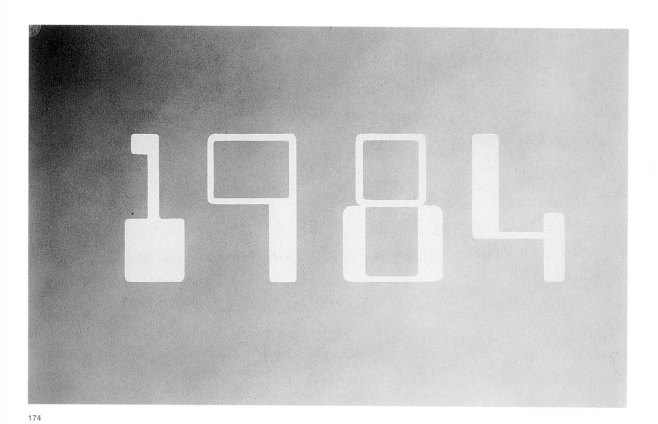

174

5

URBAN ACTION · TUNE UP

E UP – N O W

ACTION
VARIABLE SHELTERS
– ZEROX– INFORM
ATION SCREEN

URBAN IMMEDIACY
STUDY CARELS– SELF PACE
MACHINES– WORK
SHOPS– CCTV–
AUDIO VIS
UAL LIB
RARY

SERVICING
KIT OF PARTS, SHORT LIFE,
MOBILE, ACTIVE, COMMUNITY
EDUCATIONAL SERVICING

INSTANT CITY
RON HERRON – ARCHIGRAM
APRIL 1969 L.A.

Ron Herron

6

56

Robert Freeman
Silhouette on Map, Stuggart, 1961
1961

119

Jean Mascii
Alphaville
Poster
about 1965

2

Raimund Abraham
Continuous Building
1966

1

Raimund Abraham
Air-Ocean City
1966

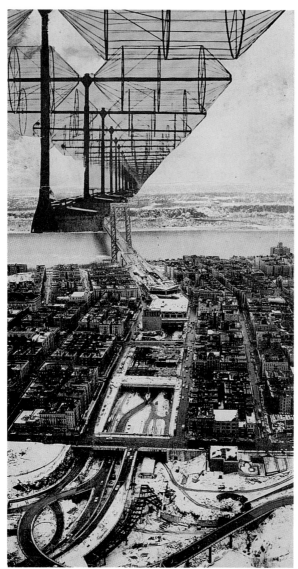

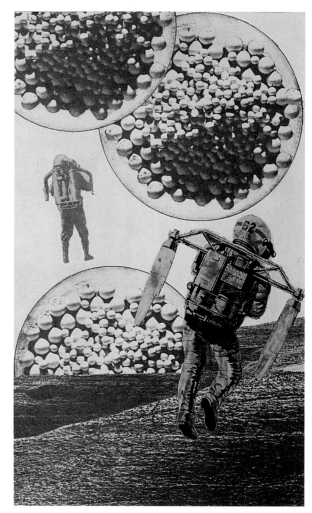

131

Olivier Mourgue
Sofa and Chair
from the series "Djinn"
about 1964

131

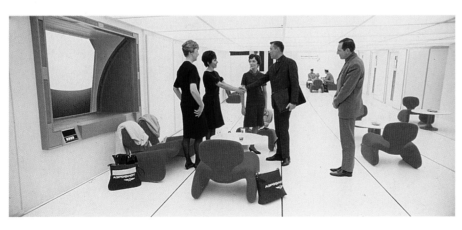

Fig. 1. Stanley Kubrick's
2001: A Space Odyssey, 1968.

Fig. 2. Verner Panton,
Phantasy Landscape, 1970.

In 1959, there were one million television sets in France. In 1967, 7.5 million. In the United States, in 1960, the debates between Kennedy and Nixon were watched by 70 million television viewers, redefining the rules of the democratic game as they were broadcast. In 1969, approximately 600 million people throughout the world watched a live broadcast of man's first steps on the moon.

If one technology was to shape the reality of the Global Village, it was television. In an interview published in <u>Playboy</u> magazine in March 1969, Marshall McLuhan, the "tube guru," asserted, "Today, television is the most significant of the electric media because it permeates nearly every home in the country, extending the central nervous system of every viewer."

One of the first effects of this technological "revolution" was to transform our relationship with time. Television, as McLuhan also pointed out, generates a feeling of "nowness," accentuated by the development in 1962 of "mondovision" provided by the Telstar satellite. History now happened live. The present merged with an uninterrupted flow of media moments. A number of artists perceived this new reality. Yoko Ono, with <u>Sky</u> <u>T.V.</u>, broadcast a live image of the sky onto her show. On Kawara undertook to merge artistic experience and the arbitrary marking of the moment.

Television turned historical experience into spectacle, and also helped to make the show an experience in itself. On November 22, 1963, the CBS network interrupted the drama *As the World Turns* to cover the news of President Kennedy's assassination. During these "four dark days" people became aware that a television show could *make history*. Dennis Hopper photographed a television broadcasting the historic pictures. As a response to the event, Andy Warhol presented Jackie Kennedy's images in a variety of forms – he was to say of her "performance" during this event that it was "the best thing she ever did!"

The '60s saw the explosion of an advertising society where everything became a product, from laundry detergent to lifestyles, including all sorts of media icons: Brigitte Bardot, Marilyn Monroe, Mick Jagger. The commercial colonization of the world's imagination had begun, and it bore America's colors. In full "creative revolution," advertising, which had just started to understand and control consumers' reflexes, brought the Pepsi generation into the world with its lucrative cult of instant gratification and "with-it" ways. On the new planet Pop everybody was dancing, typewriters were called Valentine, lamps looked like contraceptive pills, and love became one slogan among many, in an infinite universe of signs: LOVE, BRILLO, ESSO, LSD . . .

The once separate poles of popular culture and elitist art drew closer. "Vulgar" cultural products such as advertising, television, and strip cartoons burst forth upon the fine arts. Roy Lichtenstein, the master of Pop, imported printing processes and scenes from comic strips into his painting. For the Italian designers De Pas and D'Urbino, a baseball glove became a chic armchair.

S. A.

media

Media theorist

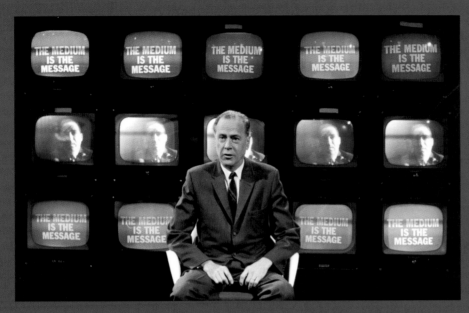

Fig. 1. Marshall McLuhan in an interview on CBC's *Other Voices* aired June 22, 1965.

Q: What were your experiences of the '60s?

A: I was born in 1944. I finished a master's degree at Ottawa and I went to Toronto for my doctorate. I was getting bored stiff in the French department at the end of the '60s, and my wife suggested I go and listen to the lectures of Northop Frye, Robertson Davies, and Marshall McLuhan (Fig. 1). It was a real revolution for me, an intellectual thunderbolt. That's what I wanted to hear. The university world was completely oriented toward the past. In literature the New Novel was barely touched on. **McLuhan lived in the present.** He thought about his time, which he grasped in a subtle and brilliant way. In the end, I worked with him. I studied with McLuhan in 1969. I translated him, I collaborated on some of his work until 1979, then eventually took charge of the McLuhan program at Toronto University.

Q: What is the importance of Marshall McLuhan in understanding this period?

A: He's a sort of intellectual icon of those years, like Herbert Marcuse or Alvin Toffler. He arrived on the scene at the beginning of the decade with *The Gutenberg Galaxy* in 1962, and *Understanding Media* in 1964. From the outset, he seemed to crystallize the spirit of the times, the spirit of these times. McLuhan understood **the fundamental importance of television,** which was starting to have a

profound effect on society. Television's glow washed over everything. It was part of the consumer society, of overabundance, of self-discovery. The '60s were the big rave-up, narcissism, a period of collective navel-gazing. It was also the time of discovering your body, yourself, other people. Television brought out there on the screen that which previously had been inside the private consciousness of the reader. It was above all the period of the cult of youth, intrinsically linked to television. Primarily, this was the first generation founded on television. It lived with it and through it, and was influenced by it into consuming products branded "young." McLuhan discovered and asserted that television, a medium that had appeared beforehand and reached maturity at this time, was the central token of the '60s, and was, to use his famous expression, the Global Village's quintessential instrument.

Q: Today we live in a totally computerized society. What's the difference between a computer and a television from this global point of view?

A: Television delivers a one-way message, in which no negotiation is possible. It's somewhat of a hard sell. McLuhan even said that television is a drug and acts like a drug on viewers. Its colors are the same as the palette of psychedelia. Rock music retains this technology: plenty of wah-wah beat, vibration, lots of emotions and experiences. The computer, on the other hand, empowers the user. What's more, you can plug into the whole wide world. Its music was disco, then house, a binary creation that suits it to perfection. We can multiply the cultural and stylistic parallels and contrasts ad infinitum. **Television's mental age hovers around seven or eight;** *Sesame Street* sums up this television age very well. Furthermore, the Americans, who aren't stupid, managed to colonize the imagination of the whole planet with this instrument in which consumption and good clean fun replaced war, to a certain extent. They offered a new model for society in which people had fun playing with little fluffy animals — a smooth world, with no sharp edges. Television offered people nonstop massage. Thanks to TV, the people in the '60s were readily happy and nice. They bathed in a positive, relaxed, and open mood (Fig. 2).

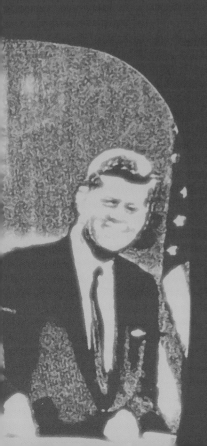

Fig. 2. Diana Rigg (Emma Peel) and Patrick Macnee (John Steed) in Sydney Cecil Newman's *The Avengers*.

Q: You also say that the '60s eventually affected some unexpected areas, the sacred, for example.

A: The '60s are also characterized by Vatican II, an attempt to make in-depth reforms in the Catholic Church. But it also became a "cathodic" church. You could see in embryo what Jean Paul II's power would later achieve. From Jean XXIII and Paul VI, as McLuhan used to say, the power of the image proved more powerful than the person. Moreover, all the great leaders of the decade understood this very well, starting with President Kennedy, who was the first television president (Fig. 3).

Q: Sputnik, the first artificial satellite, launched in 1957, heralded further developments in the '60s, with the conquest of space against the background of the Cold War. What did McLuhan think of the changes introduced by this other technology?

A: For McLuhan, this satellite made the Earth a finished object and turned it into a work of art. It set a limit where there hadn't been one. Once encircled by this human creation, our planet was no longer just a container: it itself became the contents. The sight of our Earth from the moon defined a key moment in the history of human consciousness. From the satellite, personal and universal points of view converged. In addition, ecological movements, aiming to protect the environment, started to grow during this time of raised global awareness.

Q: However, not everything was rosy, far from it. With the Cuban missile crisis, the Cold War, May '68, the Vietnam War, this time also offered counterexamples of agitation, fighting, death.

A: Yes, but the confusion didn't stop the '60s from dancing. Difficult times also make for frivolity. The Belle Époque preceded World War I. For me, the '60s constitute a sort of second Belle Époque, under the threat of guns, and Russians. In moments of tension, everybody kept watch on each other. Then afterward, everyone returned to their TV. And besides, it's actually because they spent every night watching TV that Americans got sick of the Vietnam War. After all, "make love, not war" doesn't seem to me to be such a stupid slogan.

Q: So should we talk of a sort of technological determinism? The '60s were marked by television like the previous period had been by radio or the telephone.

A: Technology doesn't determine everything, but influences so many aspects of life that it ends up by conditioning society. McLuhan's vision remains very clear about this: the social order adapts to its communication medium, but above all it's the personal psychological order that is changed. That's why we can talk of psycho-technologies. In the '60s, the average American started spending three, four, five hours a day in front of his or her little screen. During this time, another consciousness, a para-consciousness, takes hold. Obviously, it's a good idea to ask yourself questions about the negotiation of meaning with this machine, about the organizational strategies that can pass from the mental to the social. I wouldn't be surprised to see appearing soon a widespread system of surveillance, either for health, taxes, or companies and business. Our private identity, given to us and guaranteed by books, will be threatened, like McLuhan also predicted. The '60s have already made us used to the idea that screens are everywhere. They paved the way for this change and threat.

A: From the end of the '70s and throughout the '80s anything that smelled of 1968 really wasn't very popular. But now people are coming back to it. To me, the ideals of this time don't seem so stupid: **share the world, make peace** — that still seems appropriate to me.

Derrick de Kerckhove (Wanze, Belgium, b. 1944) is director of the McLuhan Program in Culture and Technology and a professor in the French Department at the University of Toronto.
A renowned media theorist, he worked for over ten years with Marshall McLuhan, with whom he co-edited *Understanding 1984* (1984). He also coedited *The Alphabet and the Brain* (1988) with Charles Lumsden, and is the author of *La société vidéo-chrétienne* (1990), *Brainframes: Technology, Mind and Business* (1991), *The Skin of Culture* (1995), and *The Architecture of Intelligence* (2000).

Interviewed by Stéphane Baillargeon

Fig. 3. Richard Nixon and John F. Kennedy, televised presidential debate, September 26, 1960.

Q: Screens were also starting to become established in the theater and in the visual arts. From your point of view as a media specialist, what do you think of artistic creation during this time?

A: The role of art is to alter the perceptions of people affected by social and technological changes. Art in the '60s played this role very well. Godard, Ionesco, and Beckett were staged everywhere. Oldenburg and Bob Dylan taught us to rethink the world and our situation in it, even if it meant seeing it in an absurd or playful way. What's more, cultural productions were colored by all sorts of currents that have grown since then: the opening up of the world, universal brotherhood, ecology, sexual equality, etc. The art at this time was characterized by a desire to bring together art and mass culture, high and low art. This trend became more pronounced and still has a profound effect today. Now we talk about software art, web art. The '60s also bequeathed us that.

Q: Your assessment of this decade that you lived through is therefore broadly positive. So how do you account for the strong negative reaction it aroused in the following decades?

Philosopher and art critic

Q: In 1964, in your article "The Art World," you developed the idea that art, with Andy Warhol's paradigmatic <u>Brillo Boxes</u>, has undergone a historical transformation that puts into full light the question of the nature of art itself. Can you describe this transformation?

A: In my recollection, there was no sense that life in the '60s was going to be much different from the way it had been before, when we entered the new decade in 1960. That year, Jean Tinguely staged the event of his self-destroying machine in the garden at MoMA, but that hardly seemed the dawn of a new era. I lived much as I had been living, writing and teaching philosophy at Columbia University, raising children, and keeping up with what was being shown in the galleries like Castelli or Martha Jackson. **I had no interest in aesthetics or the philosophy of art at the time,** since I identified with the analytical movement in philosophy, which regarded those subjects as marginal at best. Nor could I see any way of applying the classical philosophical texts to what

Fig. 1. Roy Lichtenstein, *The Kiss,* 1961.

was happening in art, which was still pretty much Abstract Expressionism. I went on sabbatical leave to France in 1962, where I wrote my first book, *Analytical Philosophy of History,* and it was at the American Library in Paris that I saw a review of Roy Lichtenstein in *Art News.* It showed a pilot kissing a girl (Fig. 1), just the way it would be drawn in a panel from a comic strip. I was astonished that a gallery should be showing a painting like that. I thought at first that it was just a novelty, vis-à-vis "What will they do next?" but it somehow made a deeper impression on me than I realized, for it soon seemed clear that **if such a work was possible, anything was now possible.**

In those days, the main issue in the art world was abstraction versus "the figure," but Pop Art somehow made such controversies seem irrelevant, and in April 1964, when Warhol exhibited the cartons at the Stable Gallery — this including, of course, the *Brillo Box* (Fig. 2) — I felt that something deep had happened. I wrote "The Art World" when I was invited to present a talk on aesthetics before the American Philosophical Association in December of that year. As I said, I had never written about art before, but people on the program committee knew that I had a lot of interest in art. I decided that Pop was raising great philosophical questions, but the main question it raised for me was what made Warhol's boxes works of art when the boxes in the supermarket that looked just like them were mere utilitarian containers, with no claim whatever to that exalted status. How could two things that seemed perceptually indiscernible differ in so profound a way? "The Art World" changed the direction of aesthetics radically.

Q: You made the point, in "The World as Warehouse," that the different artistic movements of the '60s — Fluxus, Minimalism, Pop, Conceptualism — share in common the desire to "transfigure the commonplace."

A: A lot of artists were interested, in the early '60s, in overcoming what was called "the gap between art and life." Fluxus is a case in point, though I knew nothing of Fluxus at that time. My problem was somewhat different. **The *Brillo Box* showed that in one sense, anything could be an art work, even if not everything was.** Philosophers until then believed that it was usually quite clear which things were art works and which were not. The *Brillo Box* showed that this was false — that there need be no perceptual difference between art and something else, which can resemble it to whatever degree. Still, there had to be some kind of difference if the distinction

between art and life was to mean something, and I saw my task as a philosopher to explain what it was. Pop did not develop out of, nor was it merely a reaction to, Abstract Expressionism — it was a sharp change, quite without precedent. That made it a very exciting moment — thrilling in fact. What an opportunity for philosophers!

My own account in "The Art World" was not entirely satisfactory, but the problem was real. I was deeply impressed by the fact that something like the *Brillo Box* would have been historically impossible, at least as art, at a much earlier time; and this led to the view that works of art are rather deeply penetrated by their historical situation. I proposed that something is a work of art if there is a theory in which it is so, and if there is a history in which it fits. There is an art world, which consists of individuals who know the theory and the history; and an artist, who has internalized the theory and the history, requires such an art world. So the historical explanation of Warhol's box is different, indeed radically different, from the explanation of the supermarket box.

So the *Brillo Box* opened up a lot of ideas, not only for me, but for the world. My contribution was the recognition of how momentous the change was, that we were in the midst of a conceptual revolution.

Fig. 3. Zen Master Suzuki Daisetz Teitaro in New York, 1957.

Q: Can you explain why this change occurred during the '60s rather than at any other time in the 20th century?

A: The impulse to overcome the gap between art and life was in part political — artists wanted to overcome the aura, the authority, that had accrued to art, and at the same time make it more meaningful to the "people." They wanted to make it immediately understandable, as understandable as the most everyday things one can imagine. But it was also a sort of philosophical impulse. Philosophers had gotten fed up with the pretense of technical language in philosophy, and metaphysics in thought. The real world of everyday experience was the only world there was; common sense is all we need to find our way about; ordinary language is all we need to talk about it in. What was happening in art paralleled those ideas. And there was a religious impulse too — no one wanted to sacrifice for an afterlife. Our real life was here and now. **Zen had an immense impact on a lot of us,** at least in New York (Fig. 3). Zen found salvation in the most ordinary performances. It found security in everyday things. And finally, I think the impulse came from history, with the

Fig. 2. Andy Warhol, *Brillo Box,* 1969.

recognition that human beings were now in position to blow the whole of things up. Ordinary life, with trees and streets and houses, became all at once precious. It is not incredible that art should express all this. The year of the *Brillo Box*, 1964, was when the Beatles came to America, telling us that all you need is love. It was the year the Freedom Riders went down South to register black voters. Women read Betty Friedan's book about women's liberation. Liberation was in the air. Pop was an international movement. It meant the end of authority everywhere. Warhol's first work in the '60s was based on those grimy little ads that appear as boilerplate in the back pages of the cheapest publications. Ads about fixing ourselves up to look better or to be more attractive — prettier noses, teeth, bodies. It was about finding happiness in this world, in this life. The future was so uncertain. The afterlife was no longer credible. The Living Theater demanded Paradise Now. The Old Left talked about sacrifices for a future society, whereas the New Left believed that we should have the new society in the present.

Nothing that does not explain the youth movement as a whole, globally, really explains anything. American youths did not want to lose their life in a war. They wanted to live their life now. I think we now realize that this revolution did not take place in the Muslim world, which helps explain why there is such a monumental difference between the West and the world in which all that seems to matter is the afterlife.

Q: What effect did politics — the Cold War, the Kennedy assassination, the Vietnam War — have on art?

A: The '60s occurred about halfway through the Cold War, but the latter only began to inflect the American art world late in the decade, through the Vietnam War and its impact on young people. The Kennedy assassination had an immensely disillusioning effect so far as conventional politics were concerned. I really think everyone turned in on themselves, as if people felt they could not do much, one way or another, in regard to the vast large conflict, which was the default condition of political life at the time. That sense of overall impotency changed later in the decade, when the great Vietnam protests took place, when young men really resisted going to war. These protests meant that youth turned against its own government, without necessarily going over to the other side. So alternative lifestyles — and I suppose alternative artstyles — became cultivated. But I don't

think the Soviets provided a viable alternative for many. The Old Left was not something to which the young felt attracted. So alternativity, one might say, was the order of the day. **Patriotism, which came back with great intensity after 9/11, was quite alien to America in the '60s.** The flag, which did play a role in art, always did so in an ironic way. But no one was keen on the hammer-and-sickle either.

As I think of it now, the art movements of the '60s, in America at least, were fairly local. Pop, Minimalism, Conceptual Art were almost entirely "home grown," though they had a sympathetic response in Europe. Europe was looking to America for artistic direction. Soviet-style cultural ideas had no great appeal in Western Europe, but the School of Paris was pretty much finished, and Germany was still finding its way out of the ruins of National Socialism. I think things changed radically at the end of the '60s, with the importation of Post-Structuralist philosophy — Derrida, Foucault, Lacan, and the rest. This got taken up by the critical avant-garde in America, and that was pretty much the end of American autonomy so far as artistic theory went. It was the end of (to use Greenberg's expression) "homegrown aesthetics." The '70s was a very different period, in which Deconstruction reenforced the culture of alternativity in America.

Q: The current-day artworld is a reflection of the "radical pluralist" philosophy you defined, but is contemporary art still in the line of the ideals of the '60s?

A: In the '60s and '70s, it was possible for people to say of various things that they were not art. What was and what was not art was always defined by some paradigm that my philosophy rendered entirely arbitrary. I felt we had to be open to everything. It was, in its own way, a liberationist philosophy of art. There are no movements today, in contrast with the '60s, that saw the last movements of modern times. So each artist is, as it were, on his or her own. But this *mentalité,* if I may be permitted the use of this term, was already in place at the end of the '60s. There is a tremendous desire among the young to become artists, and at the same time a tremendous wish to "make it" in the art market. But young people are more interested in getting their ideas out there than in anything else, and are willing to devote themselves to their art, even if that means finding alter-

native ways of supporting themselves. The seeds of the present were, as I say, planted in the late '60s. The ideal of alternativity — I have no better word — continues to play an important role in artistic consciousness. And I think that those who have become today's curators grew out of this. The curatoriat, as I designate it, is really what defines the art world today, and since today's curators were formed in the spirit of alternativity, emerging artists have a far more hospitable art establishment than their predecessors. The art world, that is, is continually "swept" by a hopeful curatoriat, and the inherently alternative artist — there really is no other kind — has a better chance of recognition than ever before. But — I don't know how to fit this into my picture — there is not today quite the same conception of an artistic career that there was in the '50s. Perhaps I am wrong, but **I don't see careers like Warhol's possible any longer.**

———————————————

Arthur Danto (Ann Arbor, Michigan, U.S., b. 1924) is Johnsonian Professor Emeritus of Philosophy at Columbia University, New York, and a renowned art critic for *The Nation*. His books include *The Transfiguration of the Commonplace* (1981); *The Philosophical Disenfranchisement of Art* (1986); *Encounters and Reflections* (1990), which won the National Book Critics Circle Award for criticism; *Beyond the Brillo Box* (1992); and *After the End of Art* (1995), writings delivered as A. W. Mellon Lectures on Fine Arts at the National Gallery of Art in Washington, D.C.

Interviewed by Stéphane Aquin

Fashion photographer

Fig. 1. Elizabeth Taylor in her dressing room at Cinecittà, Rome, during the filming of *Cleopatra*, 1962.

Q: You were the star of fashion photography in the '60s and you are credited with having revolutionized fashion photography. What sets the '60s apart in the world of fashion photography?

A: It was very wonderful and crazy. I had a big studio with thirty-eight people working for me. We were shooting magnificent models, we did anything that we could think of. **Anything that I wished for or wanted was made available.** If one of my assistants asked, "How could we do this?" I would just say, "I don't know, let's just do it." It was a very magical time, a very creative time. I was very much in love with what I was doing, which was so exotic and romantic and creative.

I was married to a prima ballerina, Allegra Kent. I was a *Vogue* photographer. I had a giant apartment with three children and maids, and another place like this with a swimming pool, and Pop Art on the walls. I had a wonderful Tom Wesselman, which I loved. I had a series of Picassos, a Chagall. So I had a world of my own.

Fashion photography came into the golden ages during the '60s. I was able to get on the page, not just have the photographs *in* the page but *on* the page, take the full space, be the art.

Q: Your shooting sessions of Marilyn Monroe in 1962 were uniquely erotic.

A: You could be sexy in *Playboy*, it worked but it was not very interesting. But in *Vogue*, to be sexy at that time was very avant-garde, very different. And this is what I set out to do with Marilyn Monroe.

When I met Marilyn, she made me feel that anything I wanted to do was okay. That there was nothing wrong. The personal touch with Marilyn was acceptable. She came in and said, "What do you want to do?" Then she took one of those scarves I had with me, which was see-through, put it over her face, looked at me, and said, "You want to do nudes?" I said, "That's a good idea." So she turned to her hairdresser and said, "George, what do you think about doing some nudes?" Right there was my fate, my career was in his hands. And he said, "What a divine idea!" So we went for it. She was the best model I have ever had. Photographing her was like making love.

What's interesting, after Marilyn died, women's liberation took off. When she died, all the angry girls got upset. "Marilyn could not make it." Women are certainly symbols of beauty and sexuality and fertility, and it's always the same fear; women know they have a limited time in which their power is absolute.

Q: Other stars of the '60s — Jane Fonda, Brigitte Bardot, Elizabeth Taylor (Fig. 1) — were equally demonstrative of their sexual charms.

A: Absolutely. I was drawn to those kinds of women. Jane Fonda was beautiful, but she did not have the curves that Bardot and Monroe had. And at the time I shot her she had just come out of an operation, she had her gallbladder removed. This is apparent in the photographs. Nobody has talked about that; it's interesting that there was nothing written on that. But it was totally new to reveal those marks. Women are beautiful by their scars.

Q: What about Twiggy? She incarnated a very different ideal of femininity.

A: Twiggy was unknown in New York when I first met her. I got a call from *Vogue* asking me if I was interested in doing the Paris collection. We flew over and did some tests with the model, named Twiggy (Fig. 2), and all these press people were showing up at the studio trying to get an interview with her. I knew then that if Twiggy came to America, it was going to be a big day. So I called her manager-boyfriend, Justin de Villeneuve, and I said, "What do you think of my shooting a movie if Twiggy comes to America: Twiggy in New York?" He said that would be a great idea. So we did it. And I got the idea of shooting video and mixing it with photography. That was very new at that time.

Q: What was your relation to Andy Warhol and Pop Art? He had the Factory, you had a large studio and a huge store, On First (Fig. 3), where you sold commodities made by renowned artists.

A: I thought Pop Art was wonderful. But I didn't do Pop Art, I did pop photography. I did not think of becoming an artist because I didn't feel that I had anything to say as a painter or any way of doing it. I had lunch with Warhol and I said, "I would like to sell your movies in my store" and he said, "Yeah it's interesting," but I could tell that we would never do it. He would just suck it all in and then would do it himself. So he left, went back to his studio, and this girl Valerie Solanas walked in and shot him. Right after lunch. He was shot.

Q: The late '60s were a troubled time. Many artists got involved in the anti-war movement. Did this have repercussions on your work?

Fig. 3. On First sign, New York, 1968.

A: It was becoming very dangerous. A group of people used to come to me and say, "We are of the revolutionary movement. Would you design posters for us?" They said, "All you have to do is take pretty pictures." I said, "No, I don't want to get involved with this stuff." It was not for me, I'm not a revolutionary, I just take pictures and that's fine. And I prefer them to be beautiful.

A New York fashion and advertising photographer, **Bert Stern** (Brooklyn, New York, U.S., b. 1929) worked during the '60s for magazines such as *Vogue*, *Esquire*, *Look*, *Life*, *Glamour,* and *Holiday*. He photographed Marilyn Monroe's last session in June 1962 (*The Last Sitting*, 1992). Bert Stern is also the director of a critically acclaimed film on the Newport Jazz Festival, *Jazz on a Summer's Day*, 1959.

Interviewed by Stéphane Aquin

Fig. 2. Twiggy photographed for *Vogue*, 1967.

Filmmaker

Q: Agnès Varda, how did you live through the '60s?

A: How did I live through the '60s? As a living person, a filmmaker, a woman in love, a citizen, etc. I was in my thirties in the '60s.

Q: Your films show that you were aware of what was happening, whether it was the war in Algeria in <u>Cleo</u>, or black Americans' revolt in <u>Black Panthers</u>. Were you a politically committed filmmaker?

A: The words "politically committed" and "militant" in no way correspond with my work as a filmmaker. I've never belonged to a group or party. I remember that song by Renaud, "I'm a bunch of idiots all on my own"! But the troubles, injustices, violence, and fear in the world concern me. In 1961 I invented a meeting between Cleo,

Fig. 1. Movie poster for *Cléo de 5 à 7* (Cleo from 5 to 7), 1961.

who is afraid of cancer that kills, and a soldier who is afraid of the Algerian War that kills (Fig. 1). He says clearly that such a war has no meaning for him. It was just a discreet way of bringing out the great conflict born out of colonialism and racism. If I'd had the courage, perhaps I would have chosen to be "enraged" rather than "engaged."

I saw the Cuban revolution in its early days, in 1962, when it was bursting forth and making new discoveries. I took hundreds of photos. I made a film to recount what I saw and the music I heard. I was also part of think-groups on the Vietnam War. It greatly concerned us, but we felt completely protected from it because we were *Loin du Vietnam* (Far from Vietnam). But my short film wasn't included in the final editing.

And then I was a woman and a feminist. Of course I've stood shoulder to shoulder with other women, I've marched in the streets, I demonstrated about the "Bobigny Trial," but it wasn't until 1976 that I made *L'une chante, l'autre pas* (One Sings, the Other Doesn't), a feminist "musical." In the United States, in the '60s, there were women's studies in the universities and I met some very radical women there before meeting any in France.

When blacks were demonstrating against the imprison-ment of one of their leaders, Huey Newton, Tom Luddy arranged for me to approach and meet them in San Francisco. I filmed their lives, their rallies, their speeches, and their training for *Black Panthers,* a docu-mentary. (People often ask us for extracts for more general documentaries on black history.) It was Tom, too, who helped me meet a marvelous man and jovial painter who was my old *Oncle Yanco* (Uncle Yanco), a rebel like lots of young people, anti-establishment and anti-Vietnam War.

I've mentioned all that to say that most of my films about committed people — whom I deliberately chose to film rather than others — are often the result of chance meetings during my travels and private life, and also the result of my political opinions. (Richard Roud remarked among other things that at the time of the New Wave, Alain Resnais, Chris Marker, and I lived on the left bank of the Seine and had pronounced left-wing tendencies, so he distinguished us from other filmmakers by inventing a category for us, The Left Bank.)

I want to be balanced when I talk about my work in the '60s. I remember suggesting in a film that the desire for happiness has got nothing to do with the social laws of marriage. It was *Le Bonheur* (Happiness) (Fig. 2). It followed from this that each of us (and in this film, each woman) remains a unique person, but replaceable (Fig. 3).

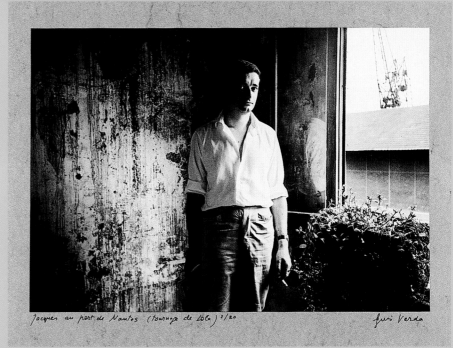

Jacques au port de Nantes (tournage de Lola) 2/20 *Agnès Varda*

Fig. 4. Jacques Demy photographed by Agnès Varda during the filming of his movie *Lola*, Nantes, 1960.

Seule, une femme pouvait oser faire ce film

MAG BODARD présente

Le Bonheur

Écrit et réalisé par
AGNÈS VARDA
avec JEAN-CLAUDE DROUOT sa femme CLAIRE et leurs deux enfants
et MARIE-FRANCE BOYER
Une production Parc-Film distribuée par COLUMBIA-EASTMANCOLOR VISA MINISTERIEL N° 7574

Fig. 2. Movie poster for *Le Bonheur* (Happiness), 1964.

Fig. 3. Agnès Varda and Marie-France Boyer on the set of *Le Bonheur* (Happiness).

You have to place these radical ideas in their time, that's to say, some four years before the explosion of ideas, behavior, and moral options whose focal point was Paris, in May '68. I missed this social explosion; we were in Los Angeles among the flower children and the draftees who were burning their draft cards.

The commitment that I've always maintained is toward the cinema — each time making a film that is sensitive and full of life, sometimes demanding audiences' concentration — rather than making a career out of films. My natural good humor has done the rest.

Remembering the '60s is first of all revisiting the laughter and nonsense, my lovely years with Jacques Demy (Fig. 4), shootings with lots of creativity, the songs in our movies that we used to hum, especially by Demy-Legrand, the surprise successes that we had, and also the word games and the traveling, the vacations with Jean-Luc [Godard] and Anna [Karina], the meals we shared, the card games and the mini-dramas. Quite simply our lives as filmmakers in the '60s.

Q: Speaking of the cinema, you blithely upset its conventions. What was your connection with the New Wave?

A: I'd never seen films, or only a few, and hadn't been to film school, so I had to invent the cinema when I made my first film, *La Pointe courte* (1954). In the opinion of other people, it turned out to be quite revolutionary. My battle in cinema, from day one, was to set fairly strict limits; for example, refusing to make scenes that were psychologically truthful (I'd written some literary dialogue and asked the actors not to act it, but only to say it), inserting bits and pieces from other people's lives, introducing the documentary idea into fictional films, as it were, or choosing a musician, Pierre Barbaud, who was fascinated by the dodecaphonic scale. Later on, he even worked "with" a Bull computer, orchestrating the score for *Les Créatures* in 1966. I was also lucky to have met George Delerue in 1957 for *L'Opéra Mouffe.* Not all my interests as a filmmaker are the same as those generally attributed to men in the New Wave (I say men, moreover, because I was the only woman among them).

As you know, it was Françoise Giroud who invented this expression New Wave to describe the filmmakers who emerged at the beginning of the '60s. It was a broad term; these filmmakers didn't have a common set of principles or a program, for example, like the Dada group that started off the Surrealist movement. There were, of course, the group of critics writing for *Cahiers du Cinéma,* and who became filmmakers in their turn; they wrote criticism and/or theory. All the other filmmakers, the independent and experimental ones, were given the same label without having any connection with *Cahiers du Cinéma.* Myself included.

Q: Where can you see the heritage of the '60s today?

A: We have seen the influence and impulses created by the New Wave in the cinema of Central Europe, in Brazil, and even in America. Afterwards, some of the attractions and influences were visible, some were not; it was even rejected in some cases. Nowadays, we can see a resurgence of "New Wave-style" filmmaking, but rarely with the good feeling that went hand-in-hand with the totally new possibilities offered in the '60s (faster negative film, lighter cameras, filming in natural settings). **Filmmaking in those days had a new, youthful vision.** It's amusing to note, by the way, that some of the New Wave veterans haven't given up. Chabrol, Resnais, Rozier, and Rohmer are still filming, more or less regularly — and myself. Nowadays, what's interesting and new is the emergence of filmmakers who are exploiting digital cameras and their possibilities, but as Prévert has a theater manager say in *Les Enfants du Paradis* (The Children of Paradise): "New? What does new look like? . . . New . . . It's as old as the hills, new."

French filmmaker **Agnès Varda** (Brussels, Belgium, b. 1928) started her career as a photographer with the Théâtre National Populaire during the time of Jean Vilar before launching into film direction with *La Pointe Courte* in 1956. A series of short and full-length films followed, including *Opéra Mouffe* (1958); *Cléo de 5 à 7* (Cleo from 5 to 7) (1961), for which she won the Prix Méliès; *Le Bonheur* (Happiness) (1964); *Oncle Yanco* (1967); *L'une chante, l'autre pas* (One Sings, the Other Doesn't) (1977); *Sans toit ni loi* (Vagabond) (1985); as well as a tribute to her late partner, Jacques Demy, *Jacquot de Nantes* (1991).

Interviewed by Stéphane Aquin

208

Victor Vasarely

Vega-Nor

1969

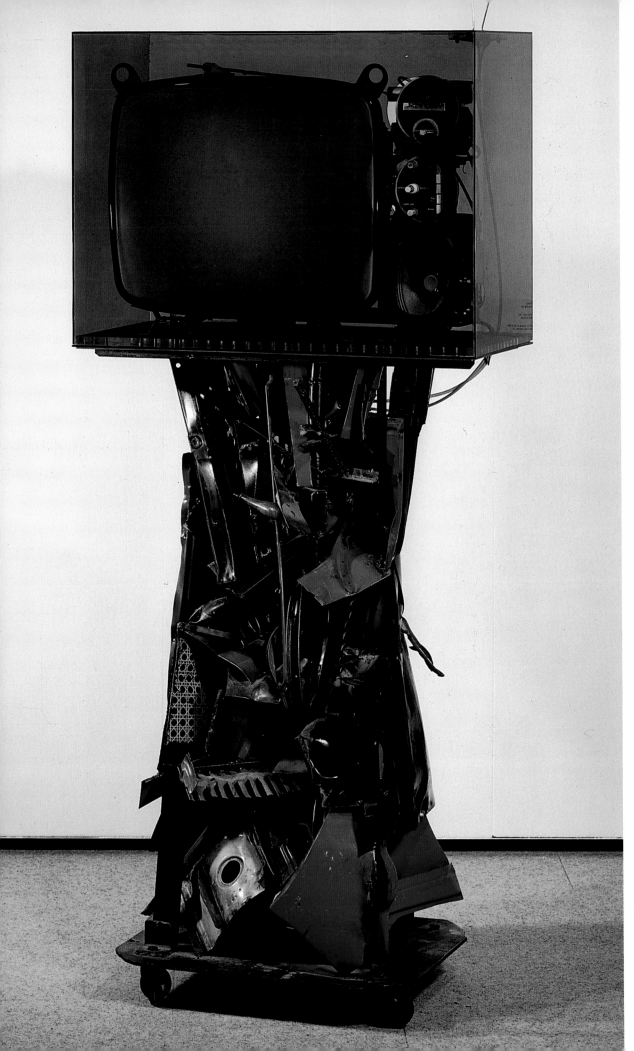

33
César
Television Ensemble
1962

83
Kahn & Jacobs
Model of the Kodak Building from
the 1964 World's Fair, New York
about 1963

139
N. E. Thing Co.
(Iain and Ingrid Baxter)
ACT No. 107
1969

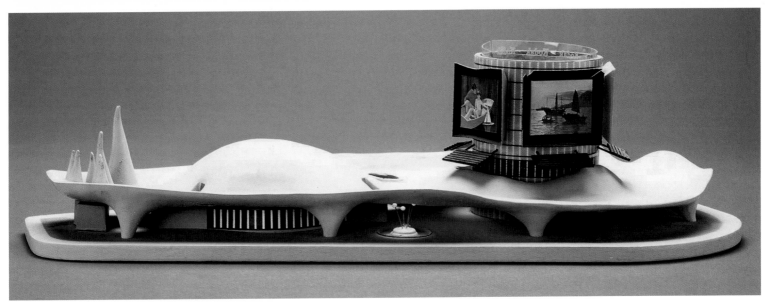

83

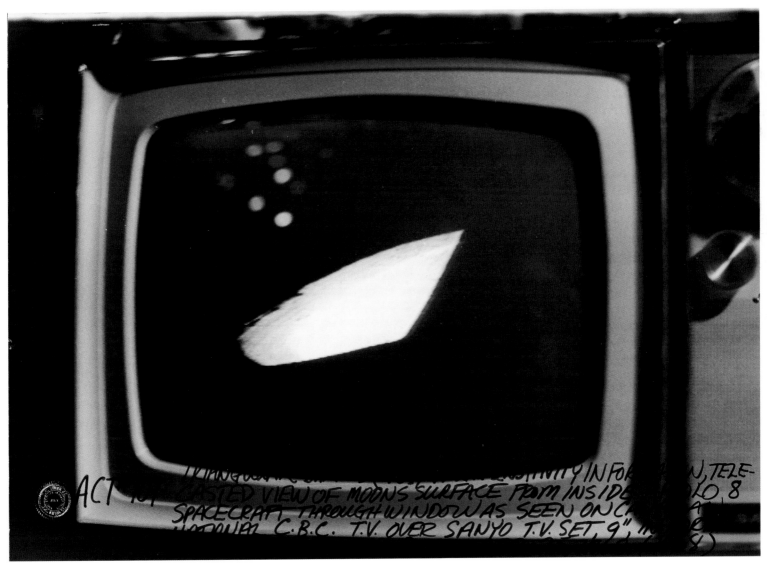

139

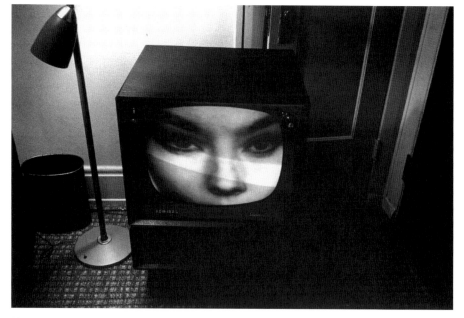

195

14

15

58

143

106
Walter Lefmann
Ron DeVito
Time Dress
1967

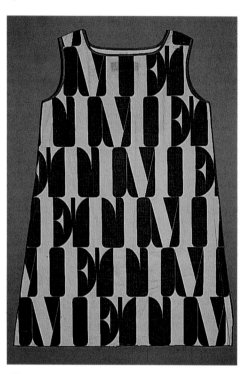

106

84, 85, 86

84
On Kawara
MAR.13.1966
from the series TODAY
1966

85
On Kawara
OCT.6.1967
from the series TODAY
1967

86
On Kawara
30JUN.68
from the series TODAY
1968

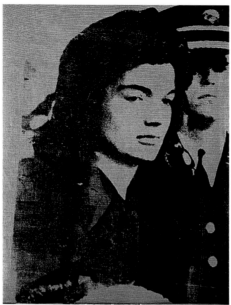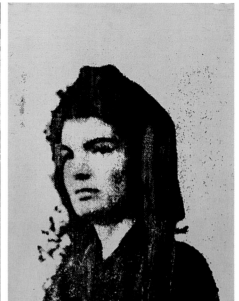

216

75

59

216
Andy Warhol
Jackie
1964

75
Dennis Hopper
Kennedy Funeral
1963

59
Lee Friedlander
Monsey, New York
1963, later print

222
J. Fred Woell
November 22, 1963 12:30 p.m.
1967

222

52

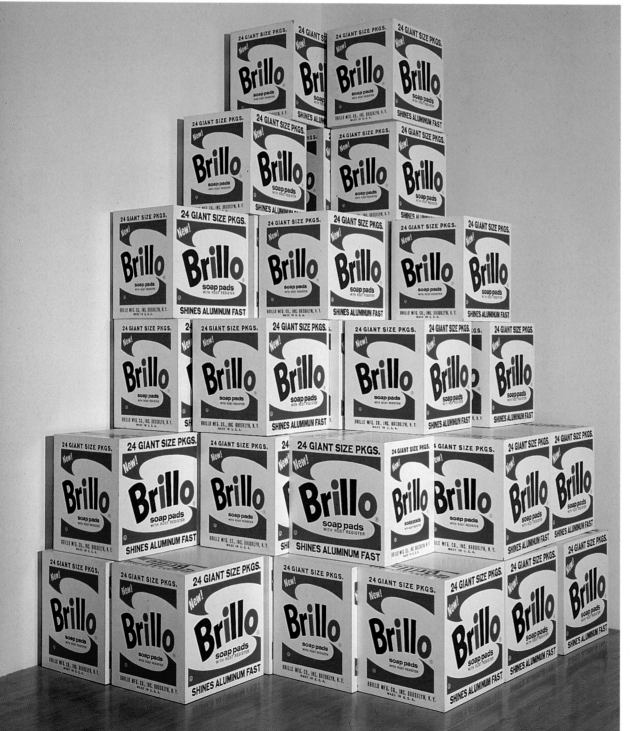

52
Öyvind Fahlström
ESSO-LSD
1967

215
Andy Warhol
Brillo Boxes
1964; version 1969

123
Cildo Meireles
*Insertions into Ideological
Circuits: Coca-Cola Project*
1970

215

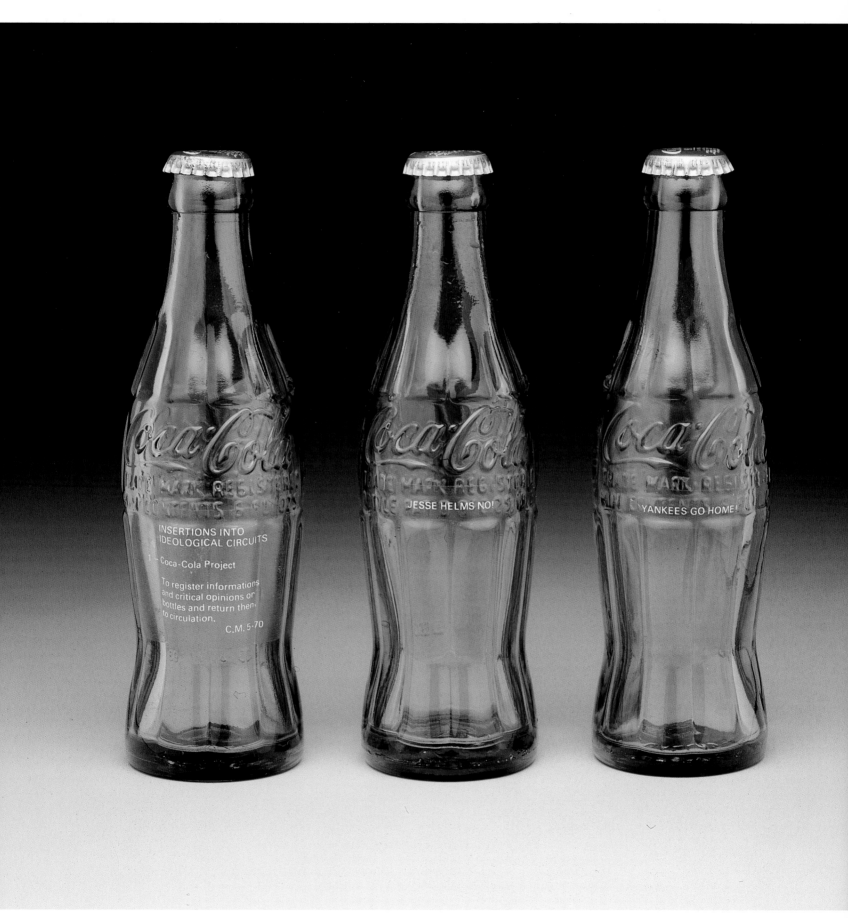

INSERTIONS INTO
IDEOLOGICAL CIRCUITS

1 — Coca-Cola Project

To register informations
and critical opinions on
bottles and return them
to circulation.
C.M. 5-70

JESSE HELMS NO!

YANKEES GO HOME!

9

Richard Artschwager
Counter II
1964

141

Claes Oldenburg
Pepsi-Cola Sign
1961

7

Arman
Warhol's Garbage
1969

141

9

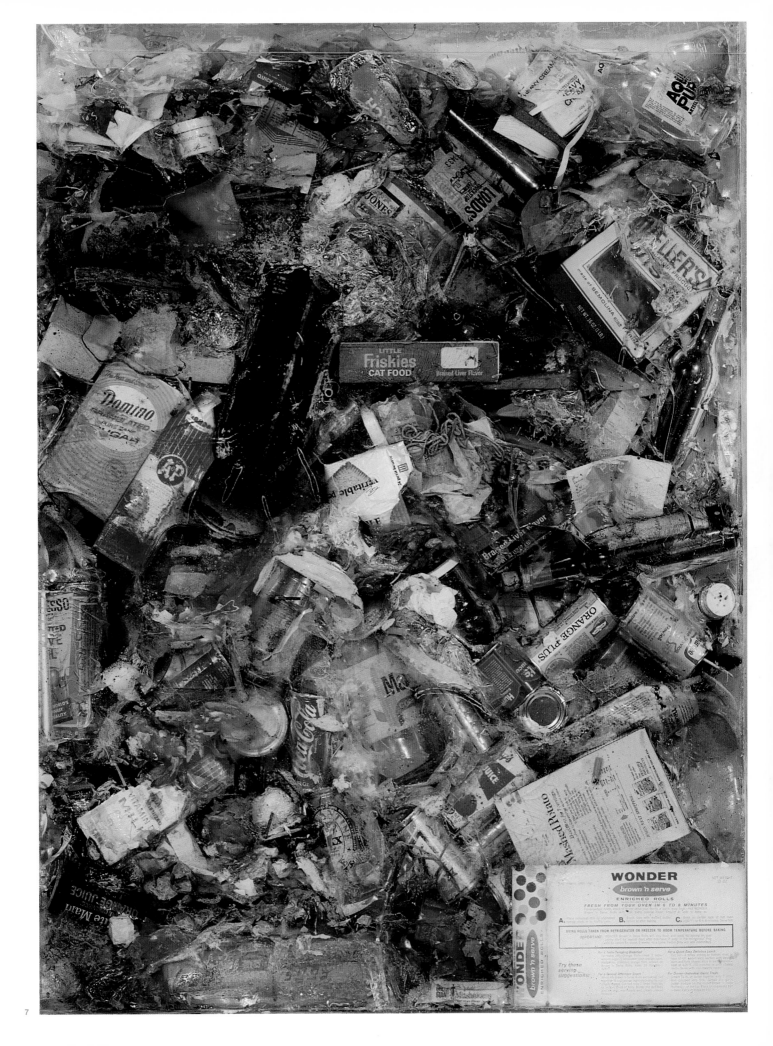

7

102

102
Gerald Laing
Brigitte Bardot
1963

36
Christo
Wrapped Magazines on a Stool
1963

196
Bert Stern
Marilyn Monroe
1962

69
Richard Hamilton
My Marilyn
1965

36

196

69

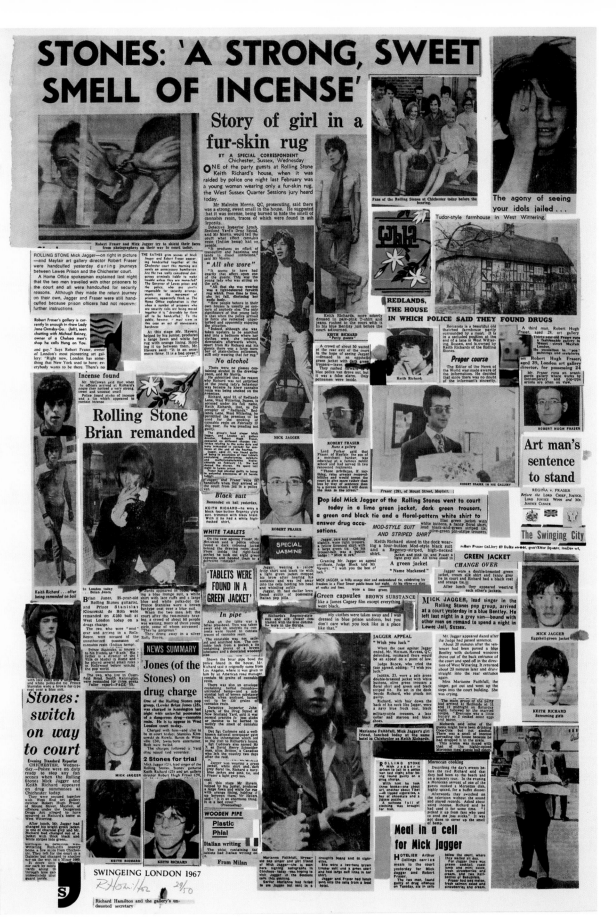

70

Richard Hamilton
Swingeing London 1967
1968

112

Richard Lindner
Rock-Rock
1966–1967

112

57

177

57
Robert Freeman
A Hard Day's Night
1964

177
Niki de Saint-Phalle
Camel
1966–1967

47
Jonathan De Pas
Donato d'Urbino
Paolo Lomazzi
Carla Scolari
Joe Sofa
1970

47

109

109
Roy Lichtenstein
Vicki
1964

78
Robert Indiana
LOVE
1966–1998

31

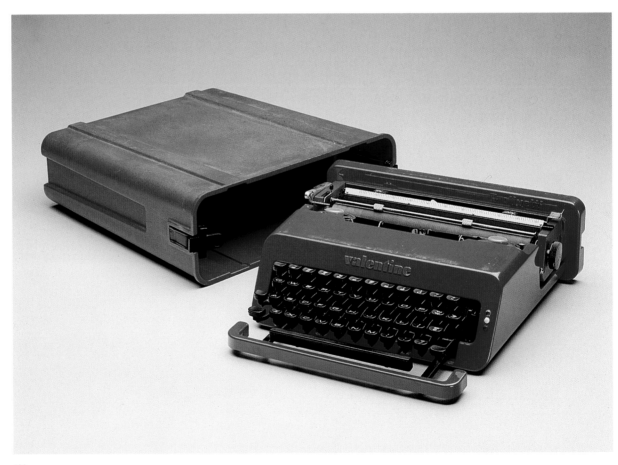

190

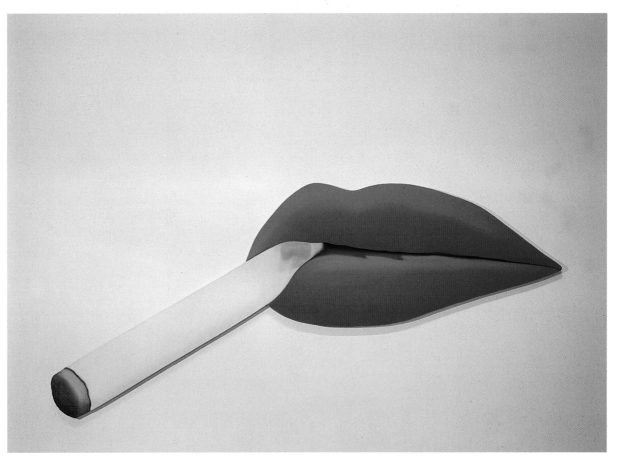

217

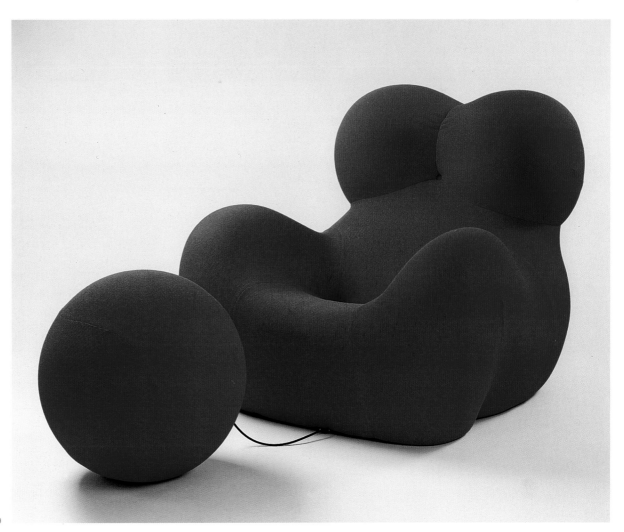

149

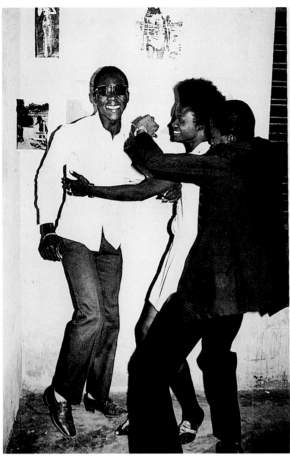

185

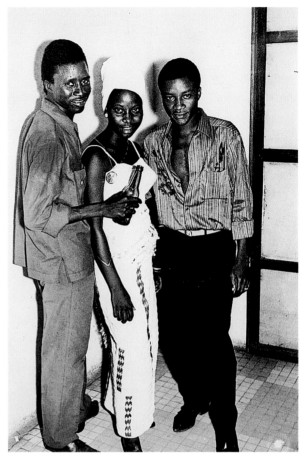

184

49

42

221

120

101

During the nights of August 12 and 13, 1961, the Berlin Wall started going up. The Global Village was torn in half. On one side was the egalitarian utopia of the communist regimes; on the other, the "free world" of the capitalist societies. The '60s became the stage for an ideological polarization of unprecedented size, whose successive crises, sometimes shown live on television — the suicidal trial of strength between Kennedy and Khrushchev over the presence of Soviet missiles in Cuba in 1962 — shook the world like so many electric shocks, creating insecurity in Western minds, in contrast with the optimism of technology and business.

One of the more ominous consequences of this confrontation was the regime of artistic censorship imposed by Khrushchev in 1962, after his visit to the sadly famous exhibition at the Manege, marking the division between "official" and "unofficial" art. While communist countries from then on showed nothing but propagandist art, Western artists reacted forthrightly to the

new world disorder. In a gesture of rare symbolic strength, Niki de Saint-Phalle fired a rifle at the Siamese twin faces of Kennedy and Khrushchev.

Political confrontation spread beyond the confines of the political conflict between the two superpowers, setting aflame countries that until then had been docile. Africa rose up against the colonial regime, sometimes bloodily, as in Algeria, at war with a divided France. In Paris, while the *Tel Quel* group argued for "disengaged" literature, others were joining forces for the liberation of the colony. Jean-Luc Godard made *Le Petit Soldat* (The Little Soldier), a film about Algeria and torture; Jean-Jacques Lebel called repeatedly for rebellion.

European artists, moreover, blazed the trail in this direction. In the United States it wasn't until the civil rights movement that the artistic community involved itself politically. America was being torn apart by its anti-racism demonstrations, reactionary violence, and bloody riots. Andy Warhol, one of the first artists to react, used silkscreen prints to replicate newspaper images of the racial violence (*Race Riot*). At the other end of the artistic spectrum Norman Rockwell pleaded for fraternity with *Murder in Mississippi*. In 1969, a year after the assassination of Martin Luther King, Jr., while the Americans were walking on the moon, the black artist Faith Ringgold revealed, with *Flag for the Moon, Die Nigger*, the other side of the American dream.

However, no conflict mobilized artists across the world more than the Vietnam War, the "first televised war." On June 27, 1965, the group Artists and Writers Protest Against the War bought a page in the *New York Times* entitled "End Your Silence." But it wasn't until the massive intensification of the American offensive in 1967 that the protest movement against the war really became wide-spread. In New York, a demonstration called Angry Arts Week took place from January 29 to February 5. Condem-nation of the war even found an echo in the decorative arts with Howard Kottler's militant ceramics and with artists belonging to the Minimalist movement. Dan Flavin created a cannon with red neon lights and called it *Monument 4 for Those Who Have Been Killed in Ambush*.

In 1968 the whole Global Village seemed to be on fire, in Paris in May, but also in Mexico City, Tokyo, and Prague, whose "spring" was to end in August with the arrival of Soviet tanks. Moving beyond politics, the revolt was to encompass all aspects of social life. Carried along on this demographic wave, the idealistic and impatient baby boomers wanted to replace the "old order" with a "new world." Among the important battles fought by the counter culture was the redefining of relationships between men and women. The sexual roles inherited from the rule of men were called into question. Michelangelo Pistoletto wrapped Venus in rags, Otto Muehl buried her. Martha Rosler laid into the cult of physical beauty. Others, such as Carolee Schneeman and Joyce Wieland, extolled female sexuality liberated from male power. Feminism was born. Homosexu-ality came out into the open. David Hockney painted two boys clinging to one another, while Diane Arbus turned her lens on the world of transvestites. Sexual categories became blurred. Yves Saint Laurent dressed women in striped suits, Pierre Cardin covered his neckties with flowers.

The final outcome of this period of unending conflict and incomplete liberation was a divided, fragmented, pulverized subject, prey to uneasy and morbid introspection of which Chuck Close's overblown portraits are a striking expres-sion. Paul Thek put wax representations of human flesh in glass vitrines, or made multiple images of another artist, his friend Peter Hujar. Behind the Iron Curtain, Leonid Lamm painted anonymous, indistinct humanity, reduced to a series of pronouns: *I, You, He, She*.

S. A.

Journalist and politician

Q: What are your memories of the 1960s, and May '68 in particular?

A: Immense happiness and a breath of hope. Indeed, at that time, we had the feeling that the future belonged to us. We took hold of our own destiny — at any rate, we had the impression that we could control it. It's what carried us along. So that's why I think back on those times with great joy. But without nostalgia, though. I don't want to go backward, make time stand still, turn the clock back and start all over again. Simply put, the '60s, particularly May '68, was an exhilarating time in my life (Fig. 1). It wasn't the only great time in my life, but one of the most fabulous, without question.

Q: What prepared you for these great times?

A: Nothing had prepared me to become one of the players in this time of change. Through an accident of history I found myself, very young, in the forefront. I had ideas, a big mouth, a knack of saying what we all were thinking thirty seconds before everybody else, a way of being and acting that suited the needs of the time. So I became the loudspeaker for this movement. But you can't say I was predestined to become a "historic figure" of May '68.

Q: You say "movement," "change," while others say "revolt," even "revolution." Was it all of those things at the same time?

Fig. 1. Daniel Cohn-Bendit at the Sorbonne, May 6, 1968.

A: It was a very profound revolt that had revolutionary tendencies because **France had then experienced the most serious national strike in its history**. At the same time, it was a very cultural revolt, a desire to reinvent life. That's what causes interpretations and analyses to constantly swing between "party" and "revolt," from "springtime" to "revolution" (Fig. 2).

Q: What do you mean by "cultural revolt"?

A: I use this term in a very broad sense. The changes that were put forward, and that came about to a certain extent, affected the very concept of life in society and as individuals. So the change involved traditional culture;

Fig. 2. *Le Pavé,* handout No. 1 produced by the Comité d'Information Révolutionnaire, May 1968.

how to be, how to love, how to look at relationships, talk to one another, etc. Traditional analysts, of the left and right, have a traditional idea of revolution — the American Revolution, the French Revolution, the Russian Revolution — there has to be blood, deaths, atrocities committed by both the old and new powers. Not for us. In May '68, a new way of making things move was set in action, a way that affected how you should be, freedom. This new revolt was also characterized by its new methods. We were the first television generation and we integrated it into our movement. Images from the outside world reached us every day. The global perspective was part of the way we planned our action. **We embodied Marshall McLuhan's phrase about the "Global Village."**

Q: What was the connection with art in this "cultural revolt"?

A: Everybody brought what they could to the movement. So artists, art students, brought an element of aesthetics, which can be clearly seen in the May posters. However, I would point out that this artistic movement remained fairly traditional in comparison with

our desire to be radical in our aesthetic of life. Frankly, some of the works were more evocative of 1920s and 1930s movements, making pastiches of workers' schools, Agit-Prop, etc. In fact, the art that had the biggest effect on us was rock music. The Americans' influence is there, especially the Beat Generation, who had been fascinated by the idea of revolt in rock and who'd talked about writing poetry about everyday life.

Q: It's also been said that this period gave unbridled license to subversion, to defiance of all forms of authority.

A: It's true that we were radically defiant in our words and behavior — but if you compare that with what we saw happening later, then we were actually very well behaved. At that time, at that particular moment, we were really the reinventors of defiance as a political act, a bit like the artists in the first half of the 20th century who had created a radical strategy of defying traditional aesthetic standards.

Q: What's left of this spirit of revolt? What's the heritage of the '60s?

A: I'd say that socially and culturally we won, but politically, we lost. And that's fine. We also wanted society to be self-governing: local councils, workers' councils, etc. All that failed. But socially and culturally we won some decisive victories: life has been revolutionized at its existential base, at its very foundations, and the world isn't like it was before. You should look for the essential heritage of the '60s in that, in the new freedoms of action and being that it gave to individuals. That ranges from the recognition of the most varied types of sexual orientation to criticism of prevailing morals.

Q: You've recently been criticized for having personally advocated certain sexual excesses. Did the cultural revolt therefore go too far in certain respects?

A: As part of this radical nonconformity we wanted to include the sexual. At the same time, this radicalism led us to push the pendulum too far in the other direction. **We acted as if the idea of anything goes was always preferable to the old standards.** Now things have returned to where they

A: The movements in the '60s were very Promethean. The ecology movement therefore signals a break with the traditional left's idolatry of industrialization. At the same time, you can find in the loose conglomeration of today's left, in the coalition formed around the Greens, roots that stem from this old period. So I'd say that I'm both part of the current and part of the breakaway. I'm totally integrated into my society, while being different.

Q: The generation of '68, your generation, is now in power. So are the baby boomers still changing the world?

A: I challenge this type of generalization. In current protest movements it's the young people of today who are leading the new revolt. The drama of my generation is not to have grown old and to have achieved power. Getting old is a drama for everybody. Taking power is a choice.

were. Freedom of choice exists, but society has reintroduced a certain amount of discretion, decency, which I think is necessary after the excesses that resulted from nonconformity. We're living in a time of stabilization.

Q: In your documentary series, Nous l'avons tant aimée, la révolution, in 1983, you followed the careers of other former leaders of the movement throughout the world, the United States, and Brazil, to show that in the end some of them didn't stay true to the ideals of their youth.

A: The desire of some people to change their lives doesn't prevent their lives from being sad or disappointing. There was a great deal of joy. Some people weren't able to cope when the ecstasy was over. There were suicides, extreme sadness. That's part of life. But anyway, you can't put down love on the pretext that couples who've been madly in love eventually split up or tear themselves to shreds. Great love can lead to great despair, but you shouldn't reject it when it comes along.

Q: You've continued in the path of socio-political action: you're president of the Greens in the European Parliament, of which you've been a member since 1994. What is the connection with your ideals when you were young?

A journalist and politician, **Daniel Cohn-Bendit** (Montauban, France, b. 1945) lives in Frankfurt. Elected to the European Parliament in 1994 under the banner of the Bündnis 90/Die Grünen, he is co-president of the Greens/Free European Alliance in the European Parliament. Daniel Cohn-Bendit was a spokesperson and leader of the May '68 revolution. He is the author of numerous works, including *La révolte étudiante* (The Student Revolt) (1968), *Nous l'avons tant aimée, la révolution* (Did We Ever Love That Revolution) (1987), *Heimat Babylon: das Wagnis der multikulturellen Demokratie* (Our Homeland, Babylon) (1992), *Une envie de politique* (A Desire for Politic) (1992), and *Xénophobies* (Xenophobias) (1998), as well as the film *C'est la vie* (That's Life) (1991).

Interviewed by Stéphane Baillargeon

Q: You were born in Nigeria and grew up there in the 1960s.

A: I was born in 1963 in a small town called Calabar on the border between Nigeria and Cameroon. I grew up in eastern Nigeria in the city of Enugu. Nigeria's population today is estimated at 120 million, and Enugu's is 5 million. My family moved to Enugu toward the end of 1970 after the Biafran civil war, which lasted from 1967 to 1970. **The war remains such a trauma in the psyche of many Igbos.** Though more than a million people died, remarkably there still hasn't been a meaningful national discussion about the war's effects or even a proper national historical recognition of its tragedy, which continues to haunt Nigeria. My position is that part of Nigeria's larger problem today is its inability to establish a representative public memory for those who died in the war.

Q: How was that dramatic reality related to the difficult, complex process of decolonization?

A: When we think of the map of colonial powers, we must realize how the imperial concept of governing colonies is really inscribed in a brazen act of social engineering, in a sense inventing from scratch new values, systems, rules, memories. In the context of civil war that much was already clear: the collision of memories was supported or divided by rules, systems, and values. Decolonization always seems to me to be an attempt to reorganize the rupture produced by colonialism in what Mudimbe has called the geography of memory in Africa. I'm using "memory" in a fairly broad sense, not just the phenomenal but a more historical sense. Obviously, like most children growing up in the '60s, I never imagined myself as decolonized; we were, in our immediate experience, modern. It was never a choice between tradition and modernity, both were normal everyday experiences that governed my upbringing. Certainly my parents' generation in the 1940s and 1950s had a greater awareness of the social world of the colonial state. I was made painfully aware of what it is to be a modern subject, that to be post-colonial really means to be introduced to the world differently only upon moving properly to the West. The tensions were immediately apparent. It seemed at the time that in order to be a properly modern subject you had to acquire the tools of modern subjectivity, which had everything to do with the West. But in this regard I had no sense of crisis about who I am; I grew up in a household that had everything you had elsewhere. I didn't grow up with a feeling of being apart, because the unresolved tensions were so apparent. I saw that the postcolonial was fully enmeshed with a number of ambiguities, such as the desire to capitalize on the promise of modernity.

Q: You went to a British public school, negotiating various aspects and absurdities of a British education in Africa. But in the '60s there was a very important modernist renaissance in Africa, a culture that could count writers such as Chinua Achebe, Wole Soyinka, politicians such as Kwame Nkrumah, Patrice Lumumba, and others. How important were these figures to you?

A: It was not so much a British public school, but its equivalent in Nigeria; one of those interesting places where the domestication of promising "native" souls was engineered. I concede it was a beautiful school, properly set in nature and isolated from the rest of the town, the better for the proper contemplation of one's state in life. Writers like Chinua Achebe and Léopold Sédar Senghor were very important, very formative. My generation was the first to begin to study postcolonial literature as part of its curriculum, alongside Chaucer and Shakespeare. It was possible to read Soyinka next to Hopkins, or Achebe with Joseph Conrad. I am interested in how the colonial text came to be domesticated within the postcolonial context, so the experience of reading postcolonial writers was very enlightening. Students of my generation went to school armed with a sense that they were absolutely not the victims of history. We were all going to produce a new kind of literature, a writing without any complexes.

postcolon

Writers and statesmen like Senghor, Achebe, Lumumba, Nkrumah presented important models for articulating the past, present, and the future — critical models from which we could make our world. The broad humanity of our reality, which came out of postcolonial literature, was first defined and articulated by them, and was not based on mimicry, nor on separation; it was part of the vitality of the soul of the African in the 20th century. It was not an invention, it simply had to be constructed into an interesting narrative.

Q: Beginning in the '60s, Western culture has been on the defensive. Its presumption of universality of values has been challenged by the rise of cultural particularisms. How do you view this conflict between the Western "canon" and the emerging postcolonial discourse?

A: We have to see the postcolonial world as some kind of reckoning with history that has yet to happen. I don't believe that it is entirely up to Africans to build this postcolonial world. The postcolonial is fully imbricated in the colonial project. To believe that the British, French, Spanish, and Dutch are not part of the post-colonial historical framework is really to miss the point. The postcolonial is implicated in that which governs the global. It is a field of recognition, a field of relations, and I think none of this sits outside the historical conscious-ness of the Western world. **I cannot agree at all when people talk of the postcolonial as an else-where,** as a distant horizon into which the West can peer every so often during exotic holidays.

Moreover, as I have often claimed, Westernism as such is the totality of the experience of the modern subject. I see that in institutional terms more than in dialectical, cultural, or geographical terms. Juridical models and economic models express "truth" through the ideology of capitalism, of democracy, of the rule of law, and so on. These are all inheritances of the postcolonial state, from Africa, to Asia, to Europe; such concepts are all-encompassing. In that sense there is a lot of thinking to be done in order to be able to decipher the contradic-tions that lie at the heart of what we designate as the postcolonial, for part of the geography of postcolonial memory spills into and overflows the Western canon. Toni Morrison showed us this in her brilliant study *Playing in the Dark* and Achebe in his critical dissection of Conrad's *Heart of Darkness*. These works helped me understand how the Western imagination conceives of the African other as the blindspot of modernity.

Q: In the '60s, what perception was there in Western culture or colonial culture of the literature and the artistic production that was coming out of Africa?

A: The creativity of people who made art in Africa was never recognized by colonialism. Far from it. What is often called traditional in African art is work that supposedly has no connection to modernity; it is in fact consigned to premodernity even though it may be 20th century. The only time in which this African modernity had any value to the West was when it was relativized with regard to the worldwide appropriation of its forms: primitivism, affinities of the tribal with the modern, and other such terminology. Africa always had to be coun-terposed to that which serves as a foil for its further consignment to the ethnographies of Western power. As we all know, all power functions in direct proportion to the exclusions it makes and the particularities it absorbs.

For me the modern has to do with the artist being aware that the work has a destination that is already fully inscribed within an institutional practice, and between the institution and other social conversations. Such an awareness brings with it a sense of resistance, a differ-ent kind of cultural-political subjectivity in the frame-work of the depersonalization wrought by colonialism.

The Negritude movement, for example, began to ques-tion the outrageous idea that there is no universal humanity to be found in the black subject. The Negritude movement was founded, incidentally, by the inevitable conjunction between Africa and the diaspora:

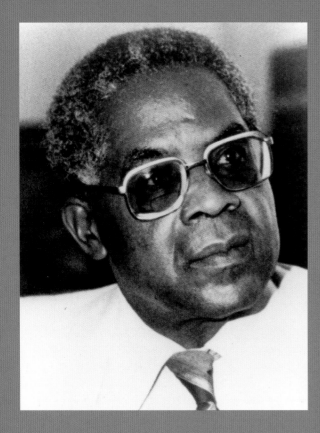

Fig. 1. Aimé Césaire.

native-born Africans, and Africans born in the context of slavery. The work of Aimé Césaire (Fig. 1), born in Martinique in 1927, is seminal in this context. His long poem "Cahier d'un retour au pays natal" (1947) was the genesis of the Negritude movement. His 1950 essay "Discourse on Colonialism" was an important marker. I would like to think of the works of this group of writers within modernism as a sort of asynchronic modernism, that reoriented and reinvested the symbolic capital of modernity.

This modernism does not come from a synchronism with the West but has a different temporal relationship to its own set of values, which can be found inside its texts or inside a particular struggle, or based on a certain type of critique or judgement. You have these two notions: art that continues in spite of there being "no art" in Africa, therefore it has to be called traditional; and art that has its own humanity and universality by the formalization of its content. On that account many African artists were tried and found wanting and therefore had to suffer a double expulsion from the canon. They could not be included in the catalogue of tradition because they wanted to be modern, and they could never really be modern because they could not be recuperated into the space of the modern tradition imposed by the West.

Q: In the West in the '60s it became evident that art was no longer intended necessarily as a product, but instead was a practice or process. How important was the concept of a radical change in African art at the time?

A: First and foremost we have to think of African artists not simply as receivers of change from somewhere else. In discussions of global culture, those who view change as coming from within the general category of the avant-garde in Europe and America often use models of radical rupture as markers of universal change, which is quite untrue or not always true. For example, artists in Africa may respond to important change in Europe or the U.S., but apply its lessons in ways that often confound or contradict the original intention. The Nigerian painter Aina Onabolu, in the early 20th century a highly skilled academic, easel painter, a pioneer of modernism in Nigeria, was radical. The easel portraits of the Lagos bourgeoisie that he painted brought about a wider social contestation of colonial authority, and at the same time aroused a form of class consciousness that hitherto was unexplored by other practicing artists. Another example is the year 1968, used indiscriminately everywhere as world-changing. **It is very easy to universalize European experience and time and make it the paradigm of historical consciousness, but the reality is much more shaded and diffuse.**

At the famous Kampala conference on African literature in 1962, the debate among the great African writers such as Achebe, Soyinka, Mphalele, Nkosi, and Ngugi was to decide what exactly defined African literature: was it to include literature written in a colonial language or could it only be written in the African language? Of course there could be no agreement on what it was, but from there, from that moment, Ngugi began to rethink his practice until he came to a point where he said farewell to writing in English and began to write in Kikuyu.

The main preoccupation of African artisans, writers, and thinkers at that time was the effort to embrace the

Fig. 2. Seydou Keïta, *Untitled,* 1952–1955.

modern. When you look at Islam, the mandate against iconic representation forbids the figure. The calligraphy of the word was the way in which you could convey complex visual ideas; **what is seen to be so traditional in the West was forbidden for Islamic culture.**

If we are to think about global culture and look for paradigms, is it possible to look only for points of convergence, or is it necessary to explain culture globally through points of difference? I think that the global is really marked deeply by difference. And that is what makes the global very interesting; it is discontinuous on every plane — in terms of experience, of value, in terms of the conceptual coordinates and the historical coordinates that people work with. This is how I can begin to relate to the perception of change within the artistic field in the '60s.

Q: Art in the '60s is very often thought of as synonymous with Pop Art. Especially in the United States, this was a reflection of the newfound abundance of a consumer society, which corresponded to high growth rates in the economies of Western countries. Obviously this was absent in other parts of the world.

A: It is difficult to imagine modernity in Africa in the 20th century reflected in notions like speed, the Industrial Revolution, etc. This is not to put Africa or anywhere else in the pre-industrial age, but we're talking about mass phenomena and, of course, **in post-colonial Africa in 1950s and 1960s consumerism was not mass phenomena.** When the Congo became independent from Belgium in 1960 there were somewhere in the neighborhood of fifteen people with a university degree in the whole country. Consumerism is always somehow bound to the creation of a middle class. There are lots of slippery edges to the lexicon of modernity and to how we really deal with the global question.

inevitability of the transformations they were going through, and at the same time find models of practice that could make sense for both their immediate audience at home and others. It was necessary to accept that this was a time of decolonization, and that artistic practice, whether in art or literature, was all part of a project of nation building — in a sense the building of African identity. So the debate that was of interest to artists in Africa was quite different from that of artists in the West who were debating the formal content and nature of the work of art.

Let me give you an example: abstraction in the West was viewed as a radical break from the tradition of representation established in Europe during the renaissance. **For Africa it was the reverse. Abstraction was traditional.** To represent the figure became

Fig. 3. Seydou Keïta, *Untitled*, 1956–1957.

remains exemplary of how photographic technology in the context of the non-West has given us an amazing archive of this other modernity. His contribution, his empathy with his subjects, is of incredible value. You only have to look at Keïta and August Sander together to perceive the difference. Sander's work is really about the 19th century, while Keïta's was really about the 20th century. Sander's work is by comparison a work of mourning; his subjects look like condemned people; they are almost like relics, instantly historical and never modern. **Keïta's work is thoroughly modern all in the way the bodies lean toward the camera, the way they look at you and express themselves.** Perhaps the kind of fetishism that became obvious in the images of Keïta is one of those moments of interception of the postcolonial and the modern that produced something really quite vital, alive, and interesting.

Poet, critic, and exhibition commissioner, **Okwui Enwezor** (Calabar, Nigeria, b. 1963) is the founder and editor of *Nka: Journal of Contemporary African Art*. He was the artistic director of Documenta 11 in Kassel, Germany, in 2002, and directed the 2nd Johannesburg Bienniale in 1997. He has written extensively on African art and its history. The numerous exhibitions he has organized include *The Short Century: Independence and Liberation Movements in Africa, 1945–1994*, presented worldwide by the Villa Stuck Museum in Munich.

Interviewed by Anna Detheridge

The older I get, the more I am convinced that it is important when talking about global confrontation to point out the kind of world that people are confronted with, do not know, and do not live as an active everyday experience. Less important is the questioning of a universal model of knowledge and modernity.

I am at the moment working on a book about Seydou Keïta (Figs. 2 and 3). It is interesting to look at why he is not really taken very seriously in the history of photography, given the systematic stringent formal beauty of his conceptual frame.

The accusation is that Keïta's work was loyal to one thing only: the human form in all its different ways, constructed or unconstructed. But his work for me

Writer

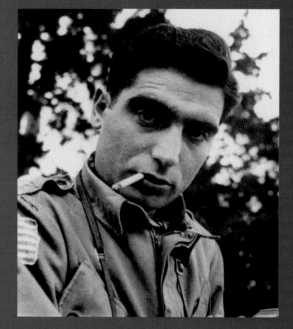

Q: I'm working on an exhibition about the art of the 1960s, and the premise is to look not exactly at pure art history but at different views of the era. I had been reading a lot about Vietnam and your book <u>In Pharaoh's Army</u> was the best thing I read. It really is a great work.

A: Thank you, I'm glad you liked it.

Q: It seems that the major works of art to come out of the Vietnam War are not visual but literary and cinematic, like your book and <u>Apocalypse Now</u>, <u>Going After Cacciato</u>, <u>Dispatches</u>, and <u>A Rumor of War</u>. When you look at the visual art of the 1960s, there's definitely art <u>about</u> Vietnam, and a lot of it is extremely powerful and effective, but it basically adheres to forms from earlier parts of the 20th century. It seems Vietnam really did not have an effect on the formal aspects of art. Should that matter? How significant is form to you?

A: I am very aware of form as an artist. **I'm not interested in the exaggerated formal tricks of postmodernism,** but self-consciousness is an absolute necessity for making art.

Fig. 1. Robert Capa on assignment for *Life,* Thai Binh, May 25, 1954.

Fig. 2. Death notice for Robert Capa, May 25, 1954.

Q: Here's my basic thought on art and Vietnam: World War I produced Dada and then Surrealism, and even the "return to order" as in Picasso. And World War II provided the groundwork for Abstract Expressionism. That's a simplification, but these were major shifts in the course of the history of art. Vietnam did not seem to alter the way that art was made or thought about in the same deep, fundamental way. Maybe we are still too close to it to make that assessment. I'm not sure. But if we do accept that, why do you think that film and literature about Vietnam seem so significant rather than visual art?

A: Maybe artists were just overwhelmed by the number and power of the images of that war and felt **they could not compete with photography.** Photography of the war was everywhere in the 1960s. Robert Capa was there earlier, he was killed there (Figs. 1 and 2). You saw Vietnam imagery everywhere. Paul Fussell, in his book *Wartime,*

says that during World War II, the public would not have been able to bear the uncensored images of what actually happened, the sheer amount and horror of war's effects.

Q: In <u>A Rumor of War</u>, Philip Caputo wrote a few passages about how battle was <u>energizing</u> to him like nothing else in life. What do you think about that? About the idea of battle as somehow, in any remote way, being a personal good thing?

A: Perhaps he thought it was energizing because his time in battle was relatively short. Your time there was a year, which was very different from other wars, in which men fought until they were dead or disabled right up to the moment one side lost. In those Bill Mauldin cartoons from World War II, you can really see the weariness of war, the toll of battle on the guys' faces as they trudge through mud and rain, just the unrelieved grayness of war. It was certainly an honest thing for Caputo to say of his experience. Other Vietnam vets have said similar things, but I wonder how energizing combat would have been after three or four years of it.

Q: There's a story about the British photographer Tim Parks who gets shot up and maimed pretty bad in Vietnam, but at the end of <u>Dispatches</u> he's yelling about how "of <u>course</u> war is glamorous!" or words like that. There <u>is</u> a glamour to Hollywood's views of the war. <u>Apocalypse Now Redux</u> was released when I was in the midst of my Vietnam reading. Maybe because I was so into the context of the war I found the film so amazing, but still, I think it's one of the great works of art of the last forty years. And that question of glamour comes up from the very beginning with the Doors and the image of the bombs. What's your take on it?

A: Film does glamorize war, no doubt. The beauty of the moving image is part of the appeal. You just can't get around this with war movies.

Q: It's an amazing visual experience to watch —

A: And the final part when they reach Kurtz — it reminds me of damnation scenes in Christian paintings of the Last Judgment (Fig. 3).

Fig. 3. Martin Sheen in Francis Ford Coppola's *Apocalypse Now,* 1979.

Q: Again, art made not at the time of Vietnam. You're referring to art from the Middle Ages and the Renaissance. I'd never thought of that scene that way, but you're right, it is like a damnation scene. What about the Vietnam Memorial by Maya Lin in Washington?

A: It's a great work.

Q: And that came from a later moment, roughly the same time as the first movies and books were coming out, in the late 1970s. What strikes me about the memorial is the combination of minimalism with narrative. It's a seamless fusion of so much that had gone before — text, land, minimalism, installation, performance. You descend into it, and read the names, and you of course see yourself.

I guess it must seem strange for a curator of contemporary art to be talking so much about books and not art itself, especially for an exhibition catalogue about art of the 1960s. Maybe the war is still too close for art history. But I do think these questions need to be asked in the context of a '60s show. Talking to you was a way to do that. Without dismissing the art of the time, we can ask where art was then, and after, and what might be the most appropriate art form to convey the war's experience. Just raising the questions is important for me, and for the exhibition. So thank you for your time.

A: You are very welcome. Thank you.

Tobias Wolff's (Birmingham, Alabama, U.S., b. 1945) collections of short stories include *In the Garden of the North American Martyrs* (1981), *Back in the World* (1985), and *The Night in Question* (1996). His first novel, *The Barracks Thief* (1984), earned him the PEN/Faulkner Award for best work of fiction. He is also the author of two autobiographies. The first, *This Boy's Life* (1989), about his childhood, was made into a film in 1993. The second, *In Pharaoh's Army: Memories of the Lost War* (1994), recounts his experiences in the Vietnam War. Tobias Wolff teaches literature at Stanford University in Palo Alto, California.

Interviewed by Charles Wylie

165

176
Niki de Saint-Phalle
Kennedy-Khrushchev
1962

154
Daniel Pommereulle
Target for Other Aims
1963

150
Michelangelo Pistoletto
Red Banner
1966

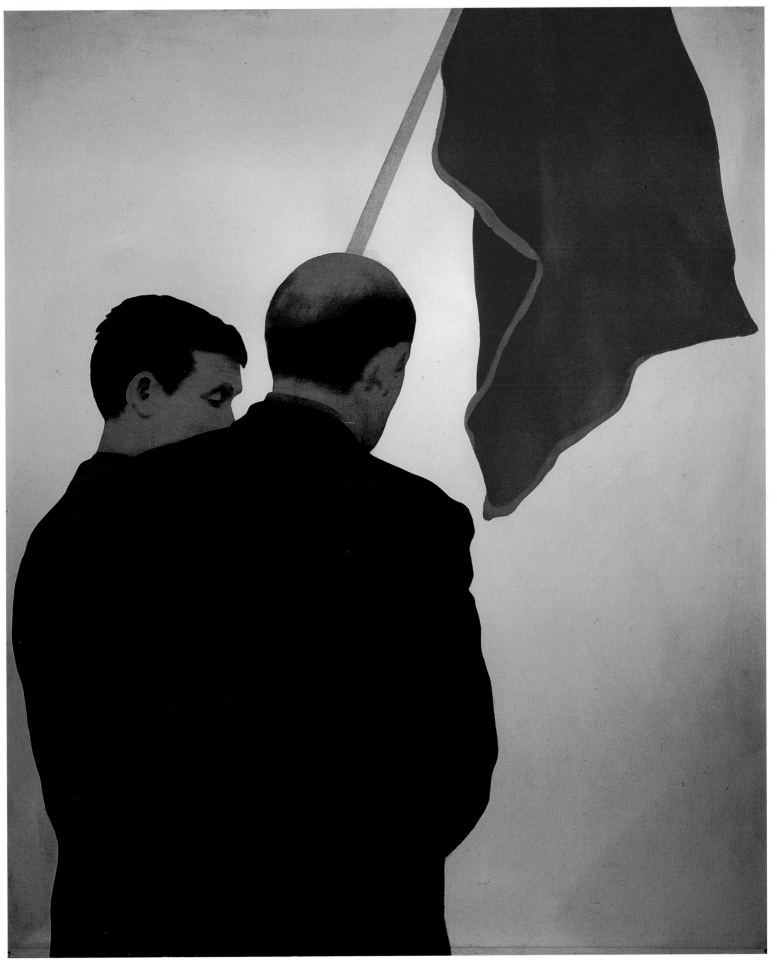

51

168

169

135

137

135
Otto Muehl
Charles de Gaulle
1967

137
Otto Muehl
Konrad Adenauer
1967

138
Otto Muehl
Nasser
1967

136
Otto Muehl
Ho Chi Minh
1967

138

136

89

18

19

89
Alberto Korda
Guerrillero Heroico
1960

18
Félix Beltrán
"Otras manos empuñaran las armas"
Poster
1969

19
Félix Beltrán
"Otras manos empuñaran las armas"
Poster
1969

164

Norman Rockwell
Murder in Mississippi
1965

214

Andy Warhol
Race Riot
about 1963

164

214

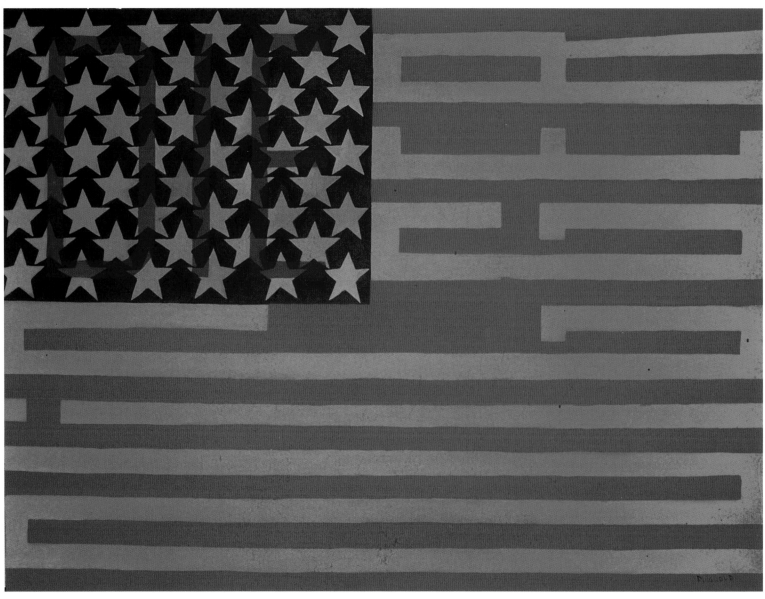

163

163

Faith Ringgold

Flag for the Moon: Die Nigger

1967–1969

110

Roy Lichtenstein

The Gun in America

Cover of *Time* (June 21, 1968)

1968

200

Joe Tilson

Page 18. Muhammad Speaks

1969–1970

110

200

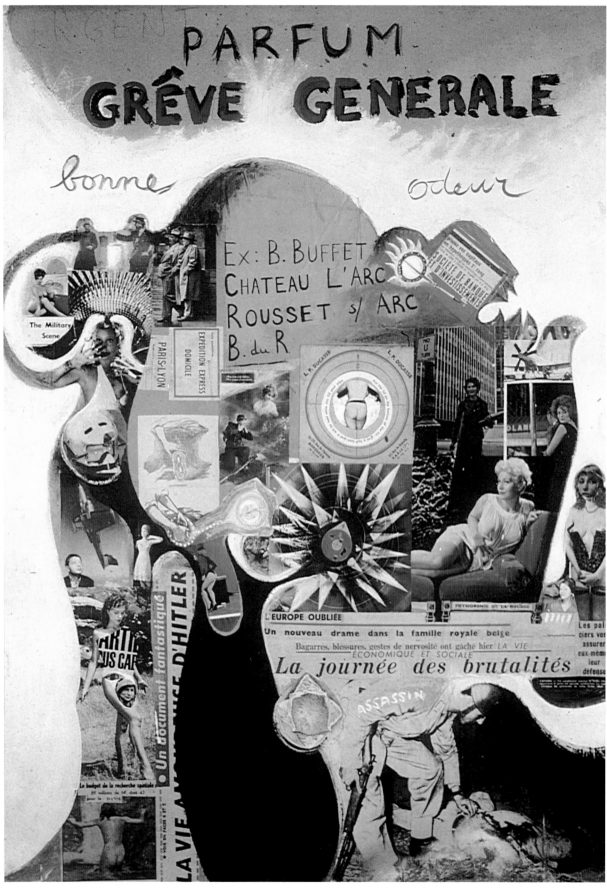

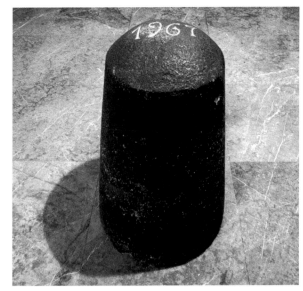

151

53

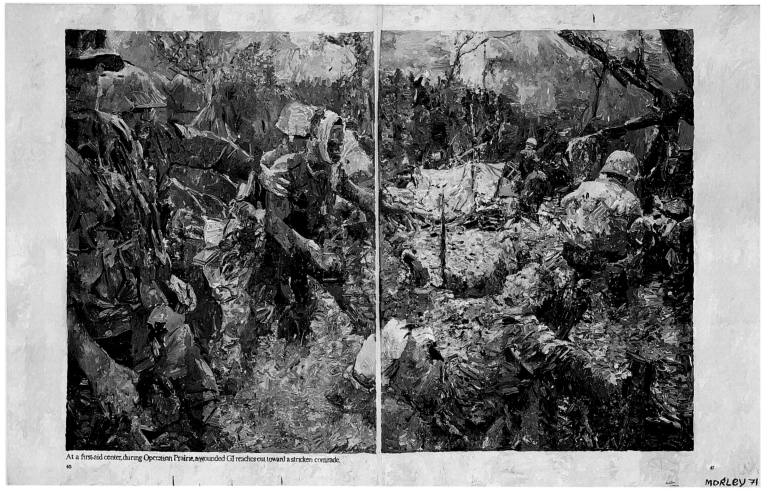

At a first-aid center, during Operation Prairie, a wounded GI reaches out toward a stricken comrade.

129

193

92

91

186

129

Malcolm Morley

At a First-aid Center in Vietnam

1971

193

Nancy Spero

Victims on Helicopter Blades

1968

92

Howard Kottler

Hollow Dream Plate

from the series "American

Supperware"

1969

91

Howard Kottler

Peace March Plate

1968

186

Tony Smith

Die

1962, fabricated 1968

27

Manuel Alvarez Bravo

The Walls Tell All

1968

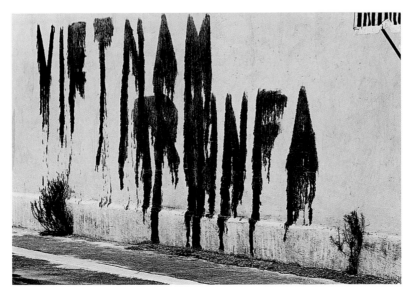

27

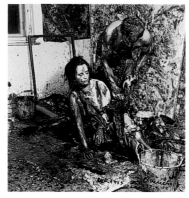
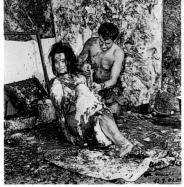
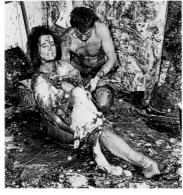
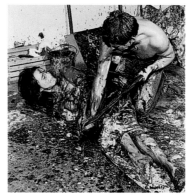

134
Otto Muehl
Burial of a Venus
Portfolio
1963

38
Christo
*Wrapped Dress, Project for
a Wedding Dress*
1967

37
Christo
*Wedding Dress and Evening
Dress, Project for the Arts
Council, Philadelphia*
1967

152
Michelangelo Pistoletto
Venus of the Rags
1967

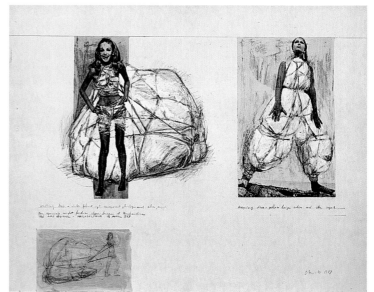

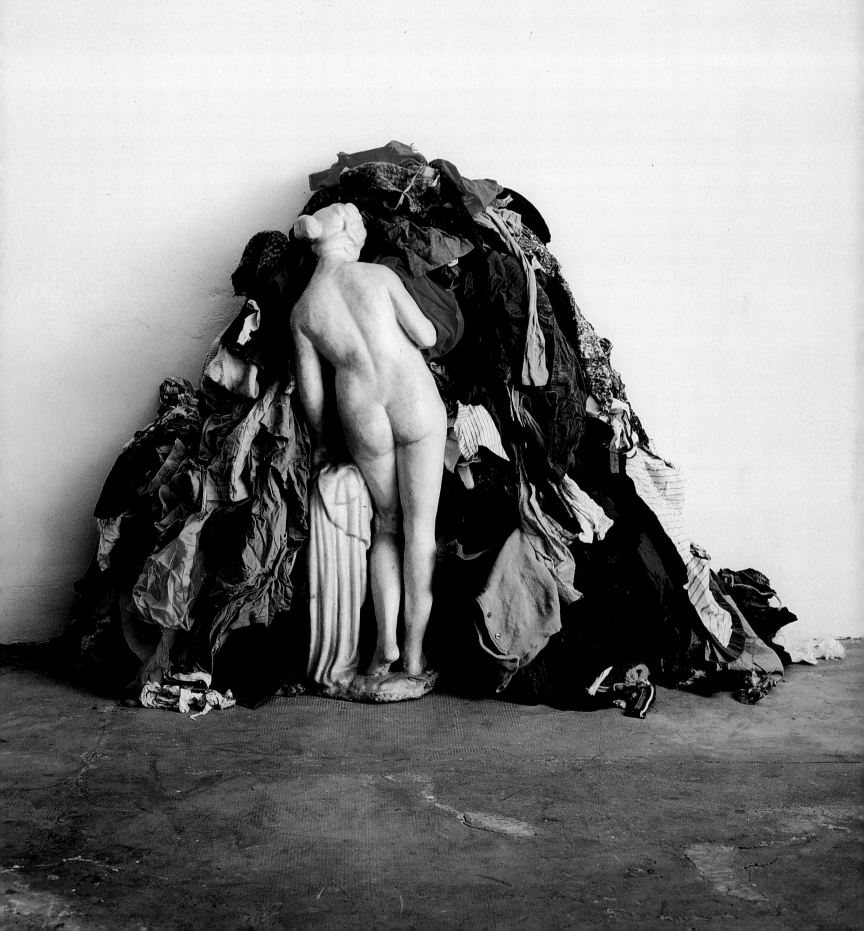

21

21

Ben

Mon envie d'être le seul

(My Desire To Be the Only One)

from the series "Introspections"

1967

11

Richard Avedon

Andy Warhol, artist.

New York City, 8-20-69

1969, print 1975

11

213
Wolf Vostell
Lippenstift-Bomber B52
1968

171
Mimmo Rotella
Triumph
1961

170
Martha Rosler
Cold Meat I
from the series "Beauty Knows
No Pain, or Body Beautiful"
about 1972

213

171

12

191

12
Pierre Ayot
*My Mother Returning from
Her Shopping*
1967

191
Nancy Spero
Female Bomb
1966

192
Nancy Spero
Male Bomb
1966

192

218

181

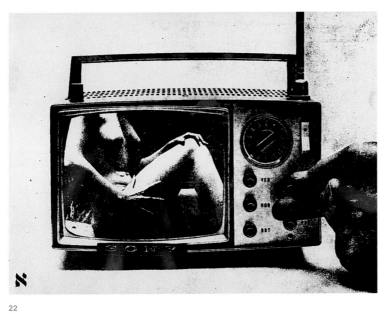

22

218
Joyce Wieland
Heart-on
1962

181
Carolee Schneemann
Meat Joy
1964

22
Wallace Berman
Untitled
1964

121
John Max
Untitled, No. 21A
about 1965–1975

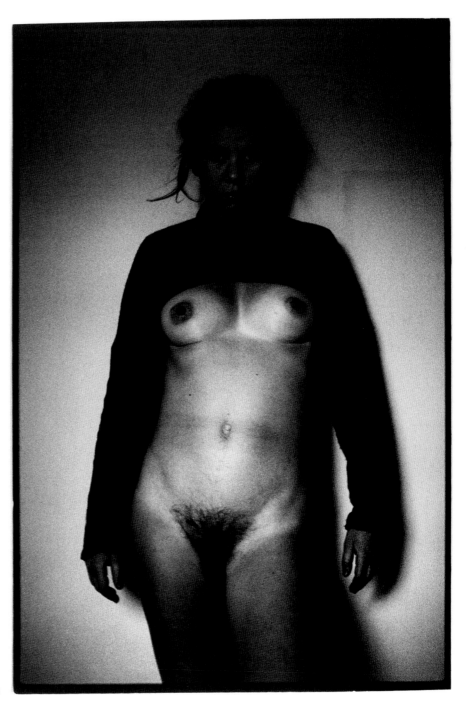

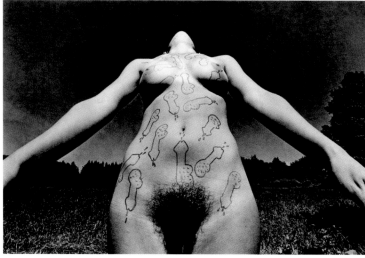

95

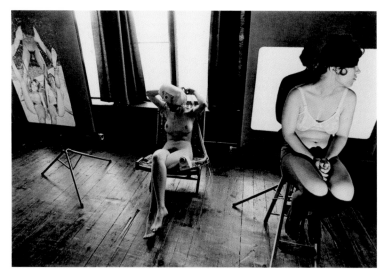

94

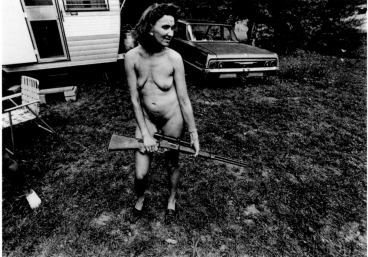

93

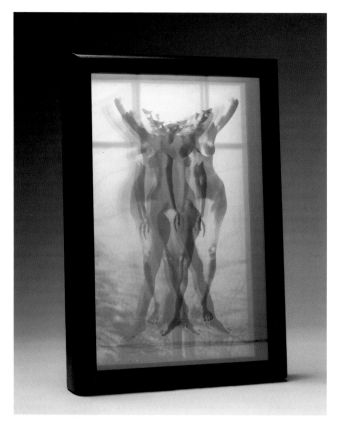

71

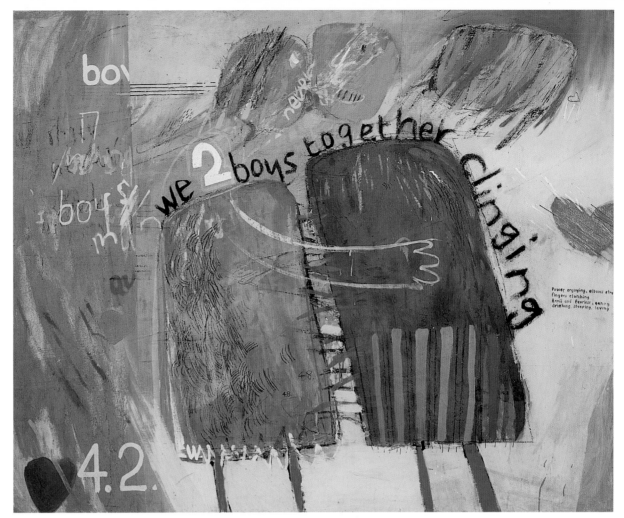

72

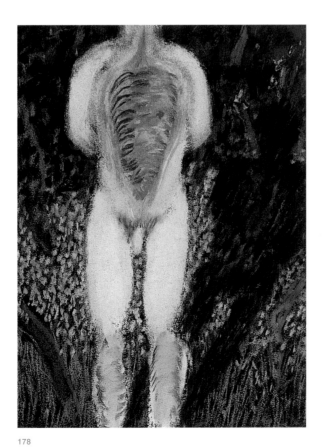

178

179

4

207

105

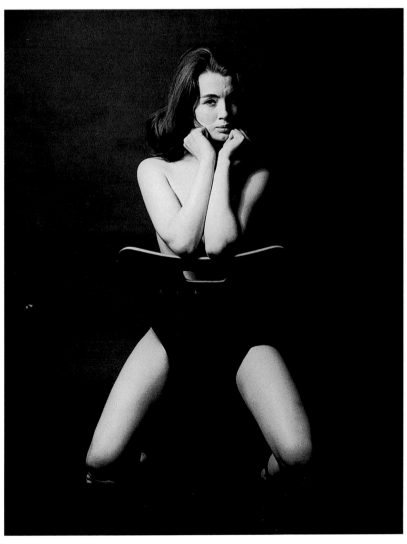

128

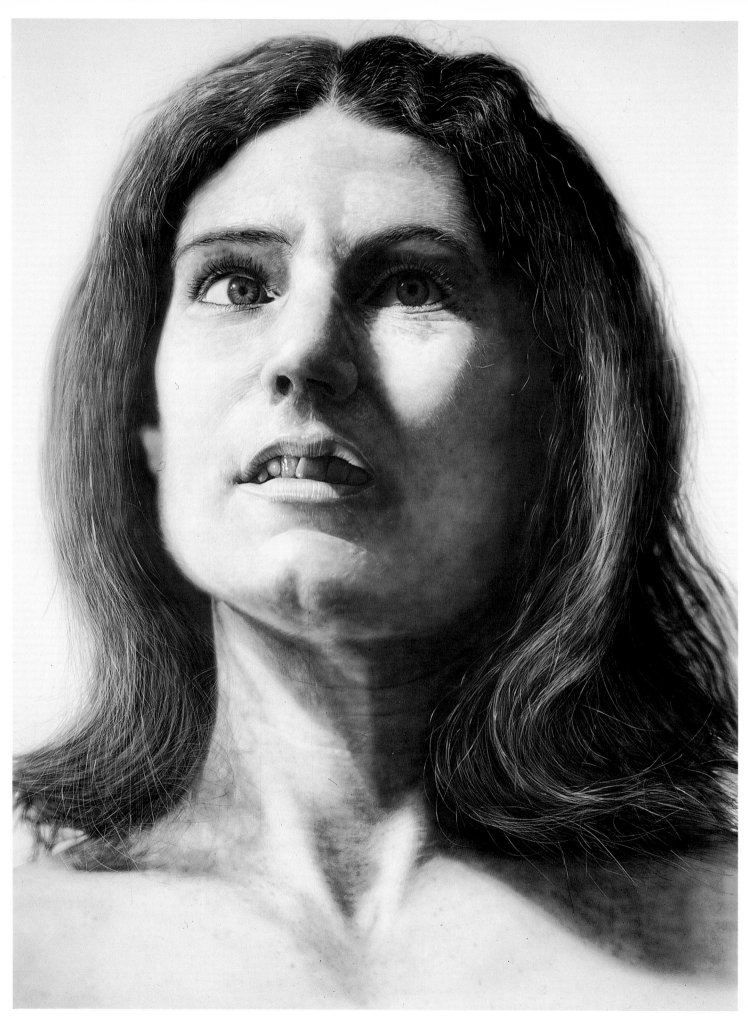

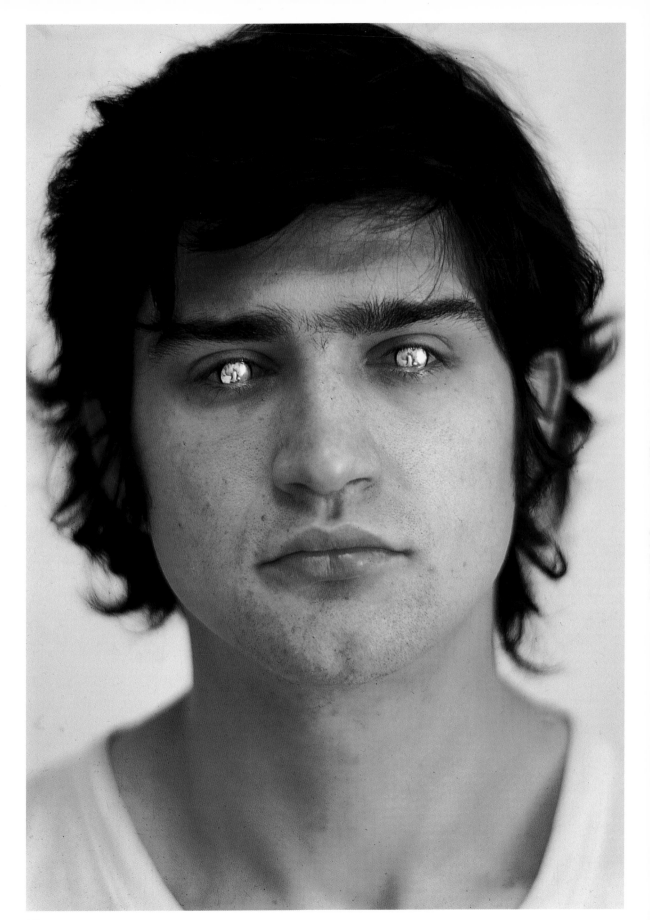

41
Chuck Close
Nancy
1968

148
Giuseppe Penone
To Turn One's Eyes Inward
1970

148

28

118

145

8

199
Paul Thek
Untitled
from the series
"Technological Reliquaries"
1965

76
Peter Hujar
Palermo Catacombs No. 8
1963

76

122

122
Ralph Eugene Meatyard
Untitled
about 1970

124
Duane Michals
Collage Portrait of
Rauschenberg in His Studio
1962

189
Michael Snow
Authorization
1969

124

189

The late 1960s were a time of optimism. A period when anything seemed possible, with hopes of bringing positive change to the world. A broad range of experiences became available to young people ready to sever their ties to the lifestyle of their parents; from rock music to the revival of occultism and mysticism, to drug use and using the Pill, to social activism. Poet Allen Ginsberg, novelists Ken Kesey and Tom Wolfe, and revolutionary explorer of the mind Dr. Timothy Leary spread the gospel of this counter culture. People attended concerts and festivals. Some were called hippies. Hair grew longer and beards became fashionable. Blue jeans and tee shirts took precedence over pants, jackets, and ties. Some young people were living in communes and traveling in weirdly painted buses.

Existentialism was the philosophy of the day. Philosophers like Jean-Paul Sartre spoke of individualistic self-sufficiency. Truth was subjective, determined by individual experiences;

the individual was more important than the community. The present mattered more than the past or future. The Me generation was born. Meanwhile, Bruce Nauman created <u>The</u> <u>True</u> <u>Artist</u> <u>Helps</u> <u>the</u> <u>World</u> <u>by</u> <u>Revealing</u> <u>Mystic</u> <u>Truths</u>, a neon sign displayed in his grocery store window, proclaiming a private thought to passersby. In <u>Titled</u> <u>(Art</u> <u>as</u> <u>Idea</u> <u>as</u> <u>Idea)</u> <u>(meaning)</u>, Joseph Kosuth put forward his self-reflective theory, emphasizing the idea over the object as a radical purging of the material world. No longer burdened by representation, Jerry Uelsmann's photographs appealed to internal, nonlinear faculties of thought and feeling.

"Turn on, tune in, and drop out!" said Leary. Record albums and singles were created in no time. In one year, the Beatles released *Sgt. Pepper's Lonely Hearts Club Band, Magical Mystery Tour,* and a two-sided single hit *Strawberry Fields Forever/Penny Lane.* Underground radio, magazines, and newspapers flourished from California to London. Brightly colored and intricately drawn posters, such as the one designed by Rick Griffin for Jimi Hendrix and John Mayall, became the perfect means to advertise concerts and festivals like Monterey, Woodstock, and Altamont. For the cover of the London-based magazine *Oz,* Martin Sharp engulfed Bob Dylan in psychedelic bubbles.

This highly creative style was not only experienced two-dimensionally. On stage, bands performed against bizarrely illuminated light shows. Musicians and singers wore brightly colored outfits that had nothing to do with *haute couture,* but everything to do with personal style. And Dave Richards designed the distinctive paint job on Janis Joplin's 1965 Porsche Cabriolet Super C.

Yet the late 1960s were not solely flower power. The idea of entropy was also seminal. Performances and recorded music, mostly documentary folk songs and experimental rock, displayed disorder. High-energy madness and destruction were part of some live shows and chaotic dissonance formed the essence of improvisational bands. Hendrix set his guitars ablaze and Pete Townsend of The Who regularly smashed his during performances. Drug and alcohol abuse claimed the lives of legendary figures Janis Joplin, Jim Morrison, and Jimi Hendrix.

The energy that fueled the civil rights movement and mobilized the counter culture also stimulated an environmental movement as people became aware of the pollutants surrounding them — automobile emissions, industrial wastes, oil spills. Many countries took action. In 1970, the United States created the Environmental Protection Agency. Massive demonstrations were held and the first Earth Day protested the pollution of the planet. Artists contributed compelling images like Rupert Garcia's *DDT* silkscreen poster. Roy Lichtenstein's poster *Save Our Water* from the *Save Our Planet* series was distributed to United Nations ambassadors to raise ecological awareness.

A close relationship with nature was essential to many artists. Robert Smithson, with his 1,500-foot *Spiral Jetty,* and process artists like Hans Haacke and Joseph Beuys transformed attitudes toward nature and the environment through artistic interventions in society and living space. For others, such as Alighiero Boetti, Claudio Parmiggiani, and Tetsumi Kudo, planet Earth was at stake.

D. C.

change

Writer

Q: Michel Tremblay, your theater was born in the 1960s, and it dealt with the great struggles of the time: the decolonization of Quebec, women's liberation, homosexuality —

A: I must stop you right away. When people talk of the '60s they automatically see collective movements, but they don't see the individual. It seems to me the '60s were experienced in two different ways. **There are people who experienced those years in a collective way, and others in, shall we say, a private way.** Large collective movements, like the one in May '68 in Paris, did have profound consequences on the period — even if the leading players, let's be honest, took advantage of them to hog the limelight and increase their stock for the future. On the other hand, probably everywhere in the world, there were people who, out of necessity, were making eminently personal gestures. In my case, if I experienced that time collectively, it was through a combination of circumstances because I was working in the theater. But I didn't identify myself with any mass movements. What I did came primarily from personal need, as it did for many artists. It was only afterward, in retrospect, by adding up all these individual acts, that one could grasp the collective aspect of that time. For this reason, **there's a big difference between the way most people experienced that time, and the way we look back on it now.**

In the same way, there's a big difference between '68 in Paris and '68 elsewhere. Here in Quebec, unlike in France, the phenomenon of 1968 was fragmented.

Fig. 2. *L'Osstidcho* premiered at the Comédie Canadienne (now the TNM), May 28, 1968. From left to right: Louise Forestier, Yvon Deschamps, Mouffe, and Robert Charlebois.

Instead of a single large demonstration, we had in the same "summer of *Les Belles Soeurs*" (Guid Sisters) (Fig. 1) three major shows by people who didn't know each other, who'd never even met, which was pretty amazing. In May there was *L'Osstidcho* (Fig. 2), the product of a small group, with Robert Charlebois, Louise Forestier, Mouffe, and Yvon Deschamps. Two months later, in July, there were the two plays by Réjean Ducharme, *Inès Pérée et Inat Tendu* and *Le Cid maghané* ("Knocked-about Cid") done by a completely different summer theater troupe. It was theater written and acted in Joual [a working-class variant of standard Canadian French], a month before *Les Belles Sœurs*, but because it was done in the countryside people talk about it less today. Then there was *Les Belles Sœurs*, a play I'd written three years before, but hadn't yet been able to stage. These demonstrations weren't prearranged, but they were all saying the same thing, they were expressing the same cultural desire.

Q: What was in your mind when you wrote Les Belles Sœurs?

A: Anything new is a reaction to a thing or an existing order. In that sense, *Les Belles Sœurs* was a reaction to films where the characters, French Canadians, spoke an implausible language, a kind of French that nobody on earth had ever spoken, a sort of "mid-Atlantic French." I said to myself that I should write it like I heard people speak it. In the beginning, *Les Belles Sœurs* was a stylistic exercise. And so, while trying to write a ten-minute scene within that constraint, a sort of logorrhea resulted. As I always say, at 23 I was young to write *Les Belles Sœurs*, but I was old to find out that I should be writing in my language.

Fig. 1. Original production of *Les Belles Sœurs* at the Théâtre du Rideau Vert, August 28, 1968.

Q: Your work is permeated with a feeling of revolt that affected the whole of French Canadian society.

A: At the time I was writing *Les Belles Sœurs*, I was starting to become aware of great injustices. Throughout my childhood **I belonged to a people who'd been kept quiet.** We'd been told that we were idiots for so long we believed it. We used to go to Eaton's where the French Canadian salesgirl who sold gloves wasn't allowed to sell them in French, so she sold them in English to a French speaker. We were brought up to think it was right, so as long as you didn't rebel, it was right. I first rebelled politically when I went to see a Mozart opera at the Place des Arts. In Montreal they should have played this opera either all in German or all in French. But because there was a singer from Toronto who couldn't speak French, they acted the opera in English and sang it in German. That really upset me, so much so that I became a separatist.

Q: You've brought your working-class background to the stage.

A: I realized at the time that Quebec plays were often written by people with a working-class background, but who'd moved away from it. Their plays were written from the outside; they were plays that passed judgment, sociological shows. But in the theater, you've got to get inside the character's skin, you give *his* vision and not the vision you have of him. I remember the feeling of being inside the characters in *Les Belles Sœurs*.

Q: That's the first responsibility of liberation theater. "My mouth will be the mouth of misfortunes that have no mouth," wrote Aimé Césaire in <u>Cahier d'un retour au pays natal</u> (Notebook on a Return to the Native Land).

A: I was aware of doing that, but not for the political reasons usually ascribed to that time. I did it out of a kind of humanism. That word's a little suspect, which I think is a shame. Because real dramas aren't political, they're first and foremost human.

Q: You are a literary person, and your theater draws from a variety of literary sources, from Greek tragedy to the theater of the absurd. But what influence has television, for example, had on you?

Fig. 3. René Lévesque hosting *Point de Mire*, Radio-Canada Television (December 12, 1956).

A: If Quebec hadn't had television in 1952, the Great Darkness, as that period in our history is called, would probably have ended later. **Television showed us there was a world outside our own.** We knew nothing before that. There was an elite, but unfortunately it was an elite that hurt the people, that kept them ignorant. When we got television, everything changed. We learned things. Television educated us. The program that influenced me the most in my life was *Point de mire*, René Lévesque's news program (Fig. 3). Without Canada realizing it, Lévesque started telling us really subversive things, suggesting new directions. I was fifteen and there was a man who explained that the electricity could belong to us. You learned things you weren't taught at school, where everything was imbued with religion. There was a very good reason why television was a kind of object of sin in the eyes of the Catholic religion.

Q: And the status of women?

A: When I was writing *Les Belles Sœurs*, in 1965, I had this thought: if these women were really talking to one another that evening, there'd be a revolution. When I was younger, about eighteen or nineteen, I realized that Quebec theater, like North American theater in general, was written by men, for men, and practically against women. I also realized that all religions were misogynous: the only respectable woman in the Catholic religion had to be a virgin and a mother at the same time. What took away my faith was the injustice suffered by women within religions. And as I grew up surrounded by women, I inevitably became aware of that through women. So writing *Les Belles Sœurs* just happened naturally. Furthermore, I wrote it in Joual, basically because this language was given to me by women.

But feminism was only in its early stages in the '60s. The great years for feminism were the '70s. Before, there were intimations of it, but they were intermittent, isolated one from another. It was a time when women were getting ready to join forces, but hadn't yet done it. Besides, I'm not sure the sexual revolution of the '60s was as egalitarian and revolutionary as people think. **Communes seemed like harems:** it was the guys who chose which girl they were going to sleep with, and not the other way around, even in communes with several couples. The prevailing misogyny in society had free rein there, but under a new guise. And a number of collective movements in the '60s that tried to reinvent society often just reproduced it with all its faults.

Q: And what about homosexuality?

A: The deciding moment for homosexual liberation came with the Stonewall Inn riots in New York in 1969 (Fig. 4). But once again that's just the public dimension. In 1969, I was twenty-seven, I'd known for a long time I was homosexual and I had an active sex life. In this respect, I always say that the most beautiful "party" of my life was Expo '67 (Fig. 5). It's the only time in my life that I screwed all sorts of people from everywhere, all colors. On the one hand, there were the restaurants of la Ronde, the Expo amusement park, and on the other hand, sex. It's true. You could try all different "flavors" for six months.

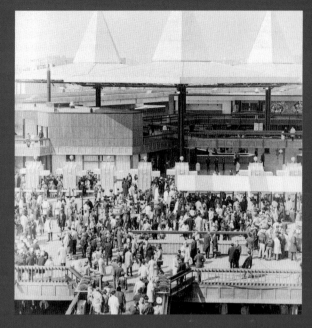

Fig. 5. Expo '67: The Place d'Accueil main gate, opening day (April 28, 1967).

Quebec playwright and novelist **Michel Tremblay** (Montreal, Quebec, Canada, b. 1942) is a key figure in contemporary French-speaking literature. Since his remarkable production of *Les Belles Sœurs* in 1968, he has written more than twenty plays, including *À toi pour toujours ta Marie-Lou* (Forever Yours, Marie-Lou) in 1972 and *Albertine en cinq temps* (Albertine in Five Times) in 1984. Michel Tremblay is also the author of several novels and short stories, as well as an epic six-volume novel, *The Plateau Mont-Royal Chronicles.*

Interviewed by Stéphane Aquin

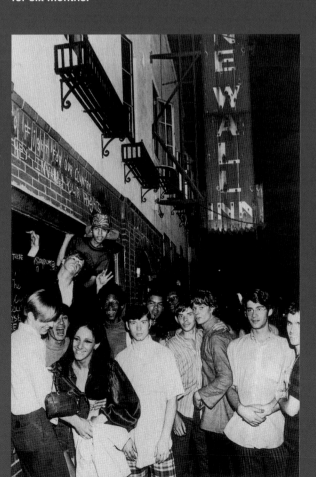

Fig. 4. People in front of the Stonewall Inn days after the June 27, 1969, police raid.

Artist and filmmaker

Q: What was it like to be a young woman artist, using her own body as material, in the '60s?

A: The resistance toward being a young woman artist in the '60s shaped my work, my politics, my view of the culture around me. This had to do with the exclusion of women from art history and the disappearance of any social model that might represent a true equity between female and male creative principles. That disparity was further revealed gradually through my own research, starting in the '60s and going into the '70s, as I discovered another art history — paintings, sculptures, inscriptions, pottery, weavings, which had always been wrongly attributed to male artists. Because male culture had stolen everything that might have been initiated by women, I would in my own private way steal, invert, destabilize this inheritance — my feminine, criminal, alternative energy!

In 1963, I had visions of recapturing the body, using my body, taking the female body out of the hands of art historical male traditions. And also I wanted to address the traditions of Pop Art — dominant at the time — in which the obsessive representation of the feminine was highly mechanistic, polished, bloodless. With the experiment *Eye Body* (Fig. 1), I proposed another aspect of visualization, of visual language. *Eye Body* was a *series*

Fig. 1. *Eye Body — Thirty-six Transformative Actions*, 1963.

of actions, almost instantaneous physical collages, in which I transformed my body for a photographic sequence as an extension of the painting-construction I was making at the time. For every exposure of a 35 mm camera, I would collage myself, obliterate the "self" by turning my body into a dimensional aspect of the installations I was building using plastic, foams, paint, glass, fur, lights. The camera was in the hands of the Icelandic artist Erró, and in this instance *he* was the inspiring muse. From Paris and married to a painter, he was truly supportive and encouraged my work.

As a student in the 1960s, I was most concerned with both the exclusion of the feminine pronoun from ordinary and formal language, and the repression/distortion of female sexuality. Until the mid-'70s, art history books only spoke of "man and his images," "the artist and his model," "each person and his tools." There was no inclusive or equitable gender usage. I maintained a file of these relentless exclusions, to track some sense of the resistance to my ideal of participation and authority. Female sexuality either belonged to pornography or was described as an aspect of a medical problem. Those exclusionary structures provoked my work. I celebrated my sexuality within the self-shot erotic film *Fuses* (Fig. 2), filmed over the course of a year with my partner, the composer James Tenney, and the appreciative presence of our cat Kitch. I edited for another year. Would this heterosexual lovemaking resemble pornography or some science study? *Fuses* introduced a new vocabulary of intimacy, tactile gesture, and a shameless, ardent sexuality.

Q: By exposing and using your body the way you did, you were pushing many limits. What was the response to your work?

A: It created some confusion. The response from the art world was initially, almost exclusively, negative, partly because my body was sufficiently ideal to be associated with traditions of male pleasure at the same time my work deformed male expectations as to how the female nude should replicate these traditions. What the body was doing was in conflict with cultural and aesthetic expectations.

Q: You first created Meat Joy in Paris at the 1964 Festival de la Libre Expression. What was the reaction?

A: In Paris, there was an immense appreciation, a huge response from the critics, the press, historians, the audience. *Meat Joy* (Fig. 3) made the front page of the newspapers, even in Italy! The work was reviewed, analyzed, and celebrated, and because it was Europe, I entered a *tradition* of exceptional women. I was suddenly lifted from my previous position of feeling lost and striving (but always energized by what I had to create!). It was amazing — what Paris and French culture inspired and gave back to me in 1964.

Audiences were more critical, more reserved in New York. In Paris, men had crawled out from the audience into our viscous space — and there was also the incident in which a man came out of the audience and tried to strangle me. When we presented *Meat Joy* in England, it was truly horrible: the viewers seemed frozen, we did not get any energy back from that audience.

Q: The projection of the film Fuses, in Cannes, also triggered very strong reactions.

Fig. 3. *Meat Joy* (collage), 1964.

A: I was standing in the back of the alternative movie theater with Susan Sontag when there was this great shouting up front and we saw men leaping around with knives and razors in their hands. They were slashing the theater seats! I asked Susan, "What's going on?" She said, "I have no idea, maybe your film was so disappointing because they expected a porno film and it's something different." They were slicing chairs out of frustration. She said, "We should get out of here before they look for *you*."

There were many remarkable comments at the time about *Fuses*. A young man said, "I don't like looking at it because I am jealous of his penis." Or "the cunnilingus sequence is just too long." One of the guys in the lab who developed the film wondered, "Does she like what he is doing to her?" and I said, "If she did not, she would say 'please stop' and it wouldn't be on film." Women responded, "This is a revelation" and "I have never seen my vagina before." Sometimes women were in tears. Men were enthusiastic, because it also gave them a vision of their own phallic power.

Fig. 2. *Fuses* (stills), 1965.

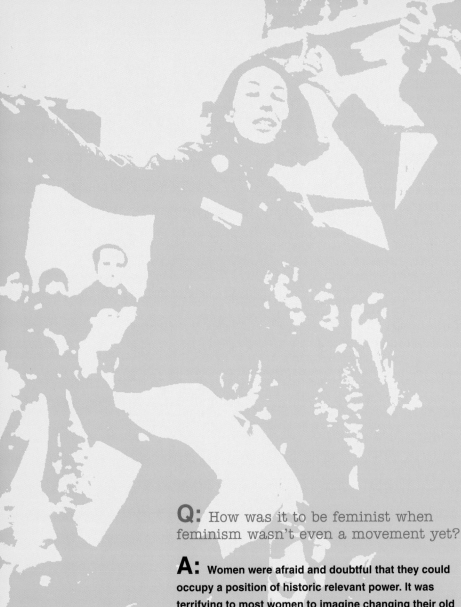

A: The women's movement owes a great deal to the civil rights movement. It provided a model of an activist community, as well as an example of determined organizing, which a true commitment demands.

White and black women artists were working more closely by the end of the '60s and the '70s. Important feminist exhibits that focused on the '70s have shamefully excluded many of the black women pioneer artists. These were extraordinary artists — Faith Ringgold, Adrian Piper, Bettye Saar, Kay Brown, Howardina Pindell, Emma Amos, Janet Henry, and others.

Q: How did you become involved in the movement against the Vietnam War?

A: In 1960 or 1961 at the University of Illinois, Jim Tenney and I met a young woman student from Vietnam. We asked, "Where is that?" She was a poet from South Vietnam explaining that the French had been previously dominating the country and that now the United States had its army coming in and was dividing the country — people were in prison camps. We were astonished! She introduced us to Vietnamese poetry and Vietnamese music, which stayed with me throughout those years as we were learning about Vietnam: were they really communists, what was the agriculture, how did the country define itself economically and politically, what was the U.S. militaristic motive?

By the mid-'60s after I saw resisters and protesters beaten in Grand Central Station by the police (Fig. 4), I began physical training exercises for groups. I wanted to extend some of the principles of my Kinetic Theater work to see if we could develop techniques for resisting when police tried to push, beat, or grab us, for saving ourselves and for collaborating, helping each other evade police brutality.

Q: How was it to be feminist when feminism wasn't even a movement yet?

A: Women were afraid and doubtful that they could occupy a position of historic relevant power. It was terrifying to most women to imagine changing their old patterns — challenging their teachers, priests, doctors, fathers, brothers, lawyers, husbands! It was very threatening to most of my friends; so initially for me there was a very small community of women who had the vision that our work could reposition and critically analyze the conventions that denied us history and trivialized our meanings and materials.

In the '60s, young women were on the sidelines. At a party, the male artists would all talk together, and we women would sit around smoking in our tiny little dresses, listening to our guys. We might meet each other another time when we would discuss what we were making or show each other works, but we were constellated around the significant men. That began to shift slowly in the '70s, creating social ruptures. Fortunately I had a supportive partner, and among our friends, the male musicians and poets encouraged my work. They were exceptional!

Q: It's been said that women served as mattresses to the sexual revolution. Do you agree?

A: The idea that women were only "mattresses" (instead of "mistresses") through the '60s is one possibility. At the same time we felt ecstasy, joy, and a great sense of communal freedom and activist purpose. You could be attracted to someone, have a toke, a couple of drinks, and go home for this wild pleasure together — out of which you would build a friendship, a love affair, or never see each other again. Sexuality was spontaneous, a communal revelation of risk and trust. The sexual freedoms contributed a politics of shared energy and social ideals. There was the sense that we were also going to change this world — to make it less violent and greedy and selfish — and that we would use our bodies together as forces against militarism, to levitate the Pentagon, to organize, to march. But we formed an amorphous and pervasive community.

Q: And the present. Do you see the benefits of your actions in today's world?

A: I am blessed by a so-far fortunate historic configuration. Each visual "pioneering" work has suffered an eight- or nine-year lag — in which it was dismissed — but by now my objects and installations have joined a complete transformation of Western culture shaped by feminist research. Research into biology, linguistics, physiology, history of religion, anthropology — every aspect of human investigation has been reexamined and deepened by feminist principles.

My sense is that tragically the psychopathic militaristic delusions that are sweeping my country, duplicating other fundamentalist social obsessions, are unconsciously in reaction to the participation of the feminine. We are caught examining the reactive, overdetermined masculine, those who would righteously destroy everything rather than relinquish patterns of domination.

Fig. 4. Grand Central Station Yip-in, 1968.

Multidisciplinary artist and filmmaker, **Carolee Schneemann** (Fox Chase, Pennsylvania, U.S., b. 1939) is the author of groundbreaking feminist and activist performances that have helped define the genre. Among them are *Glass Environment for Sound and Motion* (1962), *Newspaper Event* (1963), *Eye Body* (1963), *Meat Joy* (1964), *Snows* (1967), *Night Crawlers* (1967), *Illinois Central* (1968), and *Interior Scroll* (1975). She has directed many independant films and videos, including *Viet Flakes* (1965) and *Fuses* (1967). Her books include *More Than Meat Joy* (1979) and *Imaging Her Erotics* (2001).

Interviewed by Stéphane Aquin

INTERVIEW: THEODORE ROSZAK

Historian and writer

Q: Your book <u>The Making of a Counter Culture</u> coined a term and captured a huge audience. Alan Watts wrote in the <u>San Francisco Chronicle</u> in 1969 that it was the book to read to understand what was going on among intelligent and mysteriously rebellious children, "the Youthful Opposition." What were the important lessons there?

A: The protest movement of the 1960s and 1970s was distinguished by its **eagerness to question the rightness and rationality of industrialism.** In the past, few radical political movements had gone so far. Instead they sought to redistribute the wealth and the power of the industrial economy without inhibiting its momentum or compromising its power. Marxism, for example, never disputed that industrialism was the wave of the future, the one way forward. It endorsed modern science and all but idolized big, centralized technology. Its main thrust was to take control of the commanding heights of the capitalist system. That's what it meant by "revolution." But in the '60s, middle-class youth, who had access to the affluence and comforts of high industrial life, were willing to raise penetrating questions about just about everything we once thought was unquestionably right: the meaning of "success," the work ethic, progress as ever-increasing productivity, the scientific worldview, the value of technology, the authority of expertise. That's why I referred to the protest as a "counter culture." What was at stake went far beyond politics, beyond what any conventional political movement could accomplish. Think how remarkable it was that young people raised on mainstream Western values, with secure lives and guaranteed lucrative careers, should turn against parental

Fig. 1. Robert Edward Duncan, 1958.

values and look to traditional societies, exotic cultures, and alien religions to find a better quality of life. And at its extreme, the movement went farther. It undertook to transform the very consciousness with which we address our own identity and the world around us. Hence the fascination with drugs. This was to call into question our standards of reality and sanity. As zany as all of this seemed at the time, it was a marvellously adventurous period to live through. One cannot imagine dissent being carried to such daring lengths at any time in the near future. Not since the Romantic movement, the days of Blake and Shelley and Goethe, have we seen such an imaginative critique of the assumptions on which industrial society bases its reality principle.

Q: What happened to counter culture since?

A: Of course, with the benefit of hindsight we can see that the movement suffered for its own lack of maturity. It wanted too much too soon: instant gratification. And it sadly underestimated the power of the technocratic establishment, which has clearly survived and gained even greater power in the new global economy. But that doesn't mean the counter culture simply vanished in a puff of smoke. What it left behind remains an indispensable resource on which to raise renewed resistance to industrial values: the environmental movement, the women's movement, gay liberation, the value of racial and cultural diversity, and our deepening appreciation of the irrational psychological forces behind our society's obsession with power, growth, and profit. The critique of patriarchy is one of the enduring values of the counter culture. All this remains. That's quite a heritage. If a significant opposition ever again confronts industrial society, it will draw heavily upon these sources.

Q: History cannot be sliced in decades. Yet there seems to be something like a '60s zeitgeist.

A: I think the counter culture inherited and embodied something of the rhythm we can see in the past that has pitted the village against the city, the pastoral against the sophisticated, the tribal against the bureaucratic state, the organic against the artificial. The San Francisco poet Robert Duncan (Fig. 1) once referred to the '60s as a "symposium of the whole," in which the voices of all the outcast, downtrodden, and persecuted could be heard. If we ever lose that rhythm, we will be facing the worst kind of totalitarianism, the regime of technocratic expertise, which believes there is one best way to do anything and is prepared to use well-organized state violence to prove its point.

achievements of the '60s simply to have raised the issue of **saving democratic values within a technocratic order.** We haven't solved that problem; we've just laid it aside.

Q: The so-called information society, another "utopia," also starts to blossom during this era. How do you characterize it?

A: The phrase "information society" sets my teeth on edge. I despise hearing it. It is nothing more than an advertising slogan, not a sociological concept. The phrase is based on a gross misunderstanding of what information is and what it's worth. In fact, information is the lowest order of intellectual life. We don't live our lives on the basis of information, but on the basis of ideas, values, intuition, insight, wisdom — none of which are matters of fact or calculation. We live by experience, and machines don't have experience. It is, however, interesting to note that when computers first became prominent, there were those in the counter culture who saw this clever invention as a way of achieving a true democracy. They felt the computer would empower people and communities in ways that would undermine key institutions of business and government. This was actually a sadly mindless idea that never made any sense. Everything about computers has now become corporate and commercial — simply another commodity on the market.

Computers place intellectual resources in the hands of those who can own and control the technology. You and I may be able to access databases and send e-mail around the world, but the system as a whole is dominated by profit-driven entrepreneurs and the military industrial complex. We should recall that during the protest movement, before there were any significant number of affordable computers available, most of what got circulated was done by primitive means: books, magazines, mimeographed papers and pamphlets, broadsides, speeches at rallies, coffee-house conversations — nothing very different from communication in times long past. But the ideas of the time — "content," as it is oddly referred to today by those who run the World Wide Web, almost as if it were an afterthought — were deep; the ethical convictions of people were strong; the issues under discussion were real. And so people felt empowered by those ideas, able to understand and question and resist. These days, you can find millions of people online — in chat rooms and news-

Q: Which leads us directly to the political question. During this period, there was an anti-authoritarianism, a sense of taking matters into one's own hand. At that time, you wrote that the counter culture wanted to "proclaim a new heaven."

A: Like all times of protest, the '60s (as we now conveniently call the period that ran from the end of World War II to the early '70s) favored a vague but definite set of utopian ideals that represented the better world we might be living in: an end to authoritarian political systems, an end to international violence, fair shares for all. Not that everybody in the streets campaigning for peace and justice agreed on the same means of achieving those goals. There were, for example, Marxists and Maoists who wanted to control the commanding heights — in the name of the people, of course (I say that sarcastically). But beyond conventional left-wing notions of that kind, there was a pretty definite consensus — especially, though hardly exclusively, among the younger American generation — that these older ideological models were defunct. Marxism, for example, has never had that strong a following on the university campuses of the United States. Marxism, in any case, looked like daddy's revolution. You recall the remark that became a slogan of the students of Paris in 1968: "Je suis un marxiste — tendance Groucho." Those same students talked about taking up the pavement of Paris to find the raw earth beneath. In general, the protest of the period followed anarchist lines, whether realistically or not. The classic anarchist orientation has been to pay attention to issues of scale, opposing bigness as being inherently bad because it is inherently centralized. In the '60s numerous experiments were launched to create alternative, nonauthoritarian institutions — in education, politics, the workplace, the family, the professions — where eccentricity, diversity, personal taste, and initiative might not simply be permitted but encouraged. Let's admit that those who dropped out of big, top-down mainstream institutions in order to find a more human scale were rarely successful in designing alternatives to industrial society. They were often too impatient, too inexperienced, too transient. But let's also admit that nobody since then has found a way to turn urban-industrial society into a true, participative democracy. I believe it was one of the great

Fig. 2. Bob Dylan in concert, Florence, May 30, 2000.

groups — but most of what I see there is confused, self-pitying, abusive, foul-mouthed, and fruitlessly angry. Until we reassess the role of information in our lives and the limitations of digital technology, we will never make the best use of computers.

Q: What about the search for an "enlightened ecology," as you wrote about in Person/Planet: The Creative Disintegration of Industrial Society and The Voice of the Earth? Another legacy of the '60s?

A: It's clear enough that urban-industrial culture is placing an enormous strain on the most basic ecological systems of the Earth. That's a challenge of life-and-death significance. But we now know that the planet has continually adjusted to such challenges over the entire course of evolutionary history, from the time it had to find a way to prevent oxygen-producing organisms from incinerating the atmosphere. Within that context, the problems our contemporary industrial culture is raising should be well within the capacity of the Earth to balance and ameliorate — though not necessarily in ways that our species would prefer. But in dealing with an intelligent species, the great changes needed would have to show up as cultural values, matters of mind that would influence us to behave differently. The fact that these show up as cultural changes wouldn't mean they were not also of ecological relevance. My idea is that many of the cultural innovations of our time might be grounded in an underlying planetary need for balance, specifically the need to break down big, centralized, social and economic structures. So then, consider the desperate need people in the advanced urban industrial societies seem to feel for more personal recognition and personal autonomy, the desire to escape prefabricated identities and to do their own thing. Or simply to claim the world's attention and respect for who and what they are: the right to be unique, to be different, to discover and express one's own personality. Once this was the ideal of a few, of Bohemian artists and mad intellectuals.

But today we see this everywhere in popular culture, especially in social movements like women's liberation, gay liberation, ethnic and racial movements for self-determination. (In Person/Planet, I offer pages of examples of groups and movements that arise from this need.) Isn't it clear that such tendencies make demands upon society that are incompatible with technocratic goals? Diversity is the poison of all centralized and authoritarian institutions. So of course we see efforts by those institutions to discourage or destroy or sabotage such tendencies. Big institutions driven by profit and power simply cannot make a place for the divergent micro-identities of the people they dominate. And that, I feel, is where the great political issues of the future will be fought out.

Q: The '60s generation was a young one. Now this baby-boom generation is advancing to elderhood. You have characterized this shift as the "Longevity Revolution." What are the implications of this massive demographic shift?

A: It's astonishing that practically nobody ever anticipated the aging of the boomer generation. It was the most predictable thing in the world and yet it went unnoticed until Social Security actuaries brought up the cost of boomer retirement from about 2010 onwards. Maybe people just couldn't imagine Bob Dylan with wrinkles (Fig. 2), or Mick Jagger going bald. Whatever the reason, the aging of the boomers — and of '60s youth in countries everywhere — has only now come home to us as a significant demographic trend. As boomers move into the elder years, they will tilt our society toward age in many dramatic ways. They will require more health resources and more retirement income; they will control more wealth and more voting power than any other segment of society. For the first time in human history, the old (say, people above age fifty) will outnumber the young. Lately I've been writing on this theme, reminding boomers that they will bear special responsibilities in the coming senior dominance. They will have to set the agenda for the entire society. My hope is that the spirit and imagination and savvy that characterized many boomers in their youth will reemerge and produce sweeping social changes. Above all, I expect the senior dominance to put an end to Social Darwinist ethics: dog-eat-dog and the survival of the fittest, which has dominated the industrial marketplace for generations. The old can't be aggressive competitors. They need help, care, companionship, mutual aid. They need compassion — not as an abstract moral principle, but as a fact of daily life. One comes to see this quite naturally

as one grows older. I expect the boomers — and especially boomer women — to start registering this ethical shift within the next decade.

Q: In your work you are often quoting poets and writers, especially romantic ones as if those very sensible minds foresaw what was awaiting us in our own "Wasteland." But what about contemporary artists of the '60s, those who were making the counter culture with their artistic tools?

A: The major art forms of the protest era were poetry and rock music. You can't imagine the period without its music. That music radically changed what people expected from a popular song. It took on depth and seriousness, and much more inventiveness. This doesn't quite mean the rock singers wrote better songs than Cole Porter or Jerome Kern. They didn't. But they wrote more important songs — songs of social significance. Moreover, the events at which the music was performed — the concerts and love-ins and be-ins — became a new medium of cultural transmission, a sort of spontaneous community of rebellious spirits. The defining features of the music were dissent and self-expression, often knitted together in a kind of prophetical invoca-

tion. The style, as it has been handed on, is still unfortunately thought of as "youthful," so, with a few exceptions like Bruce Springsteen and older, surviving rockers — the music world is dominated by young, often very young performers, many of whom have nothing to offer but their youth. Indeed, one of the regrettable aspects of the '80s and '90s has been the spreading historical amnesia of later generations. The younger generations seem to have no idea what the fury of protest was once all about, that it was connected to real social and moral issues (Fig. 3). It wasn't just an act. It had to do with racial justice, women's rights, environmental sanity, civil liberties, thermonuclear war, the abuse of power, the military industrial complex. This wasn't simply fun and games. It wasn't simply an outrageous, *ecrasez le bourgeois* performance. It wasn't simply being loud or obscene or angry. And it wasn't simply making a lot of fast bucks by way of music-industry hype. **Remove the real issues from the music, and you have nothing left but egotistical noise.** Incidentally, this has something to do, in my views, with Marshall McLuhan's unfortunate influence. In current rock, I see a lot of that. Formulaic rage, attitude, hurt feelings, improvised angst — all of it meant to wow the very young, very stoned crowd out front. Alas! Maybe that's what happens to any art form that's so beholden to entrepreneurs.

Professor of history at California State University/Hayward, **Theodore Roszak** (Chicago, Illinois, U.S., b. 1933) is the author of numerous landmark essays, including *The Making of a Counter Culture* (1969), *Where the Wasteland Ends* (1972), *Person/Planet* (1978), *The Voice of the Earth* (1992), and *The Cult of Information* (1994). He was also editor of *Masculine/Feminine* (1969) and *Ecopsychology: Restoring the Earth, Healing the Mind* (1995). His novels include *The Memoirs of Elizabeth Frankenstein* (1995) and *The Devil and Daniel Silverman* (2003).

Interviewed by Stéphane Baillargeon

Fig. 3. Tomi Ungerer, *Black Power — White Power*, 1967.

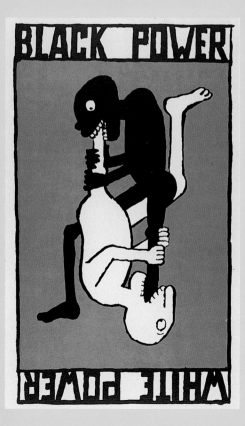

Artist, musician, and activist

Q: In your text <u>Bronze Age</u>, written at the end of the '80s, you recall a moment when "the thought of the sixties flashed in my mind. The air definitely had a special shimmer then. We were breathless from the pride and joy of being alive. I remembered carrying a glass key to open the sky." Can you tell us more about this '60s sky? What sets it apart from that of other moments of history?

A: It was the Age of Awakening for us. We were writing and creating history. We had the acute sense that it was up to us to change the world for the better. It was beautiful!

Q: When you met John Lennon, at an exhibition of your work at the Indica Gallery in London in 1966, you were already an accomplished artist and

Fig. 1. John Lennon and Yoko Ono, *Flower Power,* bed-in for peace, Montreal, May 1969.

recognized as such in America, Japan, and Europe. Your work, which has shaped Fluxus and conceptual art, has an identity of its own. How did this extraordinary relationship change your vision of art and of history?

A: We were kindred spirits. But in many ways I was still living in an ivory tower. John had a clear understanding of how the real world worked.

Q: Among your most striking performances, in 1969 in Amsterdam and then in Montreal, you and John Lennon performed a bed-in (**Fig. 1**) to promote peace in the world. This event still resounds with meaning. Media were manipulated to higher means by two artists. Art and life were combined. Personal love and world peace were united in one simple manifestation. What do you recall from this event?

A: We were totally excited about the idea of doing the event, never doubting that it would be beautiful. The event was beautiful. But we didn't know that we would be strongly attacked and criticized for it.

Q: Marshall McLuhan, in a formula now famous, advanced the notion that "the medium is the message." You wrote instead that "the message is the medium." What did you mean by this?

A: McLuhan was saying that our society, through the revolutionary changes in the form of its medium, not only made a quantitative change in communication, but a qualitative change to the substance of communication. According to McLuhan, the form of communication

Fig. 2. John Lennon and Yoko Ono, "*War Is Over! If You Want It. Happy Christmas from John & Yoko*" billboard in Times Square, 1969–1970.

was the message itself. This was an important philosophical argument. It was a new way of looking at things, which is always a good idea. In fact, McLuhan's theory acutely expressed what was happening in our society. But I was concerned that it might influence our young generation in the wrong way. **By switching the theory around to the "message is the medium," I wanted society to respect substance before form.** Form could be anything, if it had substance. As I feared, however, society has come to celebrate form without substance.

McLuhan is a philosopher. He was giving us something to chew on. I am a dreamer. **I believe in making a qualitative change to society through dreaming together.**

Q: In response to the question "What is the relationship between the world and the artist?" in 1971 you wrote, "The job of an artist is not to destroy but to change the value of things. And by doing that, artists can change the world into a Utopia where there is social freedom for everybody." Can art still change the world today?

A: We, artists, are part of a large group of people who are holding the world together so it will not destroy itself totally (Fig. 2). **The world is divided into two industries: the war industry and the peace industry.** People who participate in the war industry are people who make money on creating weapons, selling weapons, ordering weapons, and using them to create war. People who participate in the peace industry are the rest of us: artists, musicians, florists, bus drivers, farmers — anybody who does not participate in the war industry. The peace industry must flourish more than the war industry. Anybody who participates in the peace industry is somebody who is holding up the sky for all of us. That's what we are doing together. We hope that one day, with our positive visualizing, we can let the war industry disappear altogether. We will.

———————————

Visual artist, musician, filmmaker, writer, and activist, **Yoko Ono** (Tokyo, Japan, b. 1933) has played a central role in the definition of the Fluxus movement and in the emergence of conceptual art in America, Europe, and Japan during the late 1950s and 1960s. She is also considered a forerunner of new music. A public figure since her union with John Lennon, member of the Beatles, in 1966, Yoko Ono has been an indefatigable activist for world peace.

Interviewed by Stéphane Aquin

29

29
C. F. Martin & Co.
Donovan's Guitar
painted by **Patrick (John Byrne)**
late 1960s

155
Porsche GmbH
Janis Joplin's Porsche
painted by **Dave Richards**
about 1968

155

205

Unknown

*"Girls Say Yes to Boys
Who Say No"*
Poster
about 1968

183

Martin Sharp

Bob Dylan
Cover of *OZ*
1967

113

Bonnie MacLean

*Pink Floyd, Lee Michaels,
Clear Light*
Poster
1967

64

James H. Gardner (graphics)
Herb Greene (photographs)

Jefferson Airplane, Grateful Dead
Poster
1967

205

183

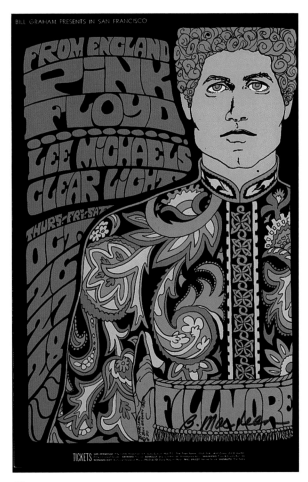

113

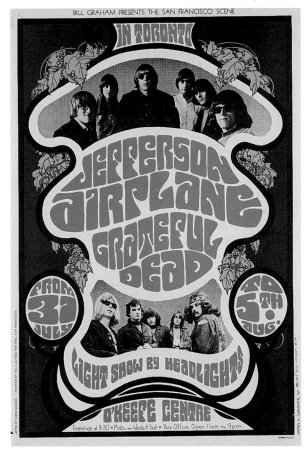

64

182

Bob Schnepf

Lothar and the Hand People,
The Doors, Captain Beefheart &
His Magic Band
Poster
1967

130

Victor Moscoso

The Doors: Break on Through
to the Other Side
Poster
1967

66

Rick Griffin

Jimi Hendrix Experience,
John Mayall and the Blues
Breakers, Albert King
Poster
1968

219

Tom Wilkes

Monterey International
Pop Festival
Poster
1967

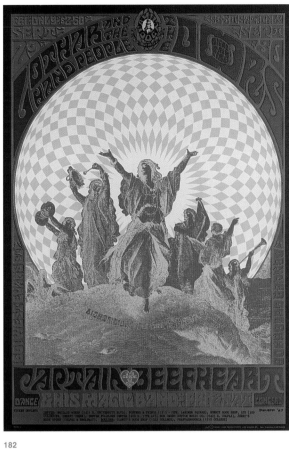

182

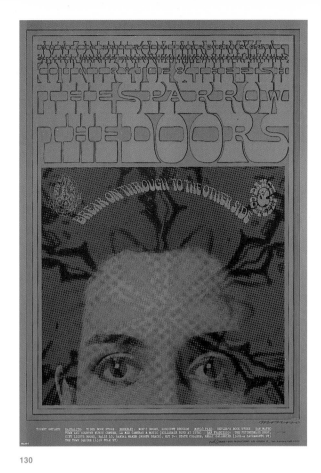

130

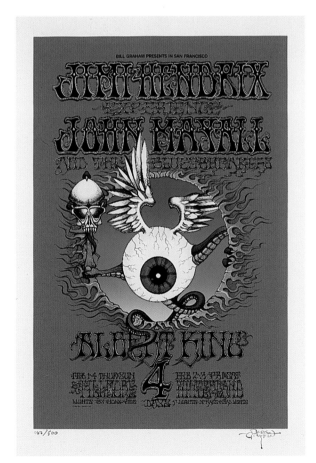

66

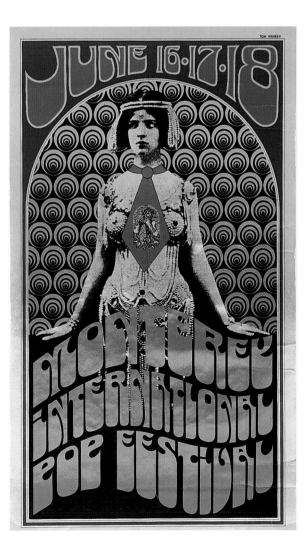

219

140

mean·ing (mēn′iŋ), *n.* 1. what is meant; what is in-
tended to be, or in fact is, signified, indicated, referred
to, or understood: signification, purport, import, sense,
or significance: as, the *meaning* of a word. 2. [Archaic],
intention; purpose. *adj.* 1. that has meaning; signifi-
cant; expressive.

90

63

206

111

147

Giuseppe Penone
8-meter Tree
1969

65

Piero Gilardi
I Sassi (The Rocks) Seating
Units
1967

147

6

67

67
Hans Haacke
Condensation Cube
1963–1965

96
Tetsumi Kudo
*Pollution — Cultivation —
New Ecology*
1971

187
Robert Smithson
Mirrors and Shelly Sand
1969–1970

96

187

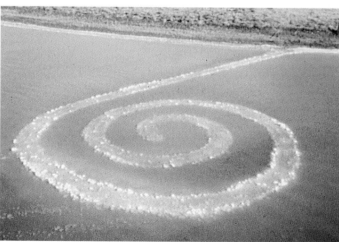

Fig. 1. Robert Smithson,
Spiral Jetty, 1970.

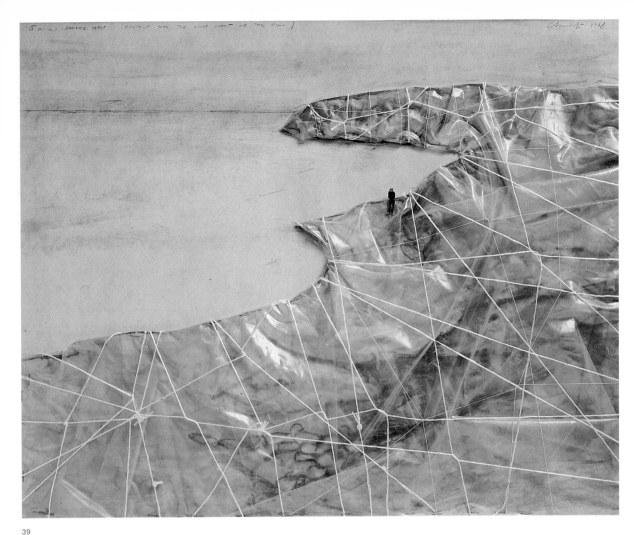

39

Christo
24 km of Packed Coast (Project for the West Coast of the U.S.A.)
1968

3

Raimund Abraham
House with Path (for Jonas Mekas)
1972

40

Christo
Packed Coast, Project for Little Bay, N.S.W., Australia
1969

39

3

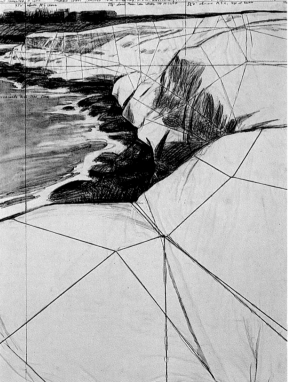

40

48

48
Velma Dozier
Rain Forest Brooch
1969

180
Timo Sarpaneva
Finlandia Vase
1964

220
Tapio Wirkkala
Miracus Vase
1968

202
Jerry N. Uelsmann
Untitled
1965

203
Jerry N. Uelsmann
Untitled
1966

204
Jerry N. Uelsmann
Untitled
1968

202

203

204

45

45
François Dallegret
Judith 69
1969

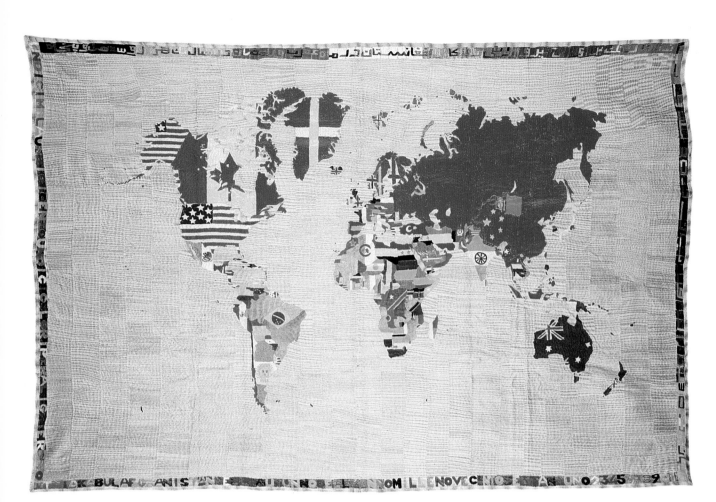

26

26

Alighiero Boetti

Map

1971

23

Joseph Beuys

Sledge

1969

146

Claudio Parmiggiani

Pellemondo

1968

23

CHRONOLOGY

1960

France: explosion, in February, of the first French atomic bomb in the Sahara. France becomes the fourth nuclear power, alongside the U.S., the USSR, and Great Britain.

South Africa: March 21, "Sharpeville Massacre." Police open fire on black demonstrators. Toll: 69 killed and 200 wounded.

USSR: May 1, the Soviets shoot down an American U-2 spy plane, creating a serious diplomatic crisis.

Turkey: in May, bloody military coup d'état.

Algeria: wishing to end the Algerian war, General de Gaulle starts negotiations to bring about self-determination for Algerians.

Canada: June 22, election of Jean Lesage's Liberal government, which undertakes the modernization of Quebec, called the Peaceful Revolution.

Congo Republic (formerly Belgian Congo, now Democratic Republic of Congo): secession of Katanga and start of a bloody civil war in the newly formed country.

Ceylon (Sri Lanka): Sirimavo Bandaranaike is elected prime minister, becoming the first woman in the world to hold this office.

Cyprus is granted independence by Great Britain.

Cuba: Fidel Castro announces the nationalization of all American companies. The United States responds by imposing an embargo on shipments to the island.

Japan: a student linked to the extreme right assassinates the leader of the Socialist Party, Inejiro Asanuma.

United States: November 9, election of Democratic candidate John F. Kennedy as president.

Africa: wave of decolonization. Cameroon, Togo, Belgian Congo, Somalia, Madagascar, Mauritania, Dahomey, the Niger, Nigeria, Upper-Volta (Burkina Faso), Ivory Coast, Chad, Central Africa, French Congo, and French West Africa are granted independence. Many other African states will see this day in the course of the decade: Sierra Leone, Rwanda, Burundi, Uganda, Kenya, Malawi, Zambia, Zanzibar (which federates with Tanganyika to form Tanzania), Gambia, Botswana, Lesotho, Equatorial Guinea, Mauritius.

During this time . . .

- English anthropologist Jane Goodall discovers that chimpanzees can make tools.
- The contraceptive pill is authorized for sale in the United States.
- Brasília, a new town, designed by the architects Lucio Costa and Oscar Niemeyer, replaces Rio de Janeiro as the capital of Brazil.
- Jean-Luc Godard releases À bout de souffle (Breathless). Federico Fellini receives the Palme d'Or at the Cannes Film Festival for La Dolce Vita, a film condemned by the Pope. Michelangelo Antonioni makes L'Avventura (The Adventure) and Alfred Hitchcock reinvents the thriller with Psycho.
- Eugène Ionesco writes Rhinoceros, while Guy Des Cars sells nearly 1.5 million copies of Cette étrange tendresse (A Strange Affection). American poet Anne Sexton releases To Bedlam and Part Way Back.
- The Flintstones appear on American television.
- The writer Albert Camus is killed in a car accident.

1961

Congo Republic: in January, assassination of Prime Minister Patrice Lumumba.

USSR: Yuri Gagarin becomes the first man to travel in space. April 12, he orbits the Earth in the Vostok I rocket.

Cuba: April 17–20, failure of the anti-Castro invasion of the Bay of Pigs.

United States: May 5, the American Alan Shepard makes a 15-minute flight in the Mercury III space capsule. May 25, John F. Kennedy announces to Congress that a man will walk on the moon before the end of the decade. In Montgomery, Alabama, the Freedom Riders encounter racist violence. Attorney general and brother of the president, Robert Kennedy, sends in the federal police.

Kuwait: in June, Great Britain announces the independence of this territory, claimed by Iraq. Confrontation is narrowly avoided.

Berlin: beginning of the building of the Wall during the nights of August 12 and 13. Tensions between the U.S. and the USSR increase.

USSR: Khrushchev begins to sever ties with Peking. The break from China flares up officially when Chou En Lai leaves Moscow prematurely.

Vietnam: the first American troops arrive in South Vietnam to counter the revolutionary goals of North Vietnam.

Israel: in Jerusalem, Adolf Eichmann, the former Nazi in charge of the "Final Solution" in 1941, is sentenced to be hanged.

During this time . . .

- June 16, Rudolf Nuriev, the star Soviet dancer, defects to the West.
- In New York, Weight Watchers is founded by Jean Nidetch, later to be bought by the food company Heinz.
- In London, Amnesty International is established to combat torture and the death penalty.
- Yves Saint Laurent, Christian Dior's successor, founds his own house.
- Michel Foucault publishes his *Histoire de la folie* (A History of Insanity), Jean Genet, *Les Paravents* (The Screens), and William Burroughs, *The Soft Machine*.
- In film, the French New Wave reaches a peak with François Truffaut's *Jules et Jim,* Alain Resnais's *L'Année dernière à Marienbad* (Last Year at Marienbad), Agnès Varda's *Cléo de 5 à 7* (Cleo from 5 to 7), and Jean-Luc Godard's *Une Femme est une femme* (A Woman Is a Woman). John Huston makes *The Misfits*, Marilyn Monroe's last film.
- The Rolling Stones are born. The Beatles make their London debut and Bob Dylan makes his first public appearance in New York.

- Start of the television series *The Avengers*.
- July 2, Louis Ferdinand Céline dies at the age of 68, and Ernest Hemingway commits suicide in Idaho.

1962

United States: February 20, John Glenn is the first American in orbit.

France: March 18, the signing of the Évian agreement recognizes Algerian independence.

Berlin: first victim of the Wall. August 17, Peter Fechter is shot by East German police as he tries to go over to the West.

United States: race riot in Jackson, Mississippi, over the admission of the black student James Meredith to the University of Mississippi. Robert Kennedy sends in the federal police again. Toll: 2 killed and 28 police injured.

Cuba: missile crisis. The United States government, in view of the continued delivery of Soviet weapons to Cuba, declares a partial blockade of the island. Armed confrontation between the two superpowers is narrowly avoided when Khrushchev orders the dismantling of Soviet bases in Cuba on October 28.

During this time . . .

- July 11, first worldwide television broadcast in "mondovision" via the American satellite *Telstar*, launched by NASA for the company AT&T.
- Vatican: Pope Jean XXIII opens the Vatican II Council, aimed at reforming the Catholic ministry and liturgy.
- Renault grants a fourth week of paid vacation to its employees, becoming the standard-bearer of French-style social progress.
- Claude Lévi-Strauss publishes *La Pensée sauvage* (The Savage Mind) and

Marshall McLuhan, *The Gutenberg Galaxy*. In the United States, James Baldwin, novelist, writes *Another Country* and Jack Kerouac, the prince of the Beat movement, *Big Sur*.

- American biologist Rachel Carson writes *Silent Spring*, drawing attention to the perils of chemical pesticides.
- Thalidomide, a drug prescribed to pregnant women, is found responsible for congenital malformations and is banned in several countries.
- Marilyn Monroe commits suicide.
- Stanley Kubrick brings Vladimir Nabokov's novel *Lolita* to the screen. James Bond, agent 007, created by the English writer Ian Fleming, appears in *Dr. No*, with Sean Connery and Ursula Andress.

1963

Haiti: break off in diplomatic relations with the Dominican Republic. May 3, President Duvalier declares martial law.

Vatican: June 3, Pope Jean XXIII dies at the age of 81. Paul VI succeeds him.

Great Britain: Army Minister John D. Profumo is relieved from his duties. He had an affair with the call girl Christine Keeler, who was also seeing an attaché at the Soviet embassy in London.

USSR: the United States, Great Britain, and the Soviet Union sign an agreement in Moscow banning nuclear testing in the atmosphere, on the seas, or in space. The "hot line" is set up between Washington and Moscow.

United States: August 28, in Washington, in front of 250,000 demonstrators for civil rights, the minister Dr. Martin Luther King, Jr., makes his famous speech, "I have a dream."

West Germany: in September, German Chancellor Konrad Adenauer, who led the country since the end of the war, retires from political life.

United States: November 22, President John F. Kennedy is assassinated in Dallas. Vice President Lyndon B. Johnson succeeds him. Two days later, Kennedy's alleged killer, Lee Harvey Oswald, is killed by Jack Ruby in front of millions of stunned television viewers.

During this time . . .

- The Beatles are at the top of the hit parade with their song *She Loves You*, which sells more than a million copies. Beatlemania is born.
- First anniversary of the French magazine *Salut les Copains*. Johnny Hallyday sings in front of 150,000 young people in Paris. The "yé-yé" movement is born.
- Ingmar Bergman makes *The Silence,* Hitchcock, *The Birds,* and Jean-Luc Godard, *Le Mépris* (Contempt) with Brigitte Bardot.
- In literature, Alain Robbe-Grillet writes *Pour un nouveau roman* (For a New Novel). Simone de Beauvoir publishes *La Force des choses* (Force of Circumstance) and Jean-Paul Sartre, *Les Mots* (Words). Allen Ginsberg, the Beat poet, writes *Reality Sandwiches and Later Poems;* Günter Grass writes *Dog Years*. John Le Carré writes his Cold-War masterpiece, *The Spy Who Came in from the Cold*.
- American poet Sylvia Plath commits suicide. Friends Edith Piaf and Jean Cocteau die on the same day, October 11.

1964

USSR/United States: January 25, first Soviet-American space experiment, the *Echo C* satellite launched by NASA, will be jointly managed.

Jerusalem: historic meeting on the Mount of Olives between Pope Paul VI and the head of the Greek Orthodox church, Athenagoras.

Cyprus: in March, the first UN forces are sent to keep the peace between Greek and Turkish Cypriots.

Brazil: April 2, coup d'état and installation of a military régime.

India: May 27, death of Prime Minister Jawaharlal Nehru.

Jordan: founding of the Palestine Liberation Organization (PLO).

Vietnam: the Tonkin Gulf incident, triggered by the attack on a U.S. warship by the North Vietnamese forces, moves Congress to authorize President Johnson to wage an undeclared war on North Vietnam.

South Africa: Nelson Mandela, founder of the African National Congress (ANC), is sentenced to life imprisonment.

USSR: Nikita Khrushchev is dismissed from his post and replaced by Alekseï Nikolaïevitch Kossigin and Leonid Brezhnev. The latter becomes secretary general of the Communist Party.

United States: Martin Luther King, Jr., is awarded the Nobel Peace Prize. Lyndon Baines Johnson is elected president. July 2, President Johnson signs the Civil Rights Act, banning all race and sex discrimination.

During this time . . .

- Intelstat (International Telecommunications Satellite Consortium) is founded by eighteen countries to establish a global communication network.
- The miniskirt is launched by British fashion designer Mary Quant.
- Pope Paul VI condemns the contraceptive pill.
- In London, the House of Commons votes to abolish the death penalty.
- American boxer Cassius Clay, hailed as the world heavyweight champion, converts to Islam and becomes Mohammed Ali.

- First triumphant tours of the Beatles and Rolling Stones in North America. The Supremes typify the Motown sound with *Baby Love*.
- Agnès Varda makes *Le Bonheur* (Happiness), Elia Kazan, *America America*, Sergio Leone, *A Fistful of Dollars*, Satiajit Ray, *The Big City*, Hiroshi Teshigahara, *Woman of the Dunes*. The black American Sidney Poitier wins the Oscar for Best Actor for his role in *The Lilies of the Field*.
- Roland Barthes publishes his *Essais critiques* (Critical Essays) and Jean-Paul Sartre turns down the Nobel Prize.
- *Barbarella*, Éric Losfeld's comic strip, enjoys enormous success.
- The toy company Mattel, producers of Barbie, introduce G.I. Joe to the market.

1965

Great Britain: January 24, Sir Winston Churchill dies in London at the age of 90.

Vietnam: in February, the first American bombing of North Vietnam is followed by the landing of the first American combat troops. In December, their numbers reach 200,000.

United States: February 21, the black American leader Malcolm X is assassinated in Harlem. March 7, a new outbreak of racial violence in Birmingham, Alabama, becomes known as Bloody Sunday.

USSR/United States: in March, the Soviet cosmonaut Alekseï Leonov makes the first space walk, tied to the *Voskhod II* spaceship with an "umbilical cord." June 3, the American astronaut Edward White leaves the *Gemini IV* capsule for a weightless spacewalk lasting twenty minutes.

United States: April 17, in Washington, first public demonstration against the Vietnam War. In October, simultaneous demonstrations take place in forty American cities.

Dominican Republic: military coup d'état. American troops land in Santo

Domingo on April 29. Under international pressure, the United States withdraws on June 3.

United States: in August, race riots in the run-down district of Watts in Los Angeles. Death toll: 35. Triumphant return of the American capsule *Gemini V*. The record for longest space flight has just been broken.

Pakistan: despite a ceasefire with India, fighting over the dispute of the Kashmir increases.

Philippines: Ferdinand Marcos becomes president.

Africa: in the Central African Republic, General Bokassa takes power. A wave of military coups d'état follows: Nigeria (January 1966), Ghana (February 1966), Sierra Leone (March 1967), Dahomey (December 1967), and the Congo (August 1968).

During this time . . .

- Opening of the Mont Blanc tunnel between France and Italy.
- In music, the first notes of youth revolt can be heard: Bob Dylan sings *Like a Rolling Stone*, the Rolling Stones, *Satisfaction*, the Who, *My Generation*.
- Norman Mailer publishes *An American Dream*. Georges Perec is awarded the Prix Renaudot for *Les Choses* (The Things). Wole Soyinka writes *The Interpreters*. Louis Althusser helps to spread Marxist thought with *Pour Marx* (For Marx) and *Lire le capital* (Reading Capital).
- Godard makes *Pierrot le fou* (Crazy Pete).

1966

India: Indira Gandhi, daughter of Jawaharlal Nehru, becomes prime minister.

USSR/United States: February 3, the Soviet probe *Luna IX* makes a "soft" landing on the moon. In June, the American lunar probe *Surveyor I* lands on the moon and sends back pictures of the lunar surface.

China: April 18, start of the Great Proletarian Cultural Revolution led by Mao Tse-Tung, whose *Little Red Book* is published with 35 million copies.

United States: black leader Stokely Carmichael launches the slogan "Black Power" for the first time in public, in Greenwood, Mississippi. In Oakland, California, Bobby Seale founds the Black Panther party. In July, violent race riots in Chicago. The protest movement spreads to Omaha, Cleveland, and Dayton. The National Guard is called in as reinforcements.

South Africa: September 6, assassination of Prime Minister Hendrik Verwoerd in the middle of a parliamentary session. September 13, the segregationist Johannes Vorster becomes prime minister.

USSR: The Soviet Communist Party condemns the Chinese cultural revolution and expels Chinese students.

During this time . . .

- India suffers the worst famine in twenty years.
- Florence is flooded by torrential rain: major damage to historic buildings.
- Courrèges revolutionizes French fashion with his "gauchos." Twiggy is the top model in London and Paris.
- The TV science-fiction series *Star Trek* proves a great success from the very beginning.
- The psychedelic counter culture is born in California. The first hippie communes appear in the Haight-Ashbury district of San Francisco. LSD is declared illegal in the United States.
- Antonioni makes *Blow-Up*, Roman Polanski, *Cul de Sac*, and Andy Warhol, *Chelsea Girls*.

- Jacques Lacan publishes his *Écrits*, Susan Sontag, *Against Interpretation*, Michel Foucault, *Des mots et des choses* (The Order of Things). In the USSR, the writers Siniavski and Daniel are accused of having published abroad works considered subversive.
- Betty Friedan founds the National Organization for Women (NOW).

1967

Nicaragua: General Anastasio Somoza is elected president of the republic.

United States: April 15, 100,000 people demonstrating against the Vietnam War follow Martin Luther King, Jr., in the peace march in New York, outside the UN building.

Greece: coup d'état by the "Colonels" Papadopoulos and Patakos in Athens. More than 6,000 opponents of the régime are interned on the island of Yaros.

Nigeria: in May, Biafra declares independence. The civil war that results is responsible for a million dead Biafrans, systematically starved by the Nigerians.

Middle East: Six-Day War. Israel, victor over Egypt, Syria, and Jordan, accepts the cease-fire proposed by the UN, but refuses to comply with resolution 242, which orders Israel to leave the conquered territories, Sinai, the West Bank, East Jerusalem, the Gaza Strip, and the Golan.

Canada: July 23, during a visit to Montreal, De Gaulle encourages Quebec separatism by calling, "Long live free Quebec!"

United States: in July, beginning of a wave of bloody race riots in Newark (23 dead), then Detroit (43 dead).

Bolivia: October 8, murder of Ernesto "Che" Guevara, revolutionary hero of Latin America, by Bolivian troops.

United States: October 22, further demonstrations against the Vietnam War in Washington. More than 500,000 American soldiers are deployed on Vietnamese soil.

Iran: October 26, Mohammad Reza Pahlavi is crowned Shah.

Romania: December 9, Nicolae Ceausescu is elected president of the Council of State.

During this time . . .

- France is hit by an unprecedented oil spill, caused by the sinking of the super-tanker *Torrey Canyon*.
- First heart transplant by Dr. Christian Barnard in Cape Town, South Africa. The 53-year-old patient, Louis Washkansky, survives for eighteen days.
- The International Exhibition of 1967, Montreal opens on April 27 with the theme of "Man and His World". "Expo '67" will welcome 50 million visitors.
- The hippie movement is in full swing. In San Francisco, the first "Human Be-in" takes place, bringing together 50,000 people to see Timothy Leary, Allen Ginsberg, the Grateful Dead, and Jefferson Airplane. In June, the pop festival Music, Love and Flowers is held in Monterey, California. It's the "summer of love."
- The Beatles sing *Lucy in the Sky with Diamonds*, the Rolling Stones, *Ruby Tuesday*, and Jimi Hendrix, *Purple Haze*.
- World boxing champion Mohammed Ali is sentenced to five years in prison for refusing to take an oath of allegiance to the American flag.
- Norman Mailer publishes *Why Are We in Vietnam?* Guy Debord creates *La Société du spectacle* (The Society of the Spectacle), Jacques Derrida, *L'Écriture et la Différence* (Writing and Difference), Gabriel Garcia Marquez, *One Hundred Years of Solitude,* and Milan Kundera, *The Joke.*
- Dustin Hoffman in *The Graduate* personifies youth rebellion.

- On television, *The Prisoner*, played by the enigmatic Patrick McGoohan, shouts, "I am not a number, I am a free man!"

1968

Vietnam: Tet offensive. For the Vietnamese new year, the Viet Cong launch a devastating offensive against more than a hundred towns and military bases in the south of Vietnam. The United States requests reinforcements.

Poland: in March, violent clashes between police and students at a peace demonstration.

France: incidents at the University of Nanterre, near Paris, and founding of the March 22 Movement by Daniel Cohn-Bendit.

Italy: student strikes spread.

United States: April 4, Martin Luther King, Jr., is assassinated in Memphis, Tennessee. His death sparks riots in more than 150 cities nationwide.

Canada: April 22, Pierre Elliott Trudeau becomes prime minister, promising a "just society."

France: May, Paris is the scene of an unprecedented student and worker uprising. France is paralyzed by a spontaneous national strike. The Sorbonne is declared a free commune and Nanterre a self-governing university. Many student demonstrations occur in Italy, Belgium, the Netherlands, Germany, Yugoslavia, Japan, Brazil, and Senegal.

United States: June 16, Senator Robert Kennedy, Democratic presidential candidate, is assassinated in Los Angeles.

Mexico: on the eve of the Olympic Games in Mexico City, bloody confrontations between students and police.

Israel: growing hostility with Palestine, Israeli air-raid against Palestinian hit-squad camps.

Czechoslovakia: August 20, end of the Prague Spring, the city is invaded by Warsaw Pact troops.

Mexico: at Tlatelolco, October 2, the army fires on students, killing several hundred.

United States: October 31, President Johnson orders a complete halt to the bombing of North Vietnam. November 4, presidential elections result in victory for Republican candidate Richard Nixon.

During this time . . .

- The USSR inaugurates the Tupolev 144, the first supersonic commercial aircraft.
- March 27, the Soviet cosmonaut Yuri Gagarin is killed in a plane accident. The whole country mourns.
- Alexander Solzhenitsin writes *The Cancer Ward*, selling nearly a million copies. The following year he is expelled from the Union of Soviet Writers.
- Black Panther member Eldridge Cleaver publishes *Soul on Ice*. American poet Lawrence Ferlinghetti publishes *Love in the Days of Rage* with May '68 as its backdrop, and his Beat colleague Allen Ginsberg writes *Planet News*.
- Roger Vadim adapts *Barbarella* for the screen and Stanley Kubrick directs *2001: A Space Odyssey*. Roman Polanski makes *Rosemary's Baby,* and François Truffaut, *Stolen Kisses*.
- Maurice Béjart creates *Messe pour le temps present* (Mass for the Present Time) in Avignon. In New York, the Living Theater presents *Paradise Now*. The musical *Hair* enjoys phenomenal success.
- The Beatles sing *Hey Jude*, Steppenwolf, *Born to Be Wild*, and the Rolling Stones release *Sympathy for the Devil*. Leonard Cohen releases *The Songs of Leonard Cohen*.

- At the Olympic games in Mexico City, American athletes Tommie Smith and John Carlos raise their fists on the victory rostrum in solidarity with Black Power. At the Grenoble Olympic Games, French skier Jean-Claude Killy triumphs, winning three gold medals for downhill, giant slalom, and slalom.

1969

Palestine: Yasser Arafat is elected president of the executive committee of the Palestine Liberation Organization (PLO).

Israel: Golda Meir becomes prime minister.

France: in April, General de Gaulle resigns from office. Georges Pompidou later succeeds him as president of the Fifth Republic.

United States: in May, violent demonstrations at the University of California/Berkeley. Richard Nixon announces the withdrawal of 25,000 American soldiers from Vietnam.

South America: bloody student riots in Argentina, Ecuador, and Peru.

Moon: July 21, the *Apollo XI* lands on the moon. Astronauts Neil Armstrong's and Edwin Aldrin's walk on the moon is watched by one billion television viewers: "One small step for man, one giant leap for mankind."

Northern Ireland: in August, violent confrontations between Catholics and Protestants in Belfast and Londonderry in Ulster. In October, for the first time, the British army opens fire on demonstrators in Belfast.

Syria: a TWA Boeing with 106 passengers, including six Israelis, is hijacked to Damascus. December 5, thirteen Syrian prisoners are exchanged for the last two passengers of the hijacked plane.

Libya: Colonel Gadhafi proclaims a republic.

Vietnam: Ho Chi Minh, president of the Democratic Republic of Vietnam, dies in Hanoi on September 3.

United States: on November 13 and 14, a demonstration brings 250,000 people to Washington to protest the Vietnam War.

United States: President Nixon announces the withdrawal of 35,000 more soldiers from Vietnam by December 15.

India: major religious disturbances in the Federal Indian State of Gujerat leave 600 dead.

West Germany: Willy Brandt becomes chancellor.

During this time . . .

- In Toulouse, first flight of the Concorde. In the United States, first test-flight of the largest passenger plane, the Boeing 747 Jumbo Jet.
- From August 13 to 15, 400,000 young people attend the Woodstock Music Festival. December 6, in Altamont, California, the concert given by the Rolling Stones before an audience of 300,000 is marked by violence.
- John Lennon and Yoko Ono protest the Vietnam War by holding "bed-ins" in Amsterdam, then Montreal. Serge Gainsbourg announces that 1969 will be an "erotic year" and sings *Je t'aime . . . moi non plus* with Jane Birkin.
- Herbert Marcuse publishes *An Essay on Liberation*, Michel Foucault, *Archéologie du Savoir* (The Archeology of Knowledge), and Theodore Roszak, *The Making of a Counter Culture*.
- The film *Easy Rider*, starring Peter Fonda and Dennis Hopper, rocks American public opinion. The counter culture has found its tragic heroes.
- In California, Charles Manson and four members of his community, the "Family," kill seven people including the actress Sharon Tate, Roman Polanski's wife.
- The maxidress replaces the miniskirt.

1970

Nigeria: final defeat for Biafran separatists.

United States: President Nixon announces that American and South Vietnamese troops are in Cambodia. In May, at a demonstration at Kent State University, Ohio, against American intervention in Cambodia, National Guardsmen kill four students.

Northern Ireland: in June, the arrest of Bernadette Devlin, a Catholic member of the British Parliament, causes further fighting and the arrival on the scene of the IRA (Irish Republican Army).

Egypt: the death of Nasser, the president of the Republic since 1954, is the deathblow for the Rogers peace plan with Israel.

Canada: October Crisis. Following the assassination of the Quebec minister Pierre Laporte by members of the FLQ (Front de libération du Québec), the federal government declares marshal law and occupies Quebec militarily.

Chile: the socialist Salvador Allende is elected president.

During this time . . .

- Alexander Solzhenitsin is awarded the Nobel Prize. Richard Bach releases the best-seller *Jonathan Livingston Seagull*. Germaine Greer publishes *The Female Eunuch*.
- Robert Altman is awarded the Palme d'Or for *M.A.S.H.* and Éric Rohmer, the Louis Delluc prize for *Le Genou de Claire* (Claire's Knee).
- The Beatles sing *Let It Be* and split up. Janis Joplin dies of a heroin overdose and Jimi Hendrix dies in London two weeks after his final concert at the Love and Peace Festival in Germany.

LIST OF EXHIBITED WORKS

1 [ill. p. 62]
Raimund Abraham
born in Lienz, Austria, in 1933
Air-Ocean City
1966
collage on cardboard
23.7 x 14.2 cm
Frankfurt am Main, Deutsches
Architektur Museum

2 [ill. p. 62]
Raimund Abraham
born in Lienz, Austria, in 1933
Continuous Building
1966
collage on cardboard
30.4 x 16.1 cm
Frankfurt am Main, Deutsches
Architektur Museum

3 [ill. p. 180]
Raimund Abraham
born in Lienz, Austria, in 1933
*House with Path (for Jonas
Mekas)*
1972
graphite and colored pencil
on paper
29.7 x 47.7 cm
Frankfurt am Main, Deutsches
Architektur Museum

4 [ill. p. 144]
Diane Arbus
New York 1923 – New York 1971
*A Naked Man Being a Woman,
N.Y.C., 1968*
1968, print 1973
gelatin silver print
36.3 x 37.4 cm
Ottawa, National Gallery of
Canada, purchase, 1977

5 [ill. p. 60]
Archigram
Ron Herron project
1930–1994
Walking City
1964
print with pencil shading
59 x 86 cm
Paris, Centre Georges
Pompidou, Musée national d'art
moderne / Centre de création
industrielle, purchase, 1992

6 [ill. p. 61]
Archigram
Ron Herron project
1930–1994
*Instant City: Urban Action —
Tune Up*
1969–1970
collage
58 x 76 cm
Paris, Centre Georges
Pompidou, Musée national d'art
moderne / Centre de création
industrielle, purchase, 1992

7 [ill. p. 91]
**Arman (Armand Pierre
Fernandez)**
born in Nice in 1928
Warhol's Garbage
1969
found objects under Plexiglas
127 x 93 x 13 cm
Nice, Musée d'Art moderne
et d'Art contemporain

8 [ill. p. 149]
Robert Arneson
Benicia, California, 1930 –
Benicia, California, 1992
Camera
1965
ceramic
13.3 x 17.8 x 12.7 cm
private collection, courtesy
Franklin Parrasch Gallery,
New York

9 [ill. p. 90]
Richard Artschwager
born in Washington, D.C.,
in 1923
Counter II
1964
formica on wood, metal turnstile
181 x 91.4 x 53.3 cm
Épinal, Musée départemental
d'art ancien et contemporain

10 [ill. p. 54]
Richard Artschwager
born in Washington, D.C.,
in 1923
*Chair, Chair, Sofa, Table,
Table, Rug*
1965
acrylic on Celotex, metal frame
58.7 x 104.5 cm
collection of Jill Sussman and
Samson Walla

11 [ill. p. 137]
Richard Avedon
born in New York in 1923
*Andy Warhol, artist. New York
City, 8-20-69*
1969, print 1975
gelatin silver print
25.1 x 20.1 cm
Courtesy Fraenkel Gallery,
San Francisco

12 [ill. p. 139]
Pierre Ayot
Montreal 1943 – Montreal 1995
*My Mother Returning from Her
Shopping*
1967
silkscreen, 9/45
76.2 x 56.8 cm
The Montreal Museum of Fine
Arts, gift of Madeleine Forcier

13 [ill. p. 50]
Gijs Bakker
born in Amersfoort,
Netherlands, in 1942
Circle in Circle Bracelets
1968
aluminum, anodized aluminum
13.5 cm (diam.)
's-Hertogenbosch, Netherlands,
Museum for Contemporary Art

14 [ill. p. 82]
Thomas F. Barrow
born in Kansas City, Missouri,
in 1938
Computer Balloon
1968
gelatin silver print
13.6 x 34.4 cm
Ottawa, National Gallery of
Canada, purchase, 1969

15 [ill. p. 82]
Thomas F. Barrow
born in Kansas City, Missouri,
in 1938
Portrait of R. F.
1968
gelatin silver print
10.8 x 34.1 cm
Ottawa, National Gallery of
Canada, purchase, 1969

16 [ill. p. 55]
Fred Forde Bassetti
born in Seattle in 1917
Flexagons Construction Set
(No. 500)
about 1960
cardboard, elastic
produced by Forde Corporation
triangular pieces: 10.4 x 10.4 x
10.4 cm
square pieces: 10.9 x 10.9 cm
Montreal, Centre canadien
d'architecture / Canadian Centre
for Architecture

17 [ill. p. 50]
Félix Beltrán
born in Havana in 1938
*"Otras manos empuñaran
las armas"*
(Others Will Take Up Arms)
1969
poster: silkscreen
produced for ICAP
54.7 x 33.3 cm
The Montreal Museum of
Fine Arts, gift in memory
of Vera J. Bala

18 [ill. p. 125]
Félix Beltrán
born in Havana in 1938
*"Otras manos empuñaran
las armas"*
(Others Will Take Up Arms)
1969
poster: silkscreen
produced for ICAP
54.7 x 33.3 cm
The Montreal Museum of
Fine Arts, gift in memory
of Vera J. Bala

19 [ill. p. 125]
Félix Beltrán
born in Havana in 1938
*"Otras manos empuñaran
las armas"*
(Others Will Take Up Arms)
1969
poster: silkscreen
produced for ICAP
54.7 x 33.3 cm
The Montreal Museum of
Fine Arts, gift in memory
of Vera J. Bala

20

Félix Beltrán

born in Havana in 1938

"Y convertiremos el revés
en victoria"

(We Will Change Failure into
Victory)

1969

poster: silkscreen

produced for ICAP

54.7 x 33.3 cm

The Montreal Museum of
Fine Arts, gift in memory
of Vera J. Bala

21 [ill. p. 136]

Ben (Benjamin Vautier)

born in Naples in 1935

Mon envie d'être le seul

(My Desire To Be the Only One)

from the series "Introspections"

1967

acrylic on canvas

105 x 105 cm

Paris, Centre Georges
Pompidou, Musée national d'art
moderne / Centre de création
industrielle, purchase, 1996

22 [ill. p. 141]

Wallace Berman

New York 1926 – Topanga
Canyon, California, 1976

Untitled

1964

Verifax collage

18 x 25 cm

collection of Dennis Hopper

23 [ill. p. 184]

Joseph Beuys

Krefeld, Germany, 1921 –
Düsseldorf 1986

Sledge

1969

wood, metal, wax, felt, cotton,
flashlight, 41/50

René Block Edition, Berlin

39 x 91 x 35.5 cm

The Montreal Museum of Fine
Arts, gift of Dr. Paul Mailhot

24

Peter Blake

born in Dartford, Kent, in 1932

Sgt. Pepper's Lonely Hearts
Club Band

1967

album cover: offset halftone plate

produced by MC Productions

31.6 x 31.6 cm

The Montreal Museum of Fine
Arts, Liliane and David M.
Stewart Collection

25

Bless Be

Necktie

1963–1969

printed cotton

144.2 x 10.2 cm

New York, The Museum at the
Fashion Institute of Technology

26 [ill. p. 184]

Alighiero Boetti

Turin 1940 – Rome 1994

Map

1971

embroided tapestry

147 x 230 cm

Turin, private collection

27 [ill. p. 133]

Manuel Alvarez Bravo

Mexico City 1902 – Mexico City
2002

The Walls Tell All

1968

gelatin silver print

16 x 24.1 cm

Pasadena, California, Norton
Simon Museum, purchase
through the Florence V. Burden
Foundation, 1971

28 [ill. p. 149]

Marcel Broodthaers

Brussels 1924 – Brussels 1976

L'Œil (The Eye)

1966

glass, paper, magazine image

29 cm (h.); 9 cm (diam.)

Belgium, Collection Dubaere

29 [ill. p. 170]

C. F. Martin & Co.

Donovan's Guitar; painting by
Patrick (John Byrne), born in
Paisley, Scotland, in 1940

Late 1960s

acrylic paint

100 x 38 x 10 cm

County Cork, Ireland, Donovan
Archive Collection

30

Pierre Cardin

born in San Andrea da Barbara,
Italy, in 1922

Necktie

1965–1970

printed silk

139.7 x 9.5 cm

New York, The Museum at the
Fashion Institute of Technology

31 [ill. p. 100]

Cesare Maria Casati

born in Milan in 1936

Emanuele Ponzio

Pillola (Pill) Table Lamps

1968

ABS, acrylic

produced by Ponteur

55.1 cm (h. with base);
13.3 cm (diam.)

The Montreal Museum of Fine
Arts, Liliane and David M.
Stewart Collection

32 [ill. p. 45]

Enrico Castellani

born in Castelmassa, Italy,
in 1930

Black Surface

1959

acrylic on canvas

80 x 50 cm

Prada Collection

33 [ill. p. 80]

César (César Baldaccini)

Marseilles 1921 – Paris 1998

Television Ensemble

1962

welded and painted sheet metal,
television under Plexiglas,
casters

166 x 76 x 50 cm

Paris, Centre Georges
Pompidou, Musée national d'art
moderne / Centre de création
industrielle, gift of Baron Elie de
Rothschild, Paris, 1980

34 [ill. p. 59]

John Chamberlain

born in Rochester, Indiana,
in 1927

Untitled

1964

crushed bodywork

76.2 x 91.5 x 61 cm

Nice, Musée d'Art moderne et
d'Art contemporain, purchase,
1989

35 [ill. p. 118]

Christo and Jeanne-Claude

both born on June 13, 1935

Christo born in Gabrovo,
Bulgaria

Jeanne-Claude born in
Casablanca

Iron Curtain – Wall of Oil Barrels,
Rue Visconti, Paris, 1961–1962

photomural, 1962

300 x 200 cm

lent by Christo and Jeanne-
Claude

© Christo 1962

Photo Jean-Dominique Lajoux

36 [ill. p. 92]

Christo

born in Gabrovo, Bulgaria,
in 1935

Wrapped Magazines on a Stool

1963

polyethylene, twine, rope,
magazines, wooden stool

54.5 x 35.5 x 43 cm

collection of Anthony Haden-
Guest

© Christo 1963

Photo David Schlegel

37 [ill. p. 134]

Christo

born in Gabrovo, Bulgaria,
in 1935

Wedding Dress and Evening
Dress, Project for the Arts
Council, Philadelphia

collage, 1967

pencil, enamel paint, wax crayon,
tracing paper, printed paper

56 x 71 cm

lent by Christo and Jeanne-
Claude

© Christo 1967

Photo Christian Baur

38 [ill. p. 134]

Christo

born in Gabrovo, Bulgaria,
in 1935

Wrapped Dress, Project for a
Wedding Dress

collage, 1967

photograph, pencil, charcoal,
crayon, enamel paint

56 x 71 cm

lent by Christo and Jeanne-
Claude

© Christo 1967

Photo Christian Baur

39 [ill. p. 180]

Christo

born in Gabrovo, Bulgaria,
in 1935

24 km of Packed Coast (Project
for the West Coast of the U.S.A.)

collage, 1968

colored pencil, crayon, oil paint,
charcoal, graphite, polyethylene,
string, staples

55.9 x 71.6 cm

Philadelphia Museum of Art, gift
of Mr. and Mrs. Nathaniel Lieb:
Centennial Gift, 1977

© Christo 1968

Photo Courtesy of the
Philadelphia Museum of Art;
Photo Graydon Wood, 2000

40 [ill. p. 180]

Christo

born in Gabrovo, Bulgaria,
in 1935

Packed Coast, Project for Little
Bay, N.S.W., Australia

collage, 1969

pencil, charcoal, twine, rope

71.1 x 55.9 cm

lent by Christo and Jeanne-
Claude

© Christo 1969

Photo Harry Shunk

41 [ill. p. 146]

Chuck Close

born in Monroe, Washington,
in 1940

Nancy

1968

acrylic on canvas

275.3 x 208.9 cm

Milwaukee Art Museum, gift of
Herbert H. Kohl Charities, Inc.
(formerly HHK Foundation for
Contemporary Art, Inc.)

42 [ill. p. 102]

Joe Colombo

Milan 1930 – Milan 1971

Smoke Goblets

1964

blown and molded glass

produced by Arnolfo di Cambio
Compagnia Italiana del Cristallo
s.r.l.

from left to right:

champagne glass:
17.5 cm (h.); 4.2 cm (diam.)

water glass:
16 cm (h.); 6.7 cm (diam.)

wine glass:
12.2 cm (h.); 6.8 cm (diam.)

spirits glass:
13 cm (h.); 6.3 cm (diam.)

whiskey glass:
10 cm (h.); 8.7 cm (diam.)

The Montreal Museum of Fine
Arts, Liliane and David M.
Stewart Collection

43 [ill. p. 44]
François Dallegret
born in Port-Lyautey, Morocco,
in 1937
Atomix — *1966*
1966
Plexiglas, stainless steel
12.6 x 12.6 x 2.8 cm
collection of François Dallegret

44
François Dallegret
born in Port-Lyautey, Morocco,
in 1937
Mini Atomix — *1966*
1966
Plexiglas, stainless steel
7.8 x 7.8 x 2.1 cm
collection of François Dallegret

45 [ill. p. 183]
François Dallegret
born in Port-Lyautey, Morocco,
in 1937
Judith 69 (triptych)
1969
inkjet prints, 1/3
30.5 x 22.9 cm (each)
collection of François Dallegret

46 [ill. p. 50]
Jonathan De Pas
Milan 1932 – Florence 1991
Donato D'Urbino
born in Milan in 1935
Paolo Lomazzi
born in Milan in 1936
Carla Scolari
Blow Armchair
1967
PVC
produced by Zanotta S.p.A.
76 x 83 x 98 cm
The Montreal Museum of Fine
Arts, Liliane and David M.
Stewart Collection

47 [ill. p. 97]
Jonathan De Pas
Milan 1932 – Florence 1991
Donato d'Urbino
born in Milan in 1935
Paolo Lomazzi
born in Milan in 1936
Carla Scolari
Joe Sofa
1970
polyurethane foam, leather
produced by Poltronova S.p.A.
94 x 191 x 120 cm

The Montreal Museum of Fine
Arts, Liliane and David M.
Stewart Collection, gift of the
American Friends of Canada
through the generosity of
Eleanore and Charles Stendig in
memory of Eve Brustein and
Rose Stendig

48 [ill. p. 181]
Velma Davis Dozier
Waco, Texas, 1901 – Dallas
1988
Rain Forest Brooch
1969
cast gold
4.8 x 3.5 x 1 cm
Dallas Museum of Art, gift of Otis
and Velma Dozier

49 [ill. p. 102]
Henry Dreyfuss
New York 1904 – South
Pasadena, California, 1972
Swinger Camera (Land Camera
Model 20)
about 1965
plastic, rubber, steel
produced by Polaroid
Corporation
12.8 x 15.4 x 13 cm
The Montreal Museum of Fine
Arts, gift of Charles L. Venable
and Martin K. Webb in honor of
Guy Cogeval

50 [ill. p. 53]
Gordon Duern
born in 1916
Keith McQuarrie
born in 1933
Apollo 861 Record Player
1966
smoked Plexiglas, brushed
aluminum
produced by Electrohome
Limited
turntable:
28 cm (h.); 46.2 cm (diam.)
speakers:
20 cm (h.); 19 cm (diam.)
Electrohome Limited

51 [ill. p. 122]
**Erró (Gudmundur
Gudnumdsson)**
born in Olafsvik, Iceland, in 1932
American Interior No. 7
1968
oil on canvas
97 x 115 cm
Aix-la-chapelle, Ludwig Forum,
Collection Ludwig

52 [ill. p. 88]
Öyvind Fahlström
São Paulo 1928 – Stockholm
1975
ESSO-LSD
1967
plastic, edition of 5
89.1 x 127 x 14.9 cm (each)
Chicago, The Art Collection of
Bank One

53 [ill. p. 131]
Dan Flavin
Jamaica, New York, 1933 –
Riverhead, New York, 1996
*Monument 4 for Those Who
Have Been Killed in Ambush
(To P. K. Who Reminded Me
about Death)*
1966
fluorescent light tubes, 2/3
182.9 x 182.9 cm
Estate of Dan Flavin

54 [ill. p. 45]
Lucio Fontana
Rosario di Santa Fe, Argentina,
1899 – Varese, Italy, 1968
*Spatial Concept, Expectations
1 + 1419*
1959–1960
oil on canvas
90 x 80 cm
Société de la Place des Arts de
Montréal, gift of Mr. and Mrs.
Guy de Repentigny

55 [ill. p. 58]
Robert Freeman
born in London in 1936
Park Lane, London, 1961
1961, print 2003
gelatin silver print
50.7 x 40.6 cm
collection of the artist

56 [ill. p. 62]
Robert Freeman
born in London in 1936
*Silhouette on Map, Stuttgart,
1961*
1961, print 2003
fiber print
29.6 x 50.8 cm
collection of the artist

57 [ill. p. 96]
Robert Freeman
born in London in 1936
A Hard Day's Night
1964, print 2003
color print from original
two-tone negative
40.6 x 42.1 cm
collection of the artist

58 [ill. p. 82]
Lee Friedlander
born in Aberdeen, Washington,
in 1934
Florida
1963, later print
gelatin silver print
28 x 36 cm
Courtesy Fraenkel Gallery,
San Francisco

59 [ill. p. 87]
Lee Friedlander
born in Aberdeen, Washington,
in 1934
Monsey, New York
1963, later print
gelatin silver print, 1/25
50.8 x 61 cm
collection of Mathew and Ann
Wolf

60a
Gérard Fromanger
born in Jouars-Pontchartrain,
France, in 1939
Rouge 1968
1968
with the collaboration of Jean-
Luc Godard
film tract, color, silent
running time: 2.5 min.
lent by Gérard Fromanger

60b
Gérard Fromanger
born in Jouars-Pontchartrain,
France, in 1939
Rouge 2
1969
with the collaboration of Marin
Karmitz
film, color, sound
running time: 3 min.
lent by Gérard Fromanger

61 [ill. p. 56]
Richard Buckminster Fuller
Milton, Massachusetts, 1895 –
Los Angeles 1983
Save Our Cities
plate from the series "Save Our
Planet"
1971
silkscreen on photo-offset
lithograph
printed by Colorcraft for H.K.L.
Ltd and Olivetti Corporation
63.3 x 69.1 cm
The Montreal Museum of Fine
Arts, gift of Olivetti Corporation

62
Charles Gagnon
Montreal 1934 – Montreal 2003
Artifact (Relationship)
1961–1962
metal, glass, wood, motor,
electronic components
144 x 51 x 40.6 cm
The Montreal Museum of Fine
Arts, anonymous gift

63 [ill. p. 175]
Rupert Garcia
born in French Camp, California,
in 1941
DDT
1969
silkscreen
59.9 x 43.7 cm
Fine Arts Museums of San
Francisco, Achenbach
Foundation for Graphic Arts, gift
of Mr. and Mrs. Robert Marcus

64 [ill. p. 172]
James H. Gardner (graphics)
Herb Greene (photographs)
*Jefferson Airplane, Grateful
Dead*
1967
poster
51.9 x 35.5 cm
Cleveland, Ohio, Rock and Roll
Hall of Fame and Museum

65 [ill. p. 177]
Piero Gilardi
born in Turin in 1942
I Sassi (The Rocks) Seating
Units
1967
painted polyurethane foam, mica
flakes
produced by Gufram s.r.l.
45.7 x 67.3 x 59.7 cm
17.1 x 27.9 x 19 cm
14 x 20.3 x 14 cm
The Montreal Museum of Fine
Arts, Liliane and David M.
Stewart Collection, gift of the
American Friends of Canada

through the generosity of
Eleanore and Charles Stendig
in memory of Eve Brustein and
Rose Stendig

66 [ill. p. 173]
Rick Griffin
Palos Verdes, California, 1944 –
Palos Verdes 1991
*Jimi Hendrix Experience, John
Mayall and the Blues Breakers,
Albert King*
1968
poster
printed for Fillmore Auditorium
and Winterland
104.5 x 71.3 cm
Cleveland, Ohio, Rock and Roll
Hall of Fame and Museum

67 [ill. p. 178]
Hans Haacke
born in Cologne in 1936
Condensation Cube
1963–1965
perspex, water, light
30.5 x 30.5 x 30.5 cm
collection of the artist

68 [ill. p. 55]
Richard Hamilton
born in London in 1922
Interior
1964–1965
color silkscreen
56.5 x 78.7 cm
Ottawa, National Gallery of
Canada, purchase, 1970

69 [ill. p. 93]
Richard Hamilton
born in London in 1922
My Marilyn
1965
color silkscreen, 16/75
64 x 76.2 cm
Ottawa, National Gallery of
Canada, purchase, 1969

70 [ill. p. 94]
Richard Hamilton
born in London in 1922
Swingeing London 1967
1968
photo-offset color lithograph on
wove paper, 29/50
70.4 x 50.1 cm
Ottawa, National Gallery of
Canada, purchase, 1975

71 [ill. p. 142]
Robert F. Heinecken
born in Denver, Colorado,
in 1931
Venus Mirrored
1968
gelatin silver on polyester film,
mirror
28.1 x 18.1 x 4.9 cm
Ottawa, National Gallery of
Canada, purchase, 1969

72 [ill. p. 143]
David Hockney
born in Bradford, England,
in 1937
We Two Boys Together Clinging
1961
oil on board
121.9 x 152.4 cm
London, Hayward Gallery, Arts
Council Collection

73 [ill. p. 56]
Hans Hollein
born in Vienna in 1934
Rolls Royce Grill on Wall Street
1966
photomontage
40.6 x 50.8 cm
New York, collection of Barbara
Plumb

74 [ill. p. 58]
Dennis Hopper
born in Dodge City, Kansas,
in 1936
Double Standard
1961
gelatin silver print
40.6 x 61 cm
collection of the artist

75 [ill. p. 86]
Dennis Hopper
born in Dodge City, Kansas,
in 1936
Kennedy Funeral
1963
gelatin silver prints
41 x 61 cm (each)
collection of the artist

76 [ill. p. 151]
Peter Hujar
Trenton, New Jersey, 1934 –
New York 1987
Palermo Catacombs No. 8
1963
gelatin silver print
51 x 41 cm (sheet)
courtesy of the Estate of Peter
Hujar and Matthew Marks
Gallery, New York

77 [ill. p. 55]
Ideal Toy Corporation
Super City Construction Set
(Model 3351-3)
1967
plastic, plastified cardboard
various sizes
The Montreal Museum of Fine
Arts (special acquisition for the
Global Village: The 1960s
exhibition)

78 [ill. p. 99]
Robert Indiana
born in New Castle, Indiana,
in 1928
LOVE
1966–1998
polychrome aluminum
183 x 183 x 91.5 cm
private collection, courtesy
Simon Salama-Caro, New York

79 [ill. p. 41]
Francisco Infante-Arana
born in Vasilievka, Russia,
in 1943
Nostalgia
(Project of the Reconstruction
of the Starry Sky)
1965
tempera on photographic paper
50 x 33 cm
New Jersey, Jane Voorhees
Zimmerli Art Museum, Rutgers,
The State University of New
Jersey, on loan from the
collection of Norton and Nancy
Dodge

80 [ill. p. 41]
Francisco Infante-Arana
born in Vasilievka, Russia,
in 1943
Star
(Project of the Reconstruction
of the Starry Sky)
1965
tempera on photographic paper
50 x 33 cm
New Brunswick, N.J., Jane
Voorhees Zimmerli Art Museum,
Rutgers, The State University of
New Jersey, The Norton and

Nancy Dodge Collection of
Nonconformist Art from the
Soviet Union

81 [ill. p. 41]
Francisco Infante-Arana
born in Vasilievka, Russia,
in 1943
Star Rain
(Project of the Reconstruction
of the Starry Sky)
1965
airbrush and gouache on paper
50 x 33 cm
New Brunswick, N.J., Jane
Voorhees Zimmerli Art Museum,
Rutgers, The State University
of New Jersey, The Norton and
Nancy Dodge Collection of
Nonconformist Art from the
Soviet Union

82 [ill. p. 47]
Donald Judd
Excelsior Springs, Missouri, 1928
– Ayala de Chinati, Texas, 1994
Untitled
1968
stainless steel, Plexiglas
22.9 x 101.6 x 78.7 cm
(each unit)
480 cm (h. of installation)
Toronto, Art Gallery of Ontario,
gift of Mr. and Mrs. Roger
Davidson, 1970, donated by the
Ontario Heritage Foundation,
1988

83 [ill. p. 81]
Kahn & Jacobs
Model of the Kodak Building from
the 1964 World's Fair, New York
about 1963
mixed media
15.2 x 59.7 x 34.3 cm
collection of Daniel Savage

84 [ill. p. 84]
On Kawara
born in Aichi Prefecture, Japan,
in 1933
MAR.13.1966
from the series TODAY
(begun 1966)
1966
acrylic on canvas, cardboard box
20.5 x 25.5 cm
courtesy the artist and David
Zwirner, New York

85 [ill. p. 84]
On Kawara
born in Aichi Prefecture, Japan,
in 1933
OCT.6.1967
from the series TODAY
(begun 1966)
1967
acrylic on canvas, cardboard box
20.5 x 25.5 cm
courtesy the artist and David
Zwirner, New York

86 [ill. p. 84]
On Kawara
born in Aichi Prefecture, Japan,
in 1933
30JUN.68
from the series TODAY
(begun 1966)
1968
acrylic on canvas, cardboard box
20.5 x 25.5 cm
courtesy the artist and David
Zwirner, New York

87 [ill. p. 39]
Yves Klein
Nice 1928 – Paris 1962
RP7 Blue Terrestrial Globe
1957
toner and synthetic resin on
plaster
36 x 21.5 x 19.5 cm
Paris, Yves Klein Archives

88 [ill. p. 48]
Yves Klein
Nice 1928 – Paris 1962
photomontage
Harry Shunk
John Kender
Leap into the Void
1960
photomontage
49.7 x 39.5 cm
Paris, Yves Klein Archives

The title of this work is based on
the headline from the mock
tabloid *Dimanche* (November 27,
1960), which Klein entitled "Le
peintre de l'espace se jette dans
le vide!" (The Painter of Space
Leaps into the Void).

89 [ill. p. 125]

Alberto Korda (Alberto Diaz Gutierrez)

Havana 1928 – Paris 2001

Guerrillero Heroico

1960

gelatin silver print

27.9 x 35.6 cm

courtesy of Couturier Gallery, Los Angeles

90 [ill. p. 174]

Joseph Kosuth

born in Toledo, Ohio, in 1945

Titled (Art as Idea as Idea) (meaning)

about 1967

photostat on paper mounted on wood

119.4 x 119.4 cm

The Menil Collection, Houston

91 [ill. p. 132]

Howard Kottler

Cleveland, Ohio, 1930 – Seattle 1989

Peace March Plate

1968

porcelain with ceramic decals and luster

26 cm (diam.)

collection of Judith and Martin Schwartz

92 [ill. p. 132]

Howard Kottler

Cleveland, Ohio, 1930 – Seattle 1989

Hollow Dream Plate

from the series "American Supperware"

1969

porcelain

26.7 cm (diam.)

Courtesy Revolution Gallery, Ferndale, Michigan, and The Estate of Howard Kottler

93 [ill. p. 142]

Les Krims

born in New York in 1942

Nudist Willing to Defend Home, 1968

1969

gelatin silver print

13.5 x 19.5 cm

Ottawa, National Gallery of Canada, purchase, 1972

94 [ill. p. 142]

Les Krims

born in New York in 1942

Projection Screen Nudes, 1968

1969

gelatin silver print

13.5 x 19.8 cm

Ottawa, National Gallery of Canada, purchase, 1972

95 [ill. p. 142]

Les Krims

born in New York in 1942

Nude with Drawn Squirting Penises, 1968

1970

gelatin silver print

13.5 x 19.6 cm

Ottawa, National Gallery of Canada, purchase, 1972

96 [ill. p. 178]

Tetsumi Kudo

Hyogo Prefecture, Japan, 1935 – Tokyo 1990

Pollution — Cultivation — New Ecology

1971

plastic objects and flowers, carboard, cellulose

53.3 x 141.7 x 73.2 cm

Paris, Centre Georges Pompidou, Musée national d'art moderne / Centre de création industrielle, gift of Mathias Fels, Paris, 1976

97 [ill. p. 40]

Yayoi Kusama

born in Matsumoto, Japan, in 1929

Flower No. 8

1953

pastel and watercolor on paper

30.5 x 23.2 cm

Youngstown, Ohio, The Butler Institute of American Art

98 [ill. p. 40]

Yayoi Kusama

born in Matsumoto, Japan, in 1929

Flower No. 10

1953

pastel and watercolor on paper

30.5 x 23.2 cm

Youngstown, Ohio, The Butler Institute of American Art

99 [ill. p. 40]

Yayoi Kusama

born in Matsumoto, Japan, in 1929

Untitled

1954

pastel and watercolor on paper

60.9 x 45.7 cm

Youngstown, Ohio, The Butler Institute of American Art

100 [ill. p. 40]

Yayoi Kusama

born in Matsumoto, Japan, in 1929

No. 17 A. H.

1956

pastel and watercolor on paper

59.1 x 45.7 cm

Youngstown, Ohio, The Butler Institute of American Art

101 [ill. p. 103]

Yefim Ladizhinsky

Odessa 1911 – Odessa 1982

A Good Bra

1967

oil on canvas

89 x 99.5 cm

New Brunswick, N.J., Jane Voorhees Zimmerli Art Museum, Rutgers, The State University of New Jersey, The Norton and Nancy Dodge Collection of Nonconformist Art from the Soviet Union

102 [ill. p. 92]

Gerald Laing

born in Newcastle upon Tyne, England, in 1936

Brigitte Bardot

1963

oil on canvas

152 x 122 cm

collection of Roddy Maude Roxby

103 [ill. p. 148]

Leonid Lamm

born in Moscow in 1928

I, You, He, She

1971

oil on canvas

65 x 129 cm

New Brunswick, N.J., Jane Voorhees Zimmerli Art Museum, Rutgers, The State University of New Jersey, The Norton and Nancy Dodge Collection of Nonconformist Art from the Soviet Union

104 [ill. p. 130]

Jean-Jacques Lebel

born in Paris in 1936

"Parfum, Grève Générale, Bonne Odeur"

1960

photographs and glued paper, paint on cardboard

112 x 82.5 cm

private collection

105 [ill. p. 145]

Jean-Jacques Lebel

born in Paris in 1936

Christine Keeler Icon

1962

glued paper and paint on wood

100 x 100 cm

private collection

106 [ill. p. 84]

Walter Lefmann

Ron DeVito

Time Dress

1967

printed paper

produced for Time, Inc.

86.6 x 64.6 cm

The Montreal Museum of Fine Arts, Liliane and David M. Stewart Collection, gift of Toni and Wesley Greenbaum

107 [ill. p. 59]

Beth Levine

born in Patchogue, New York, in 1914

Racing Car Shoes

about 1967

vinyl, buckskin, varnished leather, leather

11.5 x 22.8 x 7 cm;

11.3 x 22.4 x 7 cm

The Montreal Museum of Fine Arts, Liliane and David M. Stewart Collection

108 [ill. p. 54]

Sol Lewitt

born in Hartford, Connecticut, in 1928

Open Modular Cube

1966

painted aluminum

152.4 x 152.4 x 152.4 cm

Toronto, Art Gallery of Ontario, purchase, 1969

109 [ill. p. 98]

Roy Lichtenstein

New York 1923 – New York 1997

Vicki

1964

enamel on steel

106.7 x 106.7 x 5.1 cm

The Minneapolis Institute of Arts, gift of Mr. and Mrs. Russell Cowles II

110 [ill. p. 129]

Roy Lichtenstein

New York 1923 – New York 1997

The Gun in America

cover of *Time* (June 21, 1968)

1968

offset lithograph

printed for Time, Inc.

28.1 x 21 cm

The Montreal Museum of Fine Arts (special acquisition for the *Global Village: the 1960s* exhibition)

111 [ill. p. 175]

Roy Lichtenstein

New York 1923 – New York 1997

Save Our Water

from the series "Save Our Planet"

1971

silkscreen on photo-offset lithograph

printed by Colorcraft for H.K.L. Ltd. and Olivetti Corporation

57.7 x 81.3 cm

The Montreal Museum of Fine Arts, gift of Olivetti Corporation

112 [ill. p. 95]

Richard Lindner

Hamburg 1901 – New York 1978

Rock-Rock

1966–1967

oil on canvas

177.8 x 152.4 cm

Dallas Museum of Art, gift of Mr. and Mrs. James C. Clark

113 [ill. p. 172]

Bonnie MacLean

Pink Floyd, Lee Michaels, Clear Light

1967

poster

53.4 x 35.7 cm

Cleveland, Ohio, Rock and Roll Hall of Fame and Museum

114 [ill. p. 55]
Norman Makinson (form)
Brian Cour
Eduardo Paolozzi
pattern
Coupe Savoy Plates
from the series "Variations on a
Geometric Theme"
1953 (form)
about 1968–1969 (pattern)
printed and gilded porcelain
produced by Josiah Wedgwood
& Sons
26.7 cm (diam.) each
Dallas Museum of Art,
20th-Century Design Fund

115 [ill. p. 50]
Piero Manzoni
Soncino, Italy, 1933 – Milan 1963
Line of Infinite Length
1960
wood
16 cm (h.), 4.8 cm (diam.)
Milan, Archivio Opera Piero
Manzoni

116 [ill. p. 45]
Piero Manzoni
Soncino, Italy, 1933 – Milan 1963
Achrome
1961
glass fiber
33 x 23.5 cm
Milan, Archivio Opera Piero
Manzoni

117 [ill. p. 38]
Piero Manzoni
Soncino, Italy, 1933 – Milan 1963
Base of the World
1961
iron, bronze lettering
82 x 100 x 100 cm
Denmark, Herning
Kunstmuseum

118 [ill. p. 149]
Bruno Martinazzi
born in Turin in 1923
Goldfinger Bracelet
1969
yellow and white gold
7.5 x 6.5 x 5.5 cm
The Montreal Museum of Fine
Arts, Liliane and David M.
Stewart Collection

119 [ill. p. 62]
Jean Mascii
born in 1926
Alphaville
about 1965
poster
produced by Athos Films
Distribution
160 x 120 cm
Montreal, collection L'Affiche
Vivante

120 [ill. p. 103]
Mattel Inc.
Dolls, costumes, accessories
and furniture
from left to right, top to bottom:
Francie Bend-leg® wearing
Pazam, 1966 (doll),
1968–1969 (outfit)
Barbie® wearing Leather
Limelight, 1970 (doll),
1966–1967 (outfit)
Casey wearing original
outfit,1967–1970 (doll and outfit)
Julia wearing Candlelight
Capers, 1969 (doll),
1969–1970 (outfit)
Ken® wearing original outfit,
1970 (doll and outfit)
Barbie Side-Part American Girl®
wearing Sunflower, 1965 (doll),
1967–1968 (outfit)
Barbie Twist N'Turn® wearing
Fab Fur 1967 (doll),
1969–1970 (outfit)
Talking Barbie® wearing Brigt'N
Brocade, 1968 (doll),
1970–1971 (outfit)
Standard Barbie® wearing
Swirly Cue, 1967 (doll),
1968–1969 (outfit)
Busy Ken® wearing original
outfit, 1972 (doll and outfit)
Twiggy wearing original outfit,
1967 (doll and outfit)
Skipper Living® wearing Fancy
Pants, 1970 (doll),
1970–1971 (outfit)
cardboard couch, armchair,
cushion; radio, television,
luggage, record player, records
and record sleeves; plastic
telephone; paper glasses
various dimensions
Quebec City, Collection Denis
Allison

121 [ill. p. 141]
John Max
born in Montreal in 1936
Untitled, No. 21A
about 1965–1975
gelatin silver print
50.5 x 40.5 cm
Ottawa, National Gallery of
Canada, gift of Evelyn Coutellier,
Brussels, 1988

122 [ill. p. 152]
Ralph Eugene Meatyard
Normal, Illinois, 1925 –
Lexington, Kentucky, 1972
Untitled
about 1970
gelatin silver print
15.9 x 15.2 cm
New York, International Center of
Photography, gift of
Mr. and Mrs. Charles Traub, 1980

123 [ill. p. 89]
Cildo Meireles
born in Rio de Janeiro in 1948
*Insertions into Ideological
Circuits: Coca-Cola Project*
1970
Coca-Cola bottles, transferred
text
18 cm (h.), 6 cm (diam.) each
New York, New Museum of
Contemporary Art

124 [ill. p. 152]
Duane Michals
born in McKeesport,
Pennsylvania, in 1932
*Collage Portrait of
Rauschenberg in His Studio*
1962
gelatin silver print
20.3 x 25.4 cm
courtesy of the artist and
Pace/MacGill Gallery, New York

125 [ill. p. 148]
Duane Michals
born in McKeesport,
Pennsylvania, in 1932
The Illuminated Man
1968, printed before 1972
gelatin silver print
12.3 x 18.5 cm
Ottawa, National Gallery of
Canada, purchase, 1972

126 [ill. p. 46]
Guido Molinari
born in Montreal in 1933
Green-blue Bi-serial
1967
acrylic on canvas
254 x 205.7 cm
The Montreal Museum of Fine
Arts, Horsley and Annie
Townsend Bequest

127 [ill. p. 53]
Nicholas Monro
born in 1936
Martians
1965
painted fiberglass
120 x 60 x 30 cm (each)
collection of Mr. Rupert E. G.
Power

128 [ill. p. 145]
Lewis Morley
born in Hong Kong in 1925
Christine Keeler
1963
gelatin silver print
50.8 x 60.9 cm
collection David Knaus

129 [ill. p. 132]
Malcolm Morley
born in London in 1931
At a First-aid Center in Vietnam
1971
oil on canvas
160 x 240 cm
The Eli and Edythe L. Broad
Collection

130 [ill. p. 173]
Victor Moscoso
*The Doors: Break on Through
to the Other Side*
1967
poster
50.8 x 35.6 cm
Cleveland, Ohio, Rock and Roll
Hall of Fame and Museum

131 [ill. p. 63]
Olivier Mourgue
born in Paris in 1939
Sofa and Chair
from the series "Djinn"
about 1964

foam and Jersey fabric, metal
produced by Airborne
sofa: 66 x 144 x 76 cm
chair: 66 x 72 x 76 cm
Westerham, Kent, 20th Century
Marks

132 [ill. p. 43]
Jean-Paul Mousseau
Montreal 1925 – Montreal 1991
Blue Space Time Modulations
1963
oil on plywood
121.5 cm (diam.)
collection Lavalin of the Musée
d'art contemporain de Montréal

133
Mr. Fish
Necktie
about 1967
printed cotton
131.1 x 12.4 cm
New York, The Museum at the
Fashion Institute of Technology,
gift of Tony Sette-Ducate

134 [ill. p. 134]
Otto Muehl
born in Grodnau, Austria, in 1925
Burial of a Venus
1963
Portfolio: lithographs and
photographs
40 x 40 cm
Muehl archives

135 [ill. p. 124]
Otto Muehl
born in Grodnau, Austria, in 1925
Charles de Gaulle
1967
silkscreen, 37/50
84 x 58 cm
Muehl archives

136 [ill. p. 124]
Otto Muehl
born in Grodnau, Austria, in 1925
Ho Chi Minh
"Die Amerikaner Müssen
Abziehen" (The Americans Must
Withdraw)
1967
silkscreen
71.9 x 47.5 cm
Muehl archives

137 [ill. p. 124]
Otto Muehl
born in Grodnau, Austria, in 1925
Konrad Adenauer
1967
silkscreen, 29/65
88.3 x 70.2 cm
Muehl archives

138 [ill. p. 124]
Otto Muehl
born in Grodnau, Austria, in 1925
Nasser
1967
silkscreen, 25/50
74.3 x 46 cm
Muehl archives

139 [ill. p. 81]
N. E. Thing Co.
(Iain and Ingrid Baxter)
ACT No. 107: Triangular-Shaped (VSI) Visual Sensitivity Information, Telecasted View of Moon's Surface from inside Apollo 8 Spacecraft through Window as seen on Canadian National C.B.C. T.V. over Sanyo T.V. set 9˝, in North Vancouver, B.C., Canada, December 25, 1968 (1968)
1969
Felt pen and collage on gelatin-silver print
70.3 x 100.4 cm
Ottawa, National Gallery of Canada, purchase, 1970

140 [ill. p. 174]
Bruce Nauman
born in Fort Wayne, Indiana, in 1941
The True Artist Helps the World by Revealing Mystic Truths
1967, replica 2003
neon, glass tubing suspension frame
149.9 x 139.7 x 5.1 cm
replica authorized by the artist and the Kröller-Müller Museum Otterlo, Netherlands

141 [ill. p. 90]
Claes Oldenburg
born in Stockholm in 1929
Pepsi-Cola Sign
1961
plaster-soaked muslin, wire, enamel paint
148 x 118.1 x 19.1 cm
Los Angeles, The Museum of Contemporary Art, The Panza Collection

142 [ill. p. 56]
Claes Oldenburg
born in Stockholm in 1929
Proposed Colossal Monument for Thames River: Thames Ball
1967
crayon, pen and ink, watercolor on postcard
8.9 x 14 cm
collection of Mr. Carroll Janis

143 [ill. p. 83]
Yoko Ono
born in Tokyo, in 1933
Sky TV
1966, replica 2003
closed-circuit video installation
various dimensions
replica authorized by the artist
collection of the artist

A camera is placed on the roof of the museum, transmitting live images of the sky to the television monitor in the gallery space, thus projecting the exterior world into an interior space.

144 [ill. p. 52]
Sue Thatcher Palmer
born in Slough, England, in 1947
Space Walk Fabric
about 1969–1971
printed cotton
produced by Warner Fabrics PLC
112.4 x 121 cm
The Montreal Museum of Fine Arts, Liliane and David M. Stewart Collection, gift of Eddie Squires

145 [ill. p. 149]
Giulio Paolini
born in Genoa in 1940
Elegia
1969
plaster cast and mirror
15 x 15 x 11 cm
Turin, collection of the artist

146 [ill. p. 185]
Claudio Parmiggiani
born in Lussara, Italy, in 1943
Pellemondo
1968
leather, wood, aluminum
44 x 40 cm
Turin, collection of Christian Stein

147 [ill. p. 176]
Giuseppe Penone
born in Garessio, Italy, in 1947
8-meter Tree
1969
wood
10 x 19 x 800 cm
Ottawa, National Gallery of Canada, purchase, 1982

148 [ill. p. 147]
Giuseppe Penone
born in Garessio, Italy, in 1947
To Turn One's Eyes Inward
1970
color photograph
34.8 x 24.7 cm
private collection

149 [ill. p. 101]
Gaetano Pesce
born in La Spezia, Italy, in 1939
Up 5 and *Up 6* Armchair and Footrest
from the series "Up"
1969
polyurethane foam and viscose, nylon and Lycra fabric
produced by C&B Italia S.p.A.
armchair:
100 x 113.7 x 125.1 cm
footrest: 59.1 x 59.1 x 59.1 cm
The Montreal Museum of Fine Arts, Liliane and David M. Stewart Collection, gift of B&B Italia

150 [ill. p. 121]
Michelangelo Pistoletto
born in Biella, Italy, in 1933
Red Banner
1966
painted vellum paper on chromed steel sheet
120 x 100 cm
Switzerland, private collection, courtesy of Barr & Ochsner GmbH, Zurich

151 [ill. p. 131]
Michelangelo Pistoletto
born in Biella, Italy, in 1933
Milestone
1967
stone
80 cm (h.), 40 cm (diam.)
Biella, Italy, Fondazione Pistoletto

152 [ill. p. 135]
Michelangelo Pistoletto
born in Biella, Italy, in 1933
Venus of the Rags
1967
cement, mica, rags
160 x 130 x 130 cm
Biella, Italy, Fondazione Pistoletto

153 [ill. p. 44]
Sigmar Polke
born in Oels (now Olesnicka), Germany, in 1941
Apparatus Whereby One Potato Can Orbit Another
1969
wood, batteries, wire, screws, rubber band, battery-driven motor, potatoes, 22/30
80 x 40 x 40 cm
Dallas Museum of Art, DMA/amfAR Benefit Auction Fund

154 [ill. p. 120]
Daniel Pommereulle
born in Sceaux, Hauts-de-Seine, in 1937
Target for Other Aims
1963
painted barbed wire
25 x 45 cm
Paris, Centre Georges Pompidou, Musée national d'art moderne / Centre de création industrielle, purchase, 2002

155 [ill. p. 171]
Porsche GmbH
Janis Joplin's Porsche, painted by **Dave Richards**
about 1968 (painting)
Porsche Cabriolet (Model 356C)
1965
131 x 429 x 178 cm
collection of the Joplin Family

156
Pompeo Posar
James Bond's Girls (Beth Hyatt) cover of *Playboy* (November 1965)
1965
magazine
28.2 x 21.2 cm
The Montreal Museum of Fine Arts (special acquisition for the *Global Village: The 1960s* exhibition)

157
Emilio Pucci
Naples 1914 – Florence 1992
Necktie
1960s–1970s
print silk surah
136.5 x 8.9 cm
New York, The Museum at the Fashion Institute of Technology, gift of Margaret Kaplan

158 [ill. p. 51]
Paco Rabanne
born in San Sebastián in 1934
Dress
1967
rhodoid, acetate, nickel silver
90 x 56 cm
collection of François Dallegret
lighting: Francois Dallegret

159 [ill. p. 49]
Robert Rauschenberg
born in Port Arthur, Texas, in 1925
Skyway
1964
oil on silkscreen ink on canvas
548.6 x 487.7 cm (2 parts)
Dallas Museum of Art, purchase, The Roberts Coke Camp Fund, The 500, Inc., Mr. and Mrs. Mark Shepherd, Jr., and the General Acquisitions Fund

160 [ill. p. 52]
Martial Raysse
born in Golfe-Juan, France, in 1936
Cosmonaut's Column (Hygiene of Vision)
1960
plastic, recycled objects
74.5 x 20.5 x 20.5 cm
Nice, Musée d'Art moderne et d'Art contemporain

161 [ill. p. 57]
Gerhard Richter
born in Dresden in 1932
City Picture Mü
1968
acrylic paint on canvas
180 x 160 cm
Dallas, collection of Marguerite and Robert Hoffman, the Rachofsky Collection, and Dallas Museum of Art: Lay Family Acquisition Fund, General Acquisitions Fund, and gifts from an anonymous donor, Howard Rachofsky, Evelyn P. and Edward W. Rose, Mr. and Mrs. Paul Stoffel, and Mr. and Mrs. William T. Solomon, by exchange

162 [ill. p. 46]
Bridget Riley
born in London in 1931
Untitled (Warm and Cold Curves)
1965
emulsion on board
140.5 x 140.5 cm
private collection

163 [ill. p. 128]
Faith Ringgold
born in New York in 1930
Flag for the Moon: Die Nigger
1967–1969
oil on canvas
91.5 x 127 cm
collection of the artist, courtesy of ACA Galleries, New York

164 [ill. p. 126]
Norman Rockwell
New York 1894 – Stockbridge, Massachusetts, 1978
Murder in Mississippi
1965
oil on canvas
134.6 x 106.7 cm
Stockbridge, Massachusetts, Norman Rockwell Museum

165 [ill. p. 119]
Mikhail Roginsky
born in Moscow in 1931
Red Door
1965
oil on panel, door handle
80.2 x 17.5 cm
New Brunswick, N.J., Jane Voorhees Zimmerli Art Museum, Rutgers, The State University of New Jersey, The Norton and Nancy Dodge Collection of Nonconformist Art from the Soviet Union

166 [ill. p. 42]
James Rosenquist
born in Grand Forks, North Dakota, in 1933
Noon
1962
oil on canvas
91.4 x 121.9 cm
Los Angeles, The Museum of Contemporary Art, The Panza Collection

167 [ill. p. 123]
Martha Rosler
Balloons
from the series "Bringing the War Home: House Beautiful"
1967–1972
photomontage (printed as a color photograph)
61 x 50.8 cm
courtesy of Gorney Bravin + Lee, New York

168 [ill. p. 122]
Martha Rosler
Boy's Room
from the series "Bringing the War Home: House Beautiful"
1967–1972
photomontage (printed as a color photograph)
61 x 50.8 cm
courtesy of Gorney Bravin + Lee, New York

169 [ill. p. 123]
Martha Rosler
Giacometti
from the series "Bringing the War Home: House Beautiful"
1967–1972
photomontage (printed as a color photograph)
61 x 50.8 cm
courtesy of Gorney Bravin + Lee, New York

170 [ill. p. 138]
Martha Rosler
Cold Meat I
from the series "Beauty Knows No Pain, or Body Beautiful"
1965–1974
about 1972
photomontage (printed as a color photograph)
24.1 x 11.4 cm
courtesy of Gorney Bravin + Lee, New York

171 [ill. p. 138]
Mimmo Rotella
born in Catanzaro, Italy, in 1918
Triumph
1961
plastic bust and bra
24 x 30 x 12 cm
private collection

172
Ed Ruscha
born in Omaha, Nebraska, in 1937
Twenty-six Gasoline Stations
1963, 1969 (3rd edition)
book of photographs: offset halftone lithographs
18 x 14 x 1 cm
The Montreal Museum of Fine Arts Library

173 [ill. p. 58]
Ed Ruscha
born in Omaha, Nebraska, in 1937
Every Building on the Sunset Strip
1966
book of photographs: offset halftone lithographs
17.8 x 14.3 x 1 cm (closed)
760.7 cm (open)
The Montreal Museum of Fine Arts Library

174 [ill. p. 60]
Ed Ruscha
born in Omaha, Nebraska, in 1937
1984
1967
powdered graphite on paper
36 x 57 cm
Washington, D.C., Hirshhorn Museum and Sculpture Garden, Smithsonian Institution, The Joseph H. Hirshhorn Bequest, 1981

175
Ed Ruscha
born in Omaha, Nebraska, in 1937
Thirty-four Parking Lots in Los Angeles
1967, print 1974
book of photographs: offset halftone lithographs
26 x 21 x 1 cm
The Montreal Museum of Fine Arts Library

176 [ill. p. 120]
Niki de Saint-Phalle
Paris 1930 – San Diego, California, 2002
Kennedy-Khrushchev
1962
paint, wire mesh, various objects on wood
202 x 122.5 x 40 cm
Hanover, Sprengel Museum

177 [ill. p. 97]
Niki de Saint-Phalle
Paris 1930 – San Diego, California, 2002
Camel
1966–1967
painted polyester
168 x 198 x 57 cm
private collection

178 [ill. p. 143]
Lucas Samaras
born in Kastoria, Greece, in 1936
July 19, 1962
1962
pastel on paper
33 x 25.4 cm
courtesy PaceWildenstein, New York

179 [ill. p. 143]
Lucas Samaras
born in Kastoria, Greece, in 1936
July 20, 1962
1962
pastel on paper
33 x 25.4 cm
courtesy PaceWildenstein, New York

180 [ill. p. 181]
Timo Sarpaneva
born in Helsinki, in 1926
Finlandia Vase (Model No. 3356)
1964
blown and molded glass
produced by Iittala Lasitehdas Oy
28.1 x 23.2 cm
The Montreal Museum of Fine Arts, Liliane and David M. Stewart Collection, gift of The Lake St. Louis Historical Society

181 [ill. p. 140]
Carolee Schneemann
born in Fox Chase, Pennsylvania, in 1939
Meat Joy
1964
DVD of original film footage
running time: 6 min.
New York, Electronic Arts Intermix

Meat Joy (performance with raw fish, chicken sausages, paint, plastic, rope and paper scraps) was performed in London, Paris and New York.

182 [ill. p. 173]
Bob Schnepf
Lothar and the Hand People, The Doors, Captain Beefheart and His Magic Band
1967
poster
50.8 x 35.5 cm
Cleveland, Ohio, Rock and Roll Hall of Fame and Museum

183 [ill. p. 172]
Martin Sharp
born in 1942
Bob Dylan
cover of *OZ* (No. 7, October-November 1967)
1967
color photo lithograph
29.9 x 21 cm
The Montreal Museum of Fine Arts (special acquisition for the *Global Village: The 1960s* exhibition)

184 [ill. p. 102]
Malick Sidibé
born in Bamako, Mali, in 1936
At Keïta's Place
1960s
gelatin silver print
40.6 x 50.8 cm
courtesy of Jack Shainman Gallery, New York

185 [ill. p. 102]
Malick Sidibé
born in Bamako, Mali, in 1936
Who's Dances Best?
1960s
gelatin silver print
40.6 x 50.8 cm
courtesy of Jack Shainman Gallery, New York

186 [ill. p. 133]
Tony Smith
South Orange, New Jersey, 1912 – New York 1980
Die
1962, fabricated 1968
steel, oiled finish, 2/3
182.9 x 182.9 x 182.9 cm
courtesy Paula Cooper

187 [ill. p. 179]
Robert Smithson
Passaic, New Jersey, 1938 –
Amarillo, Texas, 1973
Mirrors and Shelly Sand
1969–1970
installation with beach sand,
shells, pebbles
fifty 30.5 x 121.9 cm mirrors,
back to back, approximately
854 cm long
Dallas Museum of Art, gift of an
anonymous donor; the Vin and
Caren Prothro Foundation; an
anonymous donor in memory of
Vin Prothro and in honor of his
cherished grandchildren, Lillian
Lee Clark and Annabel Caren
Clark; The Eugene McDermott
Foundation; Dr. and Mrs. Mark L.
Lemmon; American Consolidated
Media; Bear/Hunter; and donors
to the C. Vincent Prothro
Memorial Fund

188 [ill. p. 179]
Robert Smithson
Passaic, New Jersey, 1938 –
Amarillo, Texas, 1973
Spiral Jetty
1970
DVD of a Robert Smithson film
(1970)
running time: 34.5 min.
The Montreal Museum of Fine
Arts (special acquisition for the
Global Village: The 1960s
exhibition)

The artist created this
monumental earthwork at Great
Salt Lake, Utah, using black
basalt rocks and earth from the
site to form a coil (1,500 ft. long,
15 ft. wide) that stretches out
counterclockwise into the
translucent red water.

189 [ill. p. 153]
Michael Snow
born in Toronto in 1929
Authorization
1969
black and white photographs,
cloth tape on mirror in metal
frame
54.6 x 44.4 x 1.4 cm (with frame)
Ottawa, National Gallery of
Canada, purchase, 1969

190 [ill. p. 100]
Ettore Sottsass
born in Innsbruck, Austria,
in 1917
Perry A. King
born in London in 1938
Valentine Typewriter
1969
ABS, metal, rubber
produced by Ing. C. Olivetti &
Co., S.p.A.
11.4 x 34.3 x 35 cm
The Montreal Museum of Fine
Arts, Liliane and David M.
Stewart Collection

191 [ill. p. 139]
Nancy Spero
born in Cleveland, Ohio, in 1926
Female Bomb
1966
gouache and ink on paper
85 x 67.5 cm
courtesy Galerie Lelong, New
York

192 [ill. p. 139]
Nancy Spero
born in Cleveland, Ohio, in 1926
Male Bomb
1966
gouache and ink on paper
60 x 90 cm
Collection Jacques et Kristin Van
Daele

193 [ill. p. 132]
Nancy Spero
born in Cleveland, Ohio, in 1926
Victims on Helicopter Blades
1968
gouache and ink on paper
62.5 x 97 cm
courtesy Galerie Lelong,
New York

194 [ill. p. 46]
Frank Stella
born in Malden, Massachusetts,
in 1936
York Factory Sketch No. 1
1970
acrylic on canvas
137.5 x 416.2 x 7.9 cm
Dallas Museum of Art, gift of the
Meadows Foundation,
Incorporated

195 [ill. p. 82]
Bert Stern
born in New York in 1929
Twiggy
1960s
gelatin silver print
50.8 x 61 cm
collection of the artist

196 [ill. p. 93]
Bert Stern
born in New York in 1929
Marilyn Monroe
1962
gelatin silver print
50.8 x 61 cm
collection of the artist

197 [ill. p. 56]
Superstudio
(Adolfo Natalini, Cristiano
Toraldo di Francia, Alessandro
Magris, Roberto Magris, Gian
Pietro Frassinelli)
Continuous Monument.
New New York
1969
color lithograph
70 x 100 cm
Florence, Archivio Superstudio

198 [ill. p. 44]
Vassiliakis Takis
born in Athens in 1925
Telesculpture 1960
1960
steel, electromagnet, iron, plastic
wire
31 x 53.5 x 53.5 cm
Quebec, Collection Yvon Tardif

199 [ill. p. 150]
Paul Thek
New York 1933 – New York 1988
Untitled
from the series "Technological
Reliquaries"
1965
wax, hair, stainless steel, glass
61 x 61 x 19.1 cm
Estate of George Paul Thek,
courtesy Alexander and Bonin,
New York

200 [ill. p. 129]
Joe Tilson
born in London in 1928
Page 18. Muhammad Speaks
1969–1970
silkscreen ink on canvas on
wood relief
186 x 125 cm
private collection

201
Turnbull & Asser
Necktie
about 1970
printed silk surah
134 x 11.1 cm
New York, The Museum at the
Fashion Institute of Technology,
gift of Tony Santore, in memory
of Jack Fenstermacher

202 [ill. p. 182]
Jerry N. Uelsmann
born in Detroit in 1934
Untitled
1965, print 1969
gelatin silver print
35.3 x 27.9 cm
Ottawa, National Gallery of
Canada, purchase, 1969

203 [ill. p. 182]
Jerry N. Uelsmann
born in Detroit in 1934
Untitled
1966, printed before 1968
gelatin silver print
35.4 x 27.9 cm
Ottawa, National Gallery of
Canada, purchase, 1969

204 [ill. p. 182]
Jerry N. Uelsmann
born in Detroit in 1934
Untitled
1968, printed before 1973
gelatin silver print, toned
35.3 x 27.1 cm
Ottawa, National Gallery of
Canada, purchase, 1974

205 [ill. p. 172]
Unknown
*"Girls Say Yes to Boys Who Say
No"*
about 1968
poster: photomechanical
lithograph
106.7 x 74.9 cm

Washington, D.C., Smithsonian
Institution, National Museum of
American History, Behring
Center

206 [ill. p. 175]
Unknown,
STOPPOLLUTION
about 1970
poster: offset halftone lithograph
66 x 50.8 cm
The Montreal Museum of Fine
Arts, Liliane and David M.
Stewart Collection, gift of
Miljenko and Lucia Horvat

207 [ill. p. 144]
Agnès Varda
born in Brussels in 1928
Self-Portrait in Venice
about 1960–1961
gelatin silver print
12.6 x 17.7 cm
private collection

208 [ill. p. 79]
Victor Vasarely
Pecs, Hungary, 1906 – Paris
1997
Vega-Nor
1969
oil on canvas
204.5 x 204.5 cm
Buffalo, New York, Albright-Knox
Art Gallery, gift of Seymour H.
Knox, Jr., 1969

209 [ill. p. 43]
Oleg Vassiliev
born in Moscow in 1931
High Space
from the series "Spaces"
1968
oil on canvas, 29/65
90 x 80 cm
New Brunswick, N.J., Jane
Voorhees Zimmerli Art Museum,
Rutgers, The State University
of New Jersey, The Norton and
Nancy Dodge Collection of
Nonconformist Art from the
Soviet Union

210 [ill. p. 52]
Victor Company of Japan Ltd.
Videosphere Television Set
(JVC – Model 3240 MU)
1970
plastic, glass, metal
37 cm (h.); 28 cm (diam.)
The Montreal Museum of Fine
Arts, purchase, The Frothingham
Bursary Fund

211

Victor Company of Japan Ltd.
Videosphere Television Set
(JVC – Model 3240)
1970
plastic, glass, metal
33.2 cm (h.); 29.2 cm (diam.)
Dallas Museum of Art,
20th-Century Design Fund

212 [ill. p. 52]

Helen Von Boch
born in Germany in 1938
Avant-garde Sphere Dish Set
1969–1970
earthenware
produced by Villery & Boch
24.8 x 26.7 cm (19-piece dish set)
Dallas Museum of Art,
20th-Century Design Fund

213 [ill. p. 138]

Wolf Vostell
Leverkusen, Germany, 1932 –
Berlin 1998
Lippenstift-Bomber B52
1968
silkscreen on cardboard, lipstick
100 x 120 x 10 cm
Block Collection Berlin

214 [ill. p. 127]

Andy Warhol
Pittsburgh 1928 – New York
1987
Race Riot
about 1963
silkscreen
76.5 x 101.6 cm
Pittsburgh, The Andy Warhol
Museum, Founding Collection,
Contribution The Andy Warhol
Foundation for the Visual Arts, Inc.

215 [ill. p. 88]

Andy Warhol
Pittsburgh 1928 – New York
1987
Brillo Boxes
1964, version 1969
acrylic silkscreen on wood
50.8 x 50.8 x 43.2 cm (each)
Pasadena, Norton Simon
Museum, gift of the artist, 1969

216 [ill. p. 86]

Andy Warhol
Pittsburgh 1928 – New York 1987
Jackie
1964
synthetic polymer paint and
silkscreen prints on canvas
50.8 x 40.6 cm (each)
Pittsburgh, The Andy Warhol
Museum, Founding Collection,
Contribution The Andy Warhol
Foundation for the Visual Arts, Inc.

217 [ill. p. 101]

Tom Wesselmann
born in Cincinnati, Ohio, in 1931
Mouth No. 11
1967
oil on canvas
171.5 x 391.2 cm
Dallas Museum of Art,
Foundation for the Arts
Collection, gift of Mr. and Mrs.
James H. Clark

218 [ill. p. 140]

Joyce Wieland
Toronto 1931 – Toronto 1998
Heart-on
1962
red electrical tape, chalk, crayon,
and ink, with linen and wool on
unstretched linen
177.8 x 251.5 cm
Ottawa, National Gallery of
Canada, purchase, 1973

219 [ill. p. 173]

Tom Wilkes
*Monterey International Pop
Festival*
1967
poster
88.6 x 48.2 cm
Montreal, collection L'Affiche
Vivante

220 [ill. p. 181]

Tapio Wirkkala
Hanko, Finland, 1915 – Helsinki
1985
Miracus Vase
1968
mould blown glass
produced by Iittala
22.9 cm (h.) x 24.8 cm (diam.)
Dallas Museum of Art, the Patsy
Lacy Griffith Collection, bequest
of Patsy Lacy Griffith

221 [ill. p. 102]

J. Fred Woell
born in Evergreen Park, Illinois,
in 1934
*"Come Alive You're in the Pepsi
Generation"*
Brooch
1966
silver, brass, copper, glass, tin
10 x 10.2 cm
collection of Mrs. Kathleen
Kriegman

222 [ill. p. 87]

J. Fred Woell
born in Evergreen Park, Illinois,
in 1934
November 22, 1963 12:30 p.m.
1967
badge on detachable frame,
copper, silver, brass, gold leaf,
photo and wood
15.9 x 12.8 x 2.3 cm
Washington, D.C., Smithsonian
American Art Museum, gift of
Rose Mary Wadman

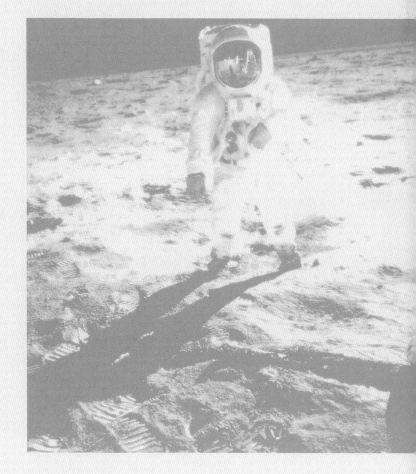

LIST OF FIGURES

SELECTED BIBLIOGRAPHY

History, Society, and Media

Anderson, Terry H. *The Movement and the Sixties*. New York: Oxford University Press, 1995.

Bony, Anne. *Les Années 60*. Paris: Éditions du Regard, 1983.

Enwezor, Okwui, (ed.). *The Short Century: Independence and Liberation Movements in Africa, 1945–1994*. Munich: Prestel, 2001.

Faas, Horst, and Tim Page. *Requiem par les photographes morts au Viêt-Nam et en Indochine* (trans. Renée Kérisit). Paris: Marval, 1998 (1997).

Farber, David, ed. *The Sixties: From Memory to History*. Chapel Hill, N.C.: University of North Carolina Press, 1994.

Fisera, Vladimir, ed. *May 1968: A Documentary Anthology*. London: Alison and Busby, 1978.

Gardiner, Juliet. *From the Bomb to the Beatles*. London: Collins & Brown, 1999.

Gitlin, Todd. *The Sixties: Years of Hope, Days of Rage*. New York: Bantam Books, 1993 (rev. ed.).

Griffiths, Philip Jones. *Vietnam Inc*. New York: Phaidon, 2001 (1971).

Johnston, R. J., ed., Peter J. Taylor and Michael J. Watts, *Geographies of Global Change: Remapping the World*. Malden, Mass.: Blackwell Publishers, 2002 (2nd ed.).

Kasher, Steven. *The Civil Rights Movement: A Photographic History, 1954–68*. Intro. Myrlie Evers-Williams. New York: Abbeville Press, 1996.

Lacout, Dominique. *Mai 68: le journal* (photos Gilles Caron). Paris: Calmann-Lévy, 1998.

Manchester, William. *In Our Time: The World As Seen by Magnum Photographers*. New York: American Federation of Arts in association with W. W. Norton, 1989.

McLuhan, Eric, and Frank Zingrone, eds., *Essential McLuhan*. Concord, Ont.: House of Anansi, 1995.

McWilliams, John C., and Randall M. Miller. *The 1960s Cultural Revolution*. Westport, Conn.: Greenwood Press, 2000.

Olson, James S., and Samuel Freeman. *Historical Dictionary of the 1960s*. Westport, Conn: Greenwood Press, 1999.

Roszak, Theodore. *The Making of a Counter Culture: Reflections on the Technocratic Society and Its Youthful Opposition*. Berkeley, Calif.: University of California Press, 1995 (1969).

Art, Design and Fashion

Alberto, Alexander, and Blake Stimson, eds. *Conceptual Art: A Critical Anthology*. Cambridge, Mass., and London: MIT Press, 1999.

Alloway, Lawrence, et al. *Modern Dreams: The Rise and Fall and Rise of Pop*. Cambridge, Mass.: MIT Press, 1988.

Ameline, Jean-Paul. *Face à l'histoire, 1933–1996: l'artiste moderne devant l'événement historique*. Paris: Pompidou Center, 1996.

Ameline, Jean-Paul, and Véronique Wiesinger. *Denise René l'intrépide: une galerie dans l'aventure de l'art abstrait, 1944–1978* (exhibition catalogue). Paris: Pompidou Center, museum graphic art gallery, April 4–June 4, 2001.

Arbour, Rose-Marie, et al. *Déclics: art et société: le Québec des années 1960 et 1970*. Montreal: Fides, 1999.

Archer, Michael. *Art Since 1960*. London: Thames & Hudson Ltd., 2002 (1997).

Armstrong, Richard, and Richard Marshall, eds. *The New Sculpture, 1965–75: Between Geometry and Gesture*. New York, Whitney Museum of American Art, 1990.

Atkinson, D. Scott (intro.), Sally Tomlinson, and Walter Medeiros. *High Societies: Psychedelic Rock Posters of Haight-Ashbury* (exhibition catalogue). San Diego: San Diego Museum of Art, 2001.

Ayres, Anne. *L.A. Pop in the Sixties* (exhibition catalogue). Newport Beach, Calif.: Newport Harbor Art Museum, 1989.

Barnicoat, John. *Posters: A Concise History*. London: Thames and Hudson, 1991 (1972).

Brauer, David E., et al. *Pop Art: U.S./U.K. Connections, 1956–1966* (exhibition catalogue). Houston, Tex.: The Menil Collection in association with Hatje Cantz Publishers, 2001.

Brett, Guy. *Force Fields: Phases of the Kinetic* (exhibition catalogue). London: Hayward Gallery/Barcelona Museum of Contemporary Art, 2000.

Burnett, David. *Toronto Painting of the 1960s* (exhibition catalogue). Toronto: Art Gallery of Ontario, 1983.

Camnitzer, Luis, Jane Farver, and Rachel Weiss. *Global Conceptualism: Points of Origin, 1950s–1980s* (exhibition catalogue). Flushing, New York: Queens Museum of Art, 1999.

Canada, art d'aujourd'hui, (exhibition catalogue). Paris: Musée national d'art moderne (organized by the National Gallery of Canada)/Presses artistiques, 1968.

Celant, Germano. *Arte Povera, Antiform: Sculptures, 1966–1969* (exhibition catalogue). March 12–April 30, 1982. Centre d'arts plastiques contemporains, Bordeaux, 1982.

Christov-Bakargiev, Carolyn, ed. *Arte Povera.* London: Phaidon Press, 1999.

Couture, Francine, ed. *Les Arts visuels au Québec dans les années soixante.* Montreal: VLB, 1993–1997 (2 vols.).

Crow, Thomas. *The Rise of the Sixties: America and European Art in the Era of Dissent.* New York: Harry N. Abrams, 1996.

Danto, Arthur C. *Beyond the Brillo Box: The Visual Arts in Post-historical Perspective.* Berkeley: University of California Press, 1998 (1992).

Decelle, Philippe, Diane Hennebert, Pierre Loze. *L'utopie du tout plastique, 1960–1973.* Brussels: Fondation pour l'architecture, 1994.

Dessauce, Marc, ed. *The Inflatable Moment: Pneumatics and Protest in '68* (exhibition catalogue), New York: Princeton Architectural Press/Architectural League of New York, 1999.

Detheridge, Anna. *Gli anni '60. Le Immagini al Potere* (exhibition catalogue). Milan: Mazzotta, 1996.

Farmer, John Alan. *The New Frontier: Art and Television, 1960–65* (exhibition catalogue). Austin Museum of Art, 2000.

Foster, Al. *The Return of the Real: The Avant-garde at the End of the Century.* Cambridge, Mass.: MIT Press, 1996.

Francis, Mark. *Les années pop, 1956–1968* (exhibition catalogue). Paris, Pompidou Center, 2001.

Garner, Philippe. *Sixties Design.* Cologne: Benedikt, 1996.

Glenn, Constance W. *The Great American Pop Art Store: Multiples of the Sixties* (exhibition catalogue). Santa Monica, Calif.: Smart Art Press/Long Beach (Calif.), University Art Museum, California State University, 1998 (1997).

Goldberg, Vicki. *The Power of Photography: How Photographs Changed Our Lives.* New York: Abbeville Press, 1993 (1991).

Goldstein, Ann, et al. *Reconsidering the Object of Art: 1965–1975* (exhibition catalogue). Los Angeles: Museum of Contemporary Art/Cambridge, Mass.: MIT Press, 1995.

Guilbaut, Serge, ed. *Reconstructing Modernism: Art in New York, Paris, and Montreal 1945–1964.* Cambridge, Mass., and London: MIT Press, 1990.

Heimann, Jim, ed. *All-American Ads: 60s.* Cologne: Benedikt, 2002.

Hendricks, Jon. *Fluxus Codex*, The Gilbert and Lila Silverman Fluxus Collection, Detroit. New York: Harry N. Abrams, 1988.

Henke, James, and Parke Puterbaugh, eds. *I Want to Take You Higher. The Psychedelic Era 1965–1969.* Cleveland: The Rock and Roll Hall of Fame and Museum/Chronicle Books, 1997.

Iles, Chrissie. *Into the Light: The Projected Image in American Art, 1964–1977* (exhibition catalogue). New York: Whitney Museum of American Art, 2001.

Kalinovska, Milena, et al. *Beyond Preconceptions: The Sixties Experiment* (exhibition catalogue). New York: Independent Curators International, 2000.

Kostelantz, Richard. *The Theatre of Mixed Means: An Introduction to Happenings, Kinetic Environments and Other Mixed-means Performances.* London: Pitman, 1970.

Krauss, Rosalind. *Passages in Modern Sculpture.* New York: Viking, 1977.

Lippard, Lucy R. *A Different War, Vietnam in Art.* Seattle: Real Cornet Press/Whatcom Museum of History and Art, 1990.

Lippard, Lucy R. *From the Center: Feminist Essays on Women's Art.* New York: E.P. Dutton & Co., Inc., 1976.

Lippard, Lucy. *Six Years in the Dematerialization of the Art Object from 1966–1972.* New York: Praeger, 1973.

Livingstone, Marco. *Pop Art* (exhibition catalogue). Trans. Dominique Le Bourg et al. Montreal: Musée des beaux-arts, Montreal, 1992.

Lobenthal, Joel. *Radical Rags: Fashions of the Sixties.* New York: Abbeville Press, 1990.

Madoff, Steven Henry, ed. *Pop Art: A Critical History.* Berkeley, Calif.: University of California Press, 1997.

Martel, Richard, ed. *Art action, 1958–1998: Happening, fluxus, intermédia, zaj, art corporel/body art, poésie action/action poetry, actionnisme viennois, viennese actionism, performance.* Quebec: Éditions Intervention, 2001.

McDermott, Catherine. *20th c. Design: Designmuseum.* London: Carlton, 1999 (1998).

McShine, Kynaston L., ed. *Information* (exhibition catalogue). New York: Museum of Modern Art, 1970.

Mellor, David. *The Sixties: Art Scene in London.* London: Phaidon Press in association with the Barbican Art Gallery, 1993.

N.Y. Painting and Sculpture: 1940–1970 (exhibition catalogue). New York: Metropolitan Museum of Art, 1970.

Phillips, Lisa. *The American Century: Art & Culture 1950–2000* (exhibition catalogue). New York: Whitney Museum of American Art/W. W. Norton & Company, Inc., 1999.

Pollard Rowe, Ann, and Rebecca A. T. Stevens, eds. *Ed Rossbach: 40 Years of Exploration and Innovation in Fiber Art* (exhibition catalogue). Washington, D.C./Asheville, N.C.: Lark Books/Textile Museum, 1990.

Rorimer, Anne. *New Art in the 60s and 70s: Redefining Reality.* New York: Thames and Hudson, 2001.

Rosenfeld, Allan, and Norton T. Dodge, eds. *From Gulag to Glasnost: Nonconformist Art from the Soviet Union: The Norton and Nancy Dodge Collection the Jane Voorhees Zimmerli Art Museum, Rutgers, the State University of New Jersey.* New York: Thames and Hudson, 1995.

Roussel, Danièle. *Der Wiener Aktionismus und die Österreicher*. Klagenfurt, Ritter, 1995.

Schimmel, Paul, et al. *Out of Actions: Between Performance and the Object, 1949–1979* (Los Angeles Museum of Contemporary Art). New York: Thames and Hudson, 1998.

Steele, Valerie. *Art, Design, and Barbie: The Evolution of a Cultural Icon.* New York: Exhibitions International, 1995.

Steele, Valerie. *Fifty Years of Fashion: New Look to Now* (Museum at the Fashion Institute of Technology, New York). New Haven: Yale University Press, 1997.

Sullivan, Edward J., ed. *Latin American Art in the Twentieth Century.* London: Phaidon Press, 1996.

Sussman, Elizabeth, ed. *On the Passage of a Few People Through a Rather Brief Moment in Time: The Situationist International 1957–1972.* Cambridge, Mass., and London: MIT Press, 1989.

Szeemann, Harald. *When Attitudes Become Form: Works, Concepts, Processes, Situations, Information.* London: ICA, Institute of Contemporary Arts/Nash House, 1969.

Vancouver, Art and Artists, 1931–1983. Vancouver: Vancouver Art Gallery, 1983.

Varnedoe, Kirk, and Gopnik Adam (eds.). *High and Low: Modern Art and Popular Culture.* New York: Museum of Modern Art, 1990.

Viatte, Germian, and Takashina Shuji (Commissioner General). *Japon des avant-gardes, 1910–1970* (exhibition catalogue). Paris: Pompidou Center, 1986.

Watson, Scott, and Shengtian Zheng. *Art of the Great Proletarian Cultural Revolution 1966–1976.* Vancouver: Morris and Helen Belkin Art Gallery, 2002.

Weill, Alain. *The Poster: A Worldwide Survey and History.* Boston: G. K. Hall, 1985.

Williams, Richard J. *After Modern Sculpture: Art in the United States and Europe, 1965–70.* Manchester: Manchester University Press, 2000.

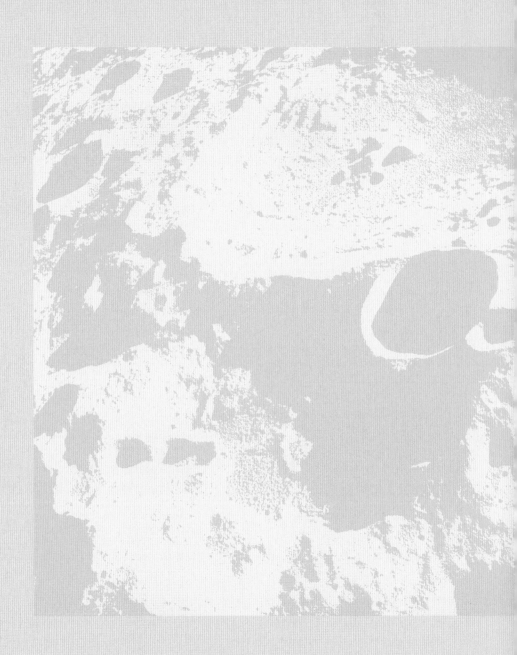

Global Village: The 1960s

Coordination
Francine Lavoie (MMFA)
Goedele Nuyttens (SDZ)
Maria-Helena Winderickx (SDZ)
Rudy Vercruysse (SDZ)

Translation
Jan Liebelt (SDZ)
Clara Gabriel (MMFA)

Copyediting
Denise Bergman

Copyrights
Linda-Anne D'Anjou (MMFA)

Technical assistance
Jasmine Landry

Design
Susan Marsh

Pre-Press and Printing
Snoeck-Ducaju & Zoon, Ghent, Belgium